DEPART

– a **MENDO** initiative & design

mendo.nl

MENDO TERRA

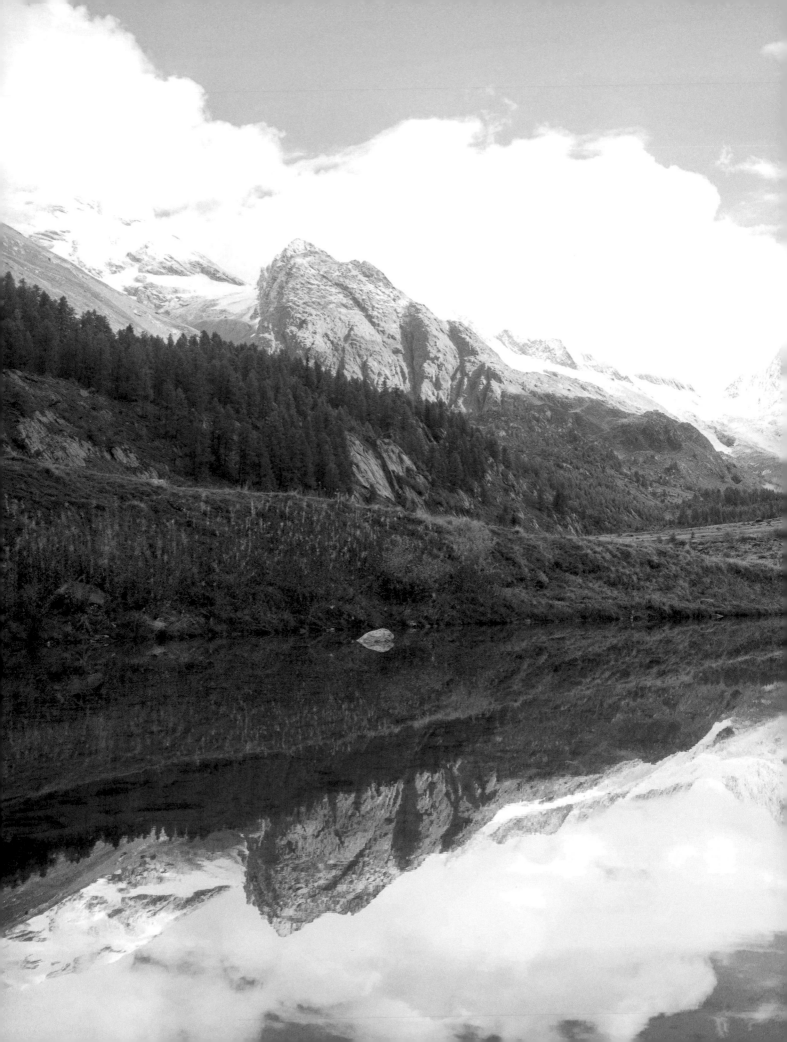

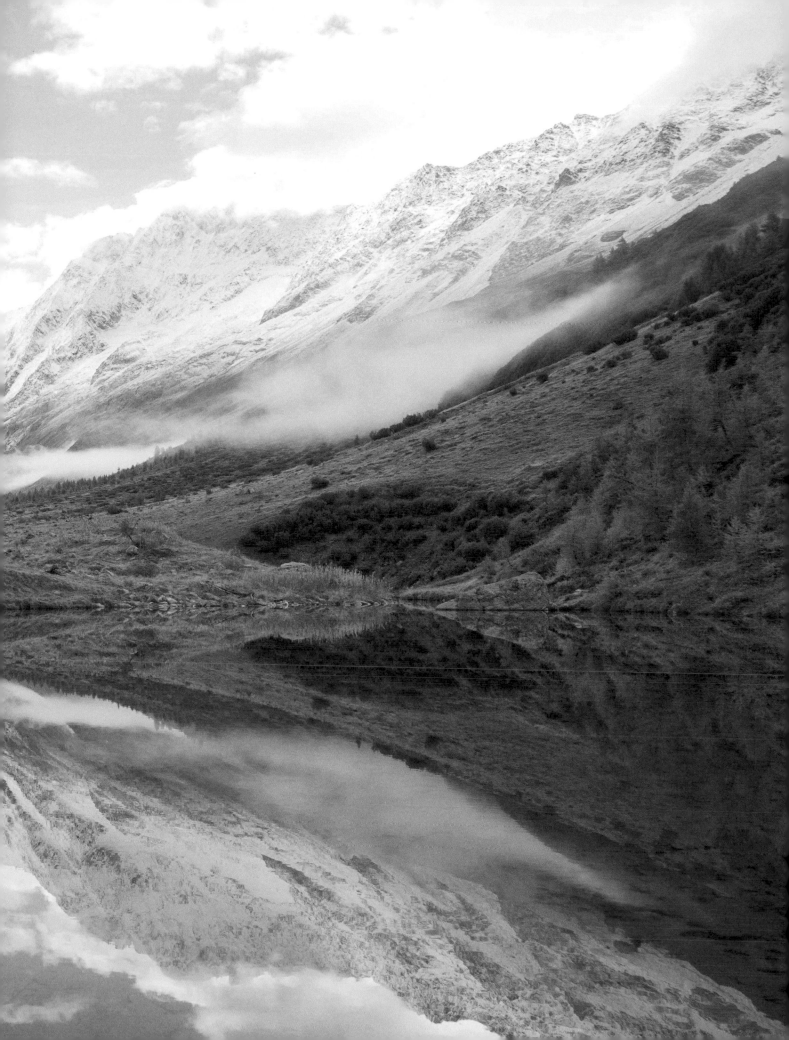

Depart tells the story of the new photographer. A photographer who's always on the move, equipped with a camera and outfitted with a big dash of courage. And because of his strong presence on social media, the new photographer never travels alone.

For *Depart*, the three Dutch Sizoo Brothers selected the photographers they admire the most. Bastiaan, Bob, Willem and the photographers they curated, guide you on a visual trip to their favorite places, all over the world.

The book contains more than 250 pages and over 300 breathtaking photos. That makes *Depart* not only a spectacular photo book — it also serves as a big shot of visual travel inspiration that will definitely trigger your wanderlust.

– a **MENDO** initiative & design

mendo.nl

DEPART

A PHOTOGRAPHIC
TRAVEL & ADVENTURE GUIDE

CURATED *by* THE SIZOO BROTHERS

Erratum: The chapter *A Photogenic Playground* (page 138) incorrectly identifies Big Sur as being on the East Coast of the United States while this should be the West Coast.

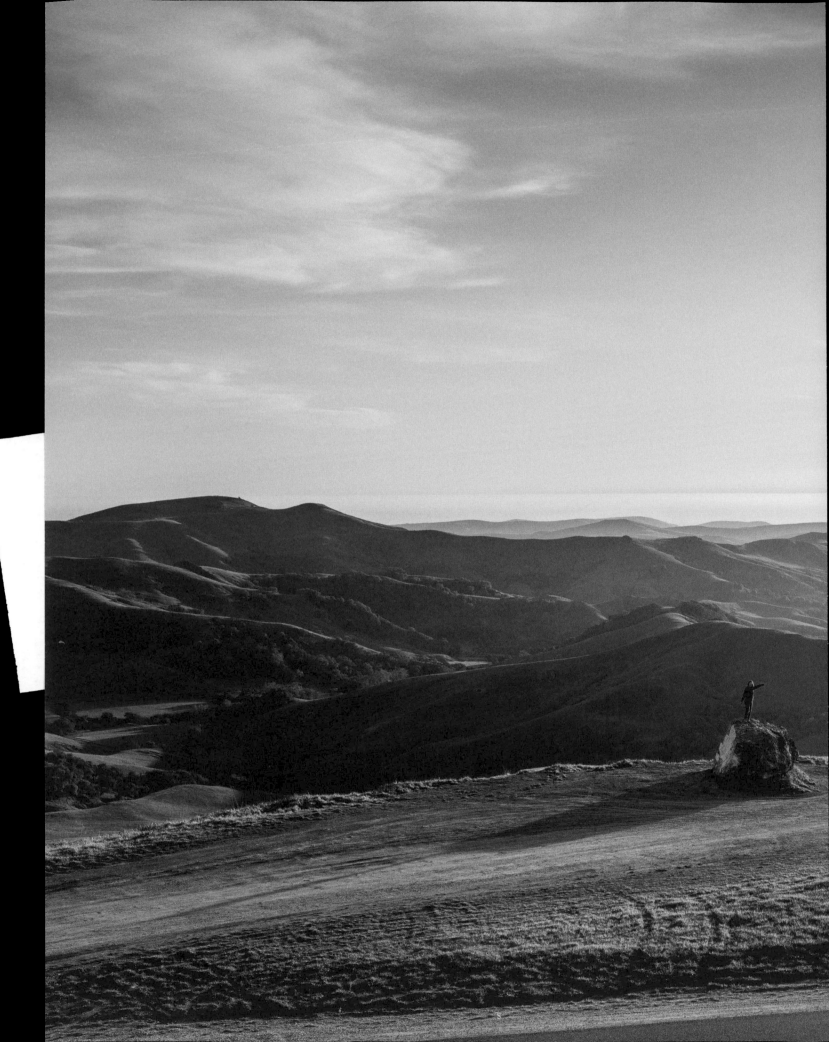

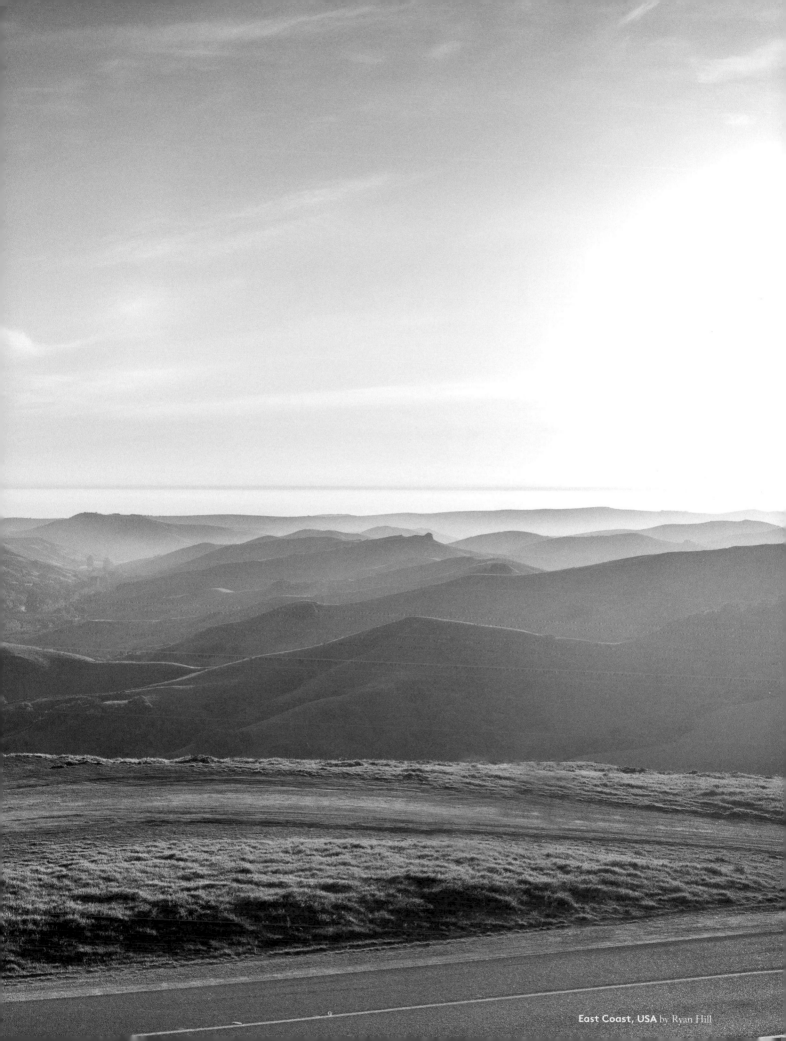

East Coast, USA by Ryan Hill

DEPART

A PHOTOGRAPHIC
TRAVEL & ADVENTURE GUIDE

words by
JOOST BASTMEIJER

The next generation's photographer is here, and he tends to do things differently. He's got no time for conventions, dares to stand out from the crowd, and just grabs his camera and heads out. Every imperfect picture develops the autodidact photographer's talent for taking a photo at exactly the right moment, of exactly the right subject. But the new photographer started out just like any other photographer - with a device full of buttons, and initially no idea how to capture the world's beauty he sees with his naked eye. Although that phase, as is evident in this book, has long passed.

When the new, mobile photographer uploads his shot from the top of the mountain, he immediately gets feedback from his massive following on social media. On the internet, everything comes together. Through the web, the new photographer finds others, who just like him, use their online channels as their canvas. He easily gets in touch with like-minded people from all over the world. They share their pictures, their stories, their tips and their tricks. Inspiring each other, the new photographers share a genuine feeling of connectedness — the visual language of photography is a powerful one.

The new class of photographers meets up with each other, often without having talked in real life before. Although you might think that that's an awkward occasion (and it sometimes is, I've been there), it normally goes pretty smoothly. This has a lot to do with the fact that these

photographers from all over the world have been following each other's moves for a long time, so they already know quite a lot about each other's lives. The meet-ups or so-called "photo walks" are the perfect moments for portrait experiments - a picture always gets better if you have someone to place in that Insta-famous "mountain-reflects-in-lake-with-pier"-shot.

Because the new photographer is already in contact with people from all over, it's easier for him to simply depart, to get on a plane and fly wherever. With healthy naivety and a dash of courage, he meets up with people that live completely different lives on the other side of the world. It doesn't really matter how otherworldly that experience may be - the love of photography is often so strong that the like-mindedness breaks down every barrier of social and cultural difference. The potential for lasting friendships is large.

Although Bob, Willem and Bastiaan Sizoo haven't met every photographer in this book, the three brothers see many of them as friends. They brought all of their "kindred spirits" together to make a book that shows how their generation of photographers "get to work" — without schooling, and without borders. Every photographer shares where their courage and inexhaustible enthusiasm has gotten them, which gives you a unique overview of some very pretty places.

From Cape Town to Iceland and from the Dutch Veluwe National Park to the exotic streets of Bangkok - the "rising online photographers" of *Depart* are always on the lookout for unique locations. But most of them aren't mountaineers, so it shouldn't be too hard for you, too, to visit the places they shoot. Let them carry you away to the most beautiful places this world has to offer — whoever uses this book as a wanderlust generator won't be disappointed.

" On the internet, everything comes together. Through the web, the new photographer finds others who just like him use their online channels as their canvas. "

– Joost Bastmeijer

Table
of
contents

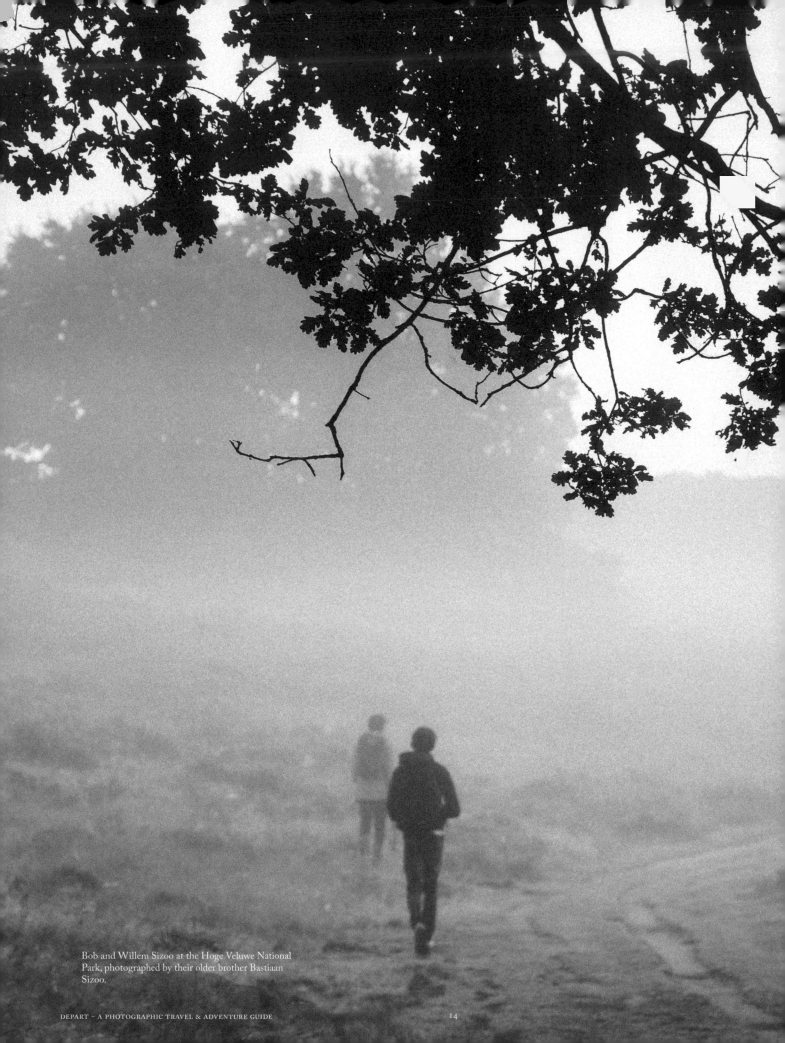

Bob and Willem Sizoo at the Hoge Veluwe National Park, photographed by their older brother Bastiaan Sizoo.

CURATED
by
THE SIZOO BROTHERS

Together with their older brother Bastiaan, twins Bob and Willem Sizoo are *The Sizoo Bros*, three young and "Insta-famous" photographers from The Netherlands. They inherited their love to travel from their parents, who lived in different places all over the world and took their kids on many adventurous trips. The three decided to do more with photography after Bastiaan (born in 1997) won a *National Geographic Junior* photo contest. The three started taking pictures with their iPods and small digital cameras, and soon gathered a growing number of followers on the Instagram app, when they were just 14 and 16 years old. For a couple of years, the social medium has been the main reason for them to wake up very early, grab their bikes and take off into the woods. There, they would take pictures of each other in either the golden light of the rising sun, or the thick fog hanging low over the ground. Their ambition grew with their following, however, and the three got more into portrait and street photography. Over 280.000 people are wandering with them, and the brothers received more and more collaboration offers from brands. After a New York-based photographer started posting the hashtag *#supersizoobrothers* under their Instagram pictures, the three presented themselves more as a photographer trio. That's also the reason they started the *@sizoobrothers* account, where they post the best pictures both of themselves and of the rest of the Instagram community. For them, and a lot of other photographers they invited to appear in this book, *Depart* is the first time their photos are printed, bundled and published offline.

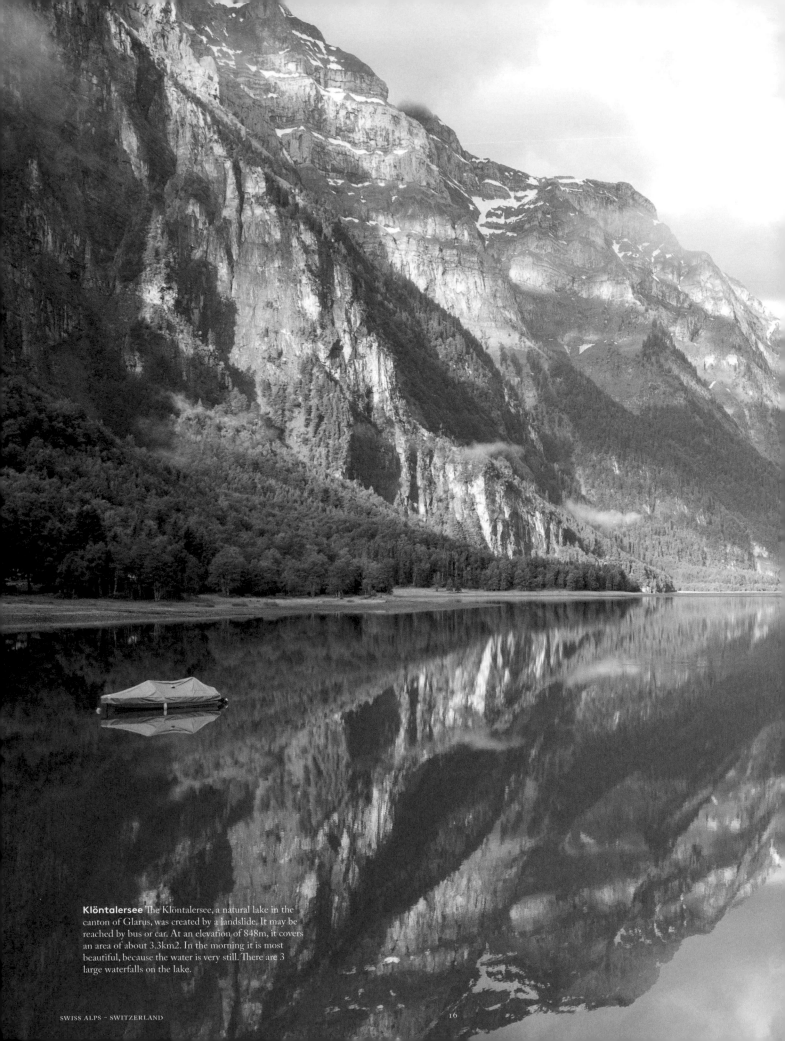

Klöntalersee The Klöntalersee, a natural lake in the canton of Glarus, was created by a landslide. It may be reached by bus or car. At an elevation of 848m, it covers an area of about 3.3km2. In the morning it is most beautiful, because the water is very still. There are 3 large waterfalls on the lake.

NEVER MIND
THE WEATHER

LOCATION Glarus, Switserland COORDINATES 47.024198, 8.947174
PHOTOGRAPHER Andre Stummer, Arth Goldau, Switzerland @andrestummer

"It doesn't matter who takes the best photos, but what feeling the photos give you." If you visit the Instagram account of the 29-year old photographer Andre Stummer, you'll see this quotation above his mountain-filled photo feed. The lion's share of his 2000+ photos is taken in the land of Alps, cheese, watches and chocolate — Switzerland.

Andre mostly travels the country on his own: "I mostly travel by car, and I sleep in my tent," he says. "It's great to just ride the cable car to the top of one of the Alps and start a hike through the mountains. I love to go back to the same areas. It doesn't matter if it's raining, snowing or if the sun shines — the Swiss alps always look different."

↑ **Bellwald** Bellwald is a small mountain village in the Valais. In the summer of 2015, a new suspension bridge, 280m long and 1.40m wide, opened. It is available all year round for pedestrians, wheelchairs, and bicycles. The middle point of the bridge offers a unique view.

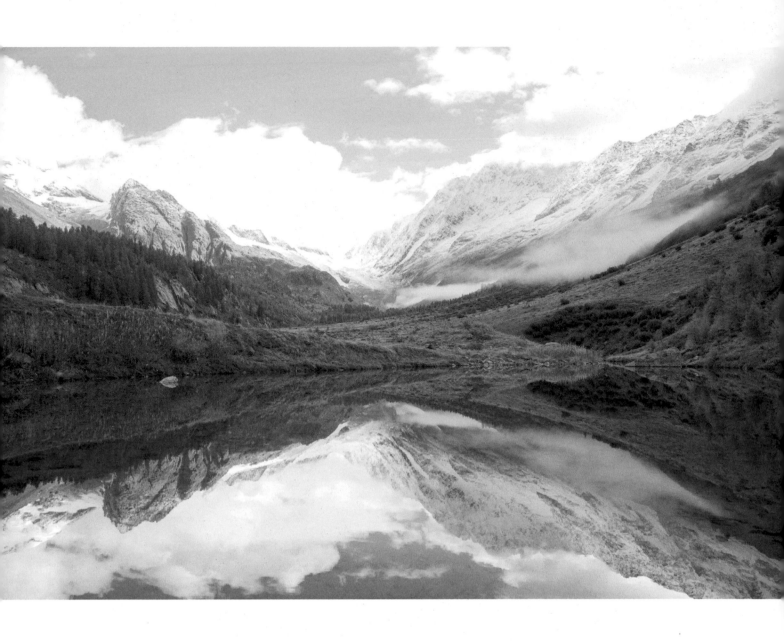

The Lötschental The Lötschental in the Upper
Valais is the largest northern tributary of the Rhone
in Switzerland. Located in the Jungfrau-Aletsch-
Bietschhorn area of Bernese Alps, it is a UNESCO
World Heritage protected site. About 27 kilometers
long, it comprises 150 square kilometers. The glaciers
of the Lötschental cover 13.7 percent of the area.
Especially in spring, it is very interesting to explore
the glacier caves.

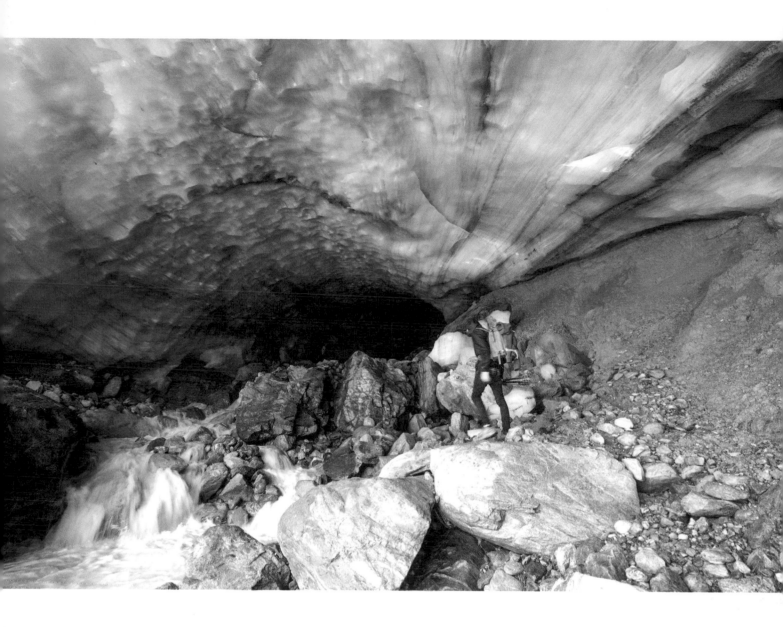

" I love to go back to the same areas.
It doesn't matter if it's raining, snowing
or if the sun shines - the Swiss alps
always look different. "

– Andre Stummer

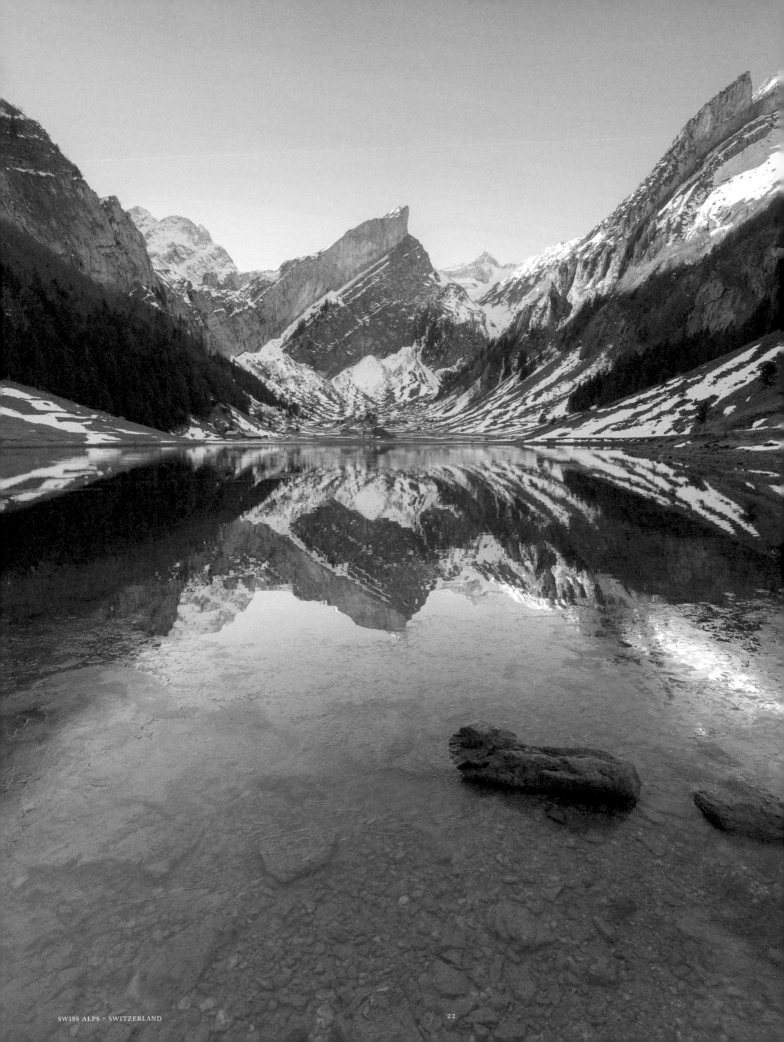

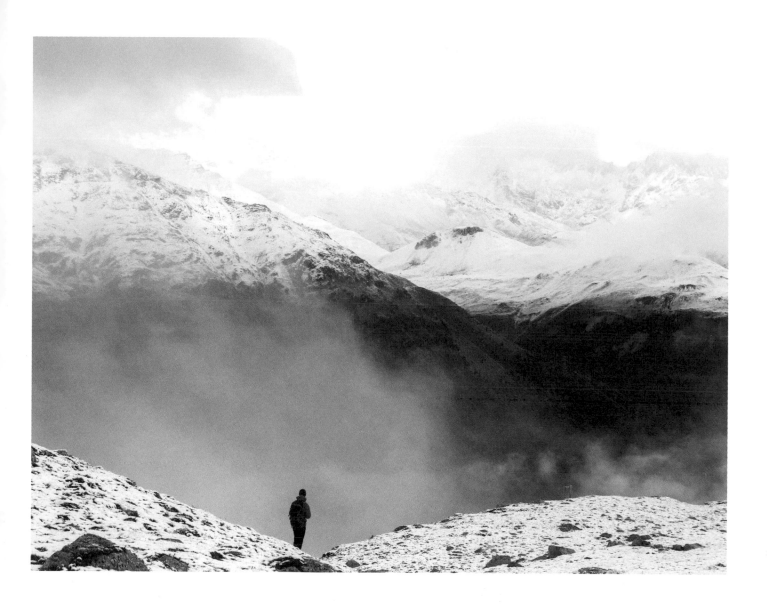

↑ **The Engadine** The Engadine is a 1600-1800m high valley with lakes marked (Engadine lakes: Lake Sils, Silvaplana, Lej da Champfèr and St. Moritz). Easy to reach by train or car, the Engadine offers many walking-tour companies.

← **The Seealpsee** The Seealpsee is in Appenzell, of the famous cheese. The best time is November, because not so many people are on the lake and the sun shines late into the valley. Seealpsee is a lake in the Alpstein range of the canton of Appenzell Inner Rhodes, at elevation of 1,143.2 m.

Andre now lives in Switzerland, but was actually born in Germany. He says, "I was born near Berlin, but I'm glad I now live in Switzerland." As you can see from the photos, Andre isn't really a homebody — he's in the Swiss outdoors a lot. "It's truly a breathtaking wonderland," he says, "with so many mountains, lakes, cities and people. Switzerland is always worth a visit."

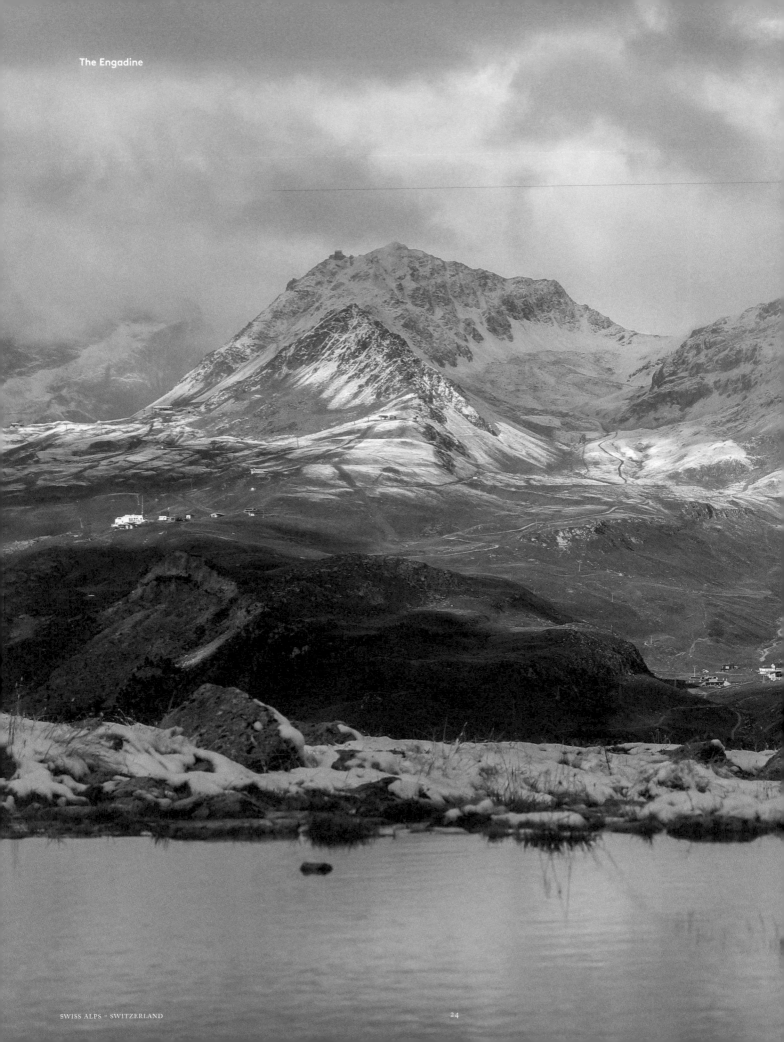

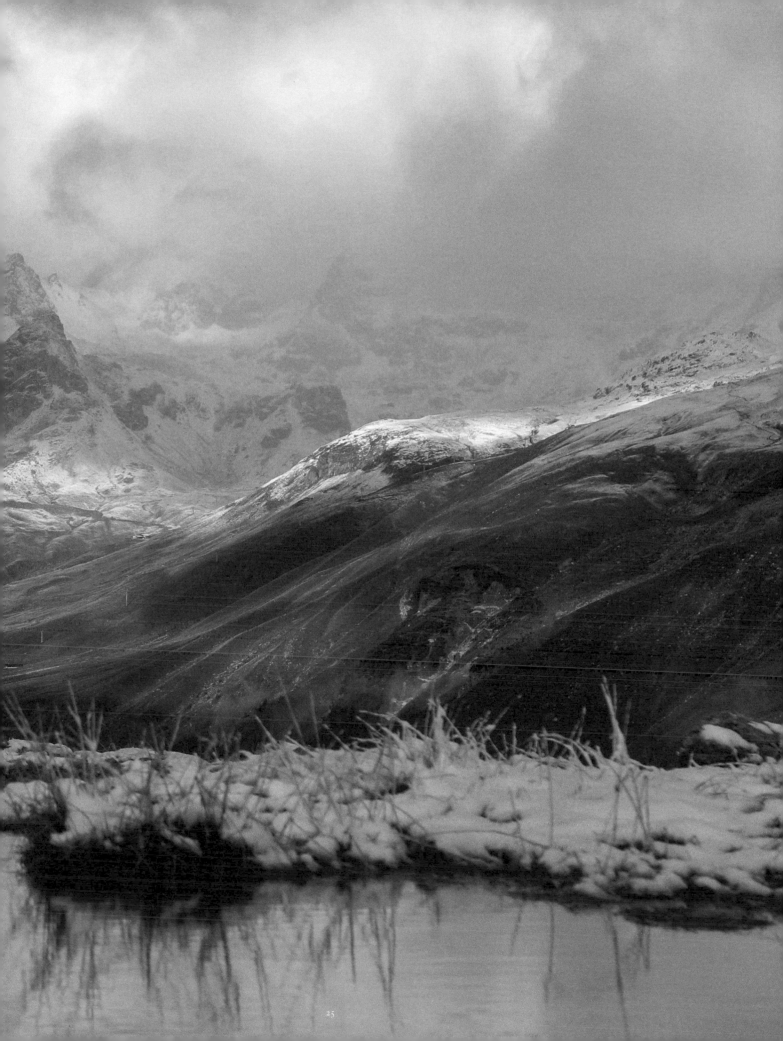

Daniel Chaney @danielchaney

ON THE GOLDEN CLIFF

LOCATION Cape Kiwanda - Pacific City, Oregon, USA **COORDINATES** 45.217801, -123.979281
PHOTOGRAPHER Daniel Chaney, Nashville, USA @danielchaney

"Cape Kiwanda is the most beautiful place I have ever visited. It has it all," says American photographer Daniel Chaney. "Last year, two of my best friends and I piled into a Prius and took a road trip from Nashville to Vancouver, California." They had one sole purpose: an epic adventure. "It had been a dream of ours for a while, and when summer hit, we knew we had to hit the road."

"It wasn't until I spent the evening climbing the rock quarries and chasing the sunset that I fully grasped the beauty," explains Daniel. They went hiking with a couple of locals, just before sunset. "We ended the day sitting on the golden cliff. We watched the disappearing sun and listened to the waves that crashed against the rocky shore. It was the most memorable moment of the trip."

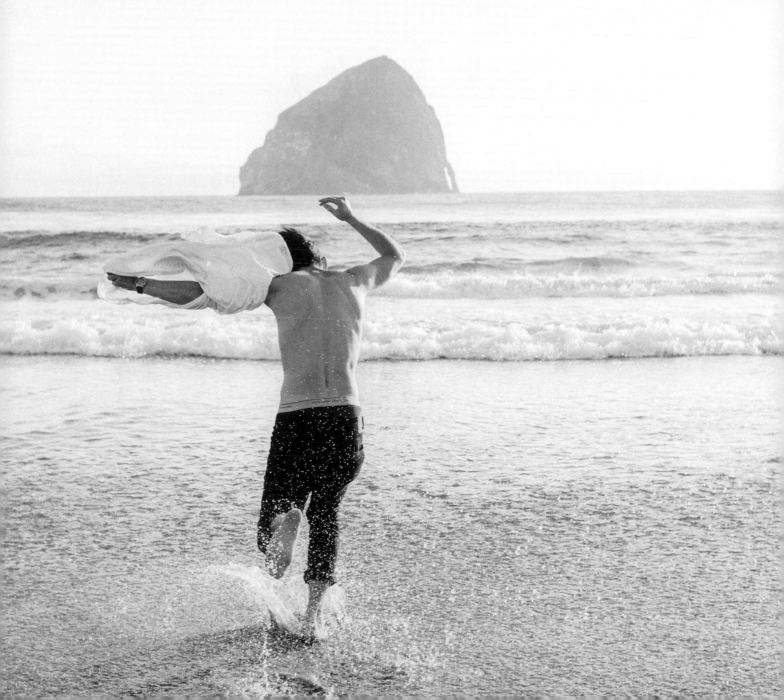

Cape Kiwanda, USA Freedom.

" It wasn't until I spent the evening climbing the rock quarries and chasing the sunset that I fully grasped the beauty. "
– Daniel Chaney

Cape Kiwanda, USA I emphasized the ocean's teal glow and the rock's orange texture; I love the way these colors compliment each other.

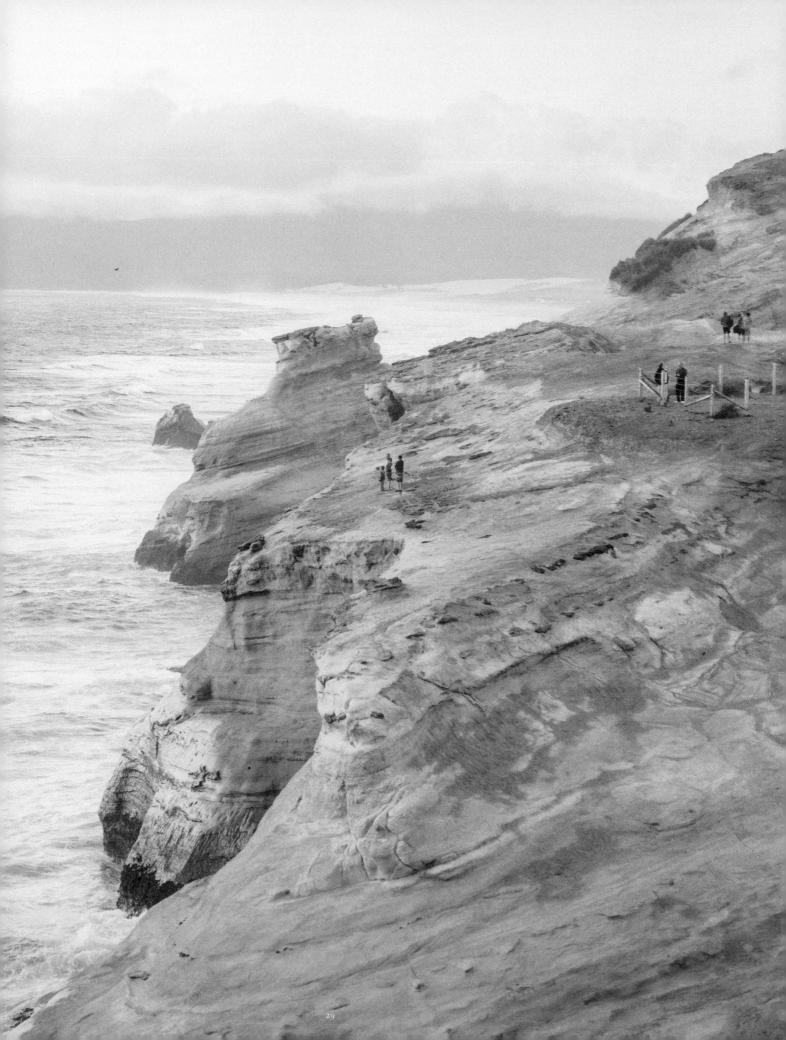

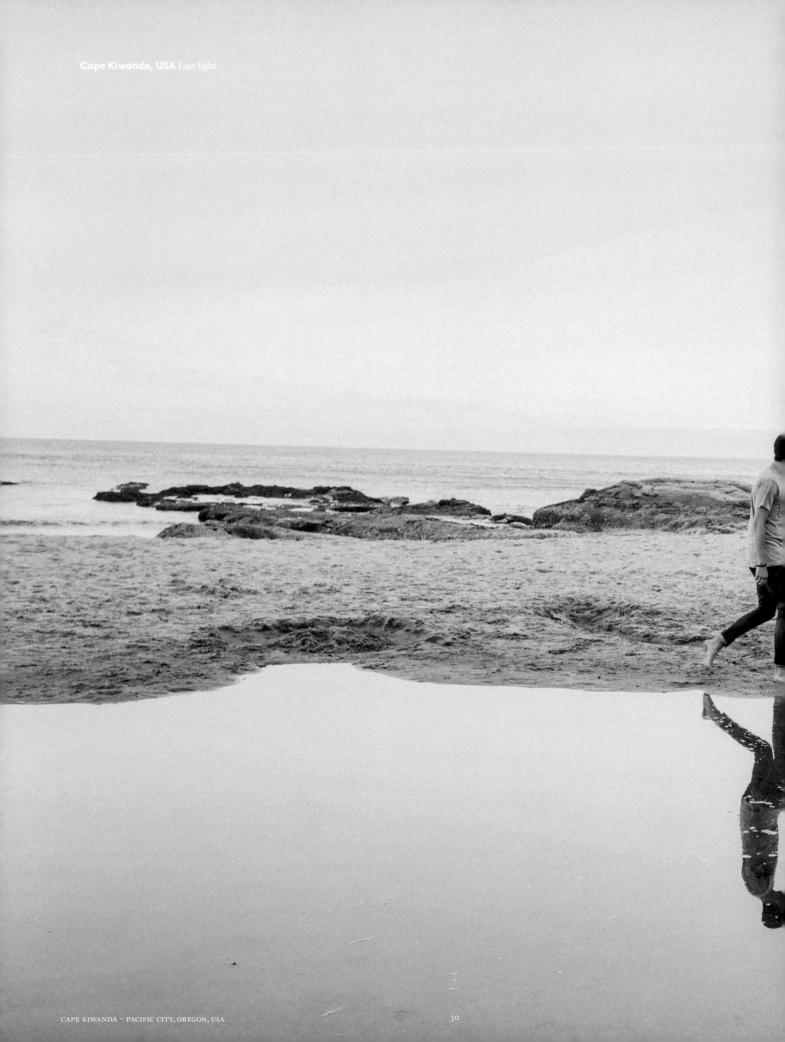

Cape Kiwanda, USA Last light.

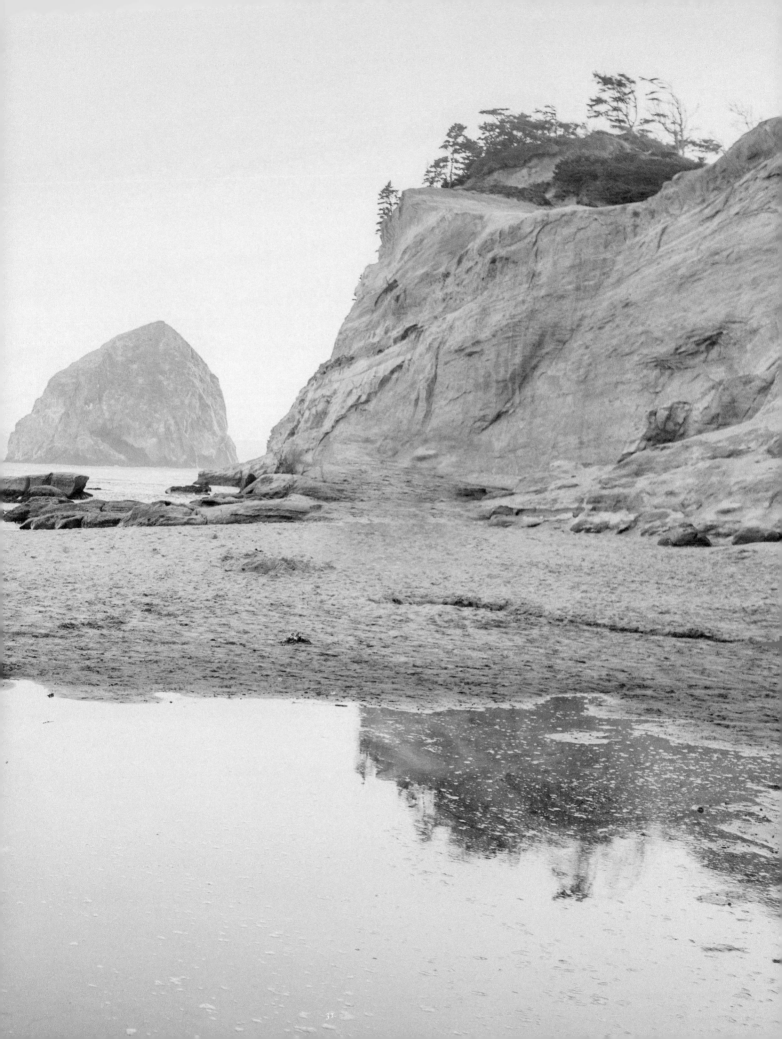

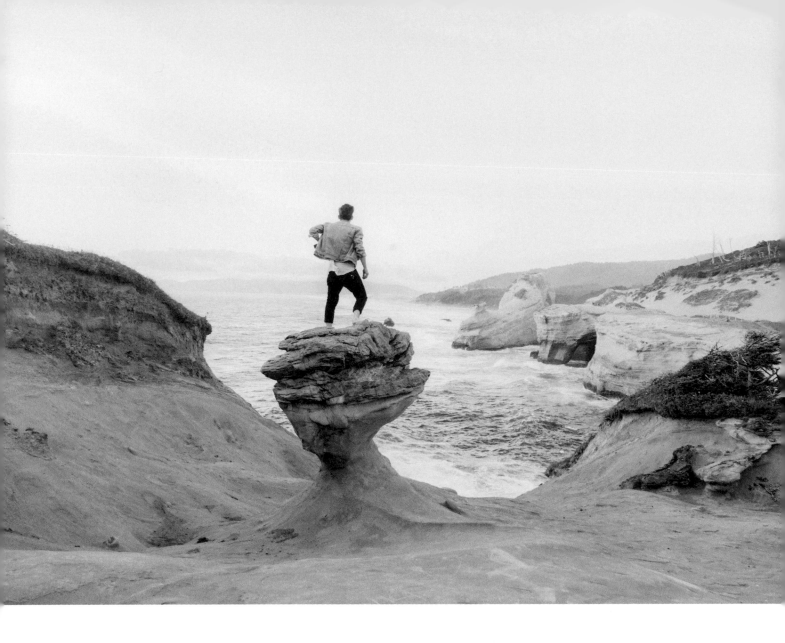

↑ **Cape Kiwanda, USA** Evan overlooking the coast
from a rock knob. This was for me, the most sought
after location of the entire trip.

↗ **Cape Kiwanda, USA** Chasing the golden sunset.

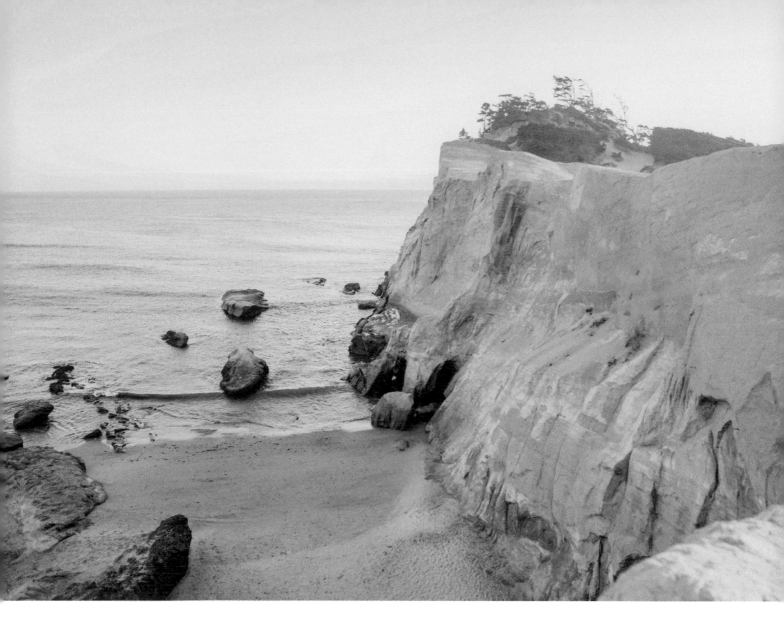

" We ended the day sitting on the golden cliff.
We watched the disappearing sun and listened to
the waves that crashed against the rocky shore.
It was the most memorable moment of the trip. "

– Daniel Chaney

When Daniel Chaney isn't on the road with his friends, he works as a photographer in the American city, Nashville. "I'm specialized in fashion, editorial and adventure photography," Daniel says. He is convinced that people are more emotionally engaged on a visual level, "I'm passionate about creating meaningful moments that express wonder, nostalgia, and imagination."

A

DUTCH

SAFARI

LOCATION Gelderland, The Netherlands **COORDINATES** 52.045438, 5.824104
PHOTOGRAPHER Bastiaan Sizoo, Amsterdam, The Netherlands @bastiaansizoo

Together with his two younger brothers, Bastiaan Sizoo spends many early mornings in a big nature reserve in the Eastern part of The Netherlands called the Hoge Veluwe. Initially, they just took trips through the area during daytime to walk their dog. However, they took an early train once, and were mesmerized. "We discovered that it's actually one of the most beautiful places in The Netherlands," he says. "There's a direct train from our home to the entrance of the park, so we often go there just to take photographs."

The park, not that well-known outside The Netherlands, is especially enchanting when it's a bit foggy and the light is just right, Bastiaan explains: "when you visit the park as early as we do, you rarely see other people. We sometimes encounter a park ranger or a group of bird watchers. We like to come to the park at 6 AM, when the birds are still whistling loudly and the animals aren't hiding from visitors. When you spot a deer jumping away at the sound of your boots, it has almost a South African vibe to it."

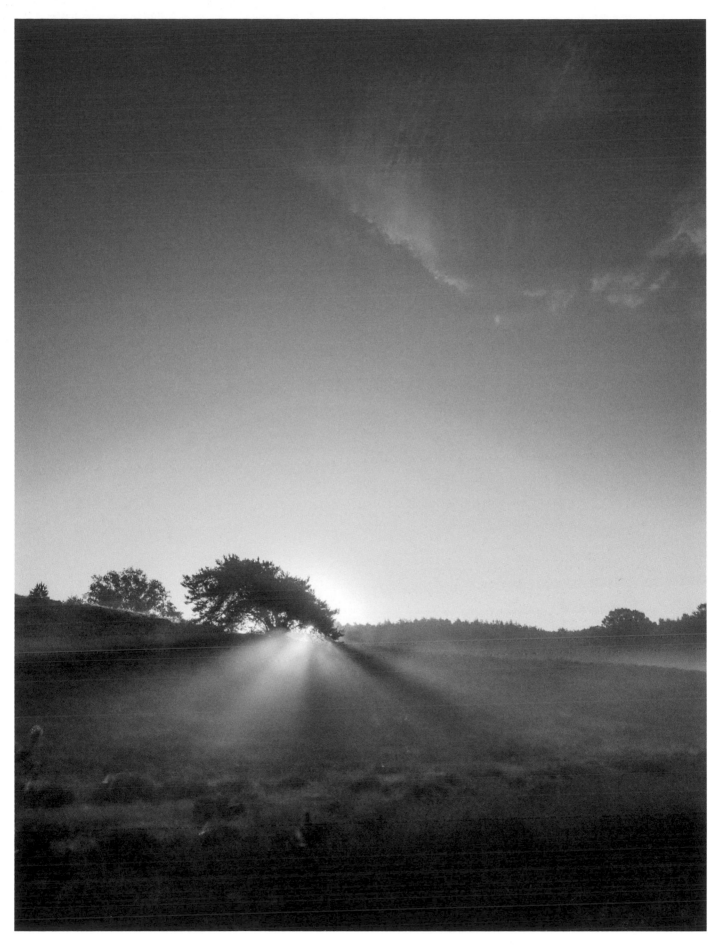

Hoge Veluwe A rare moment that only lasted for a few minutes.
This is a good example of the South African vibe of the Veluwe area.

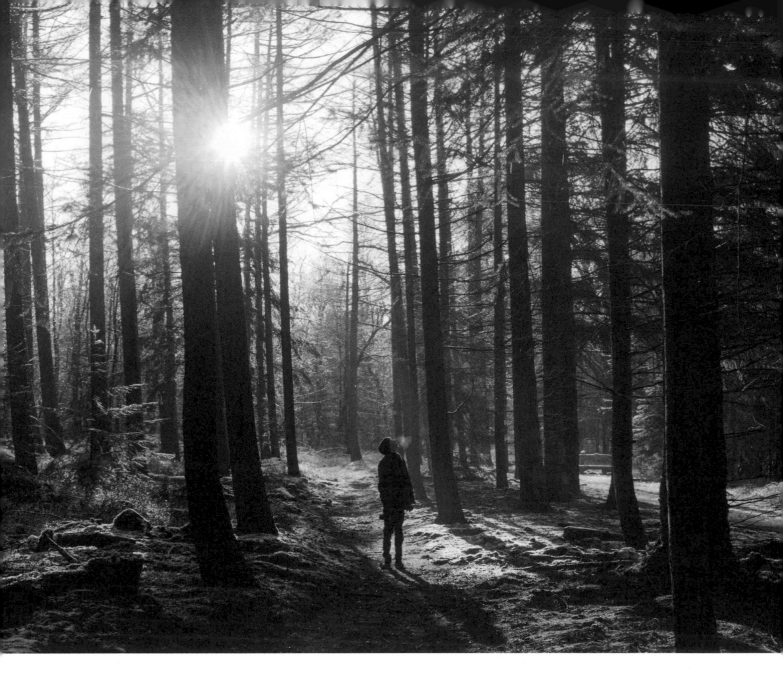

↑ **Hoge Veluwe** My brother Willem taking in the majestic sight of the forest after snow had covered the whole park.

↗ **Hoge Veluwe** Bob and I found a large hill to get a good purchase on the landscape.

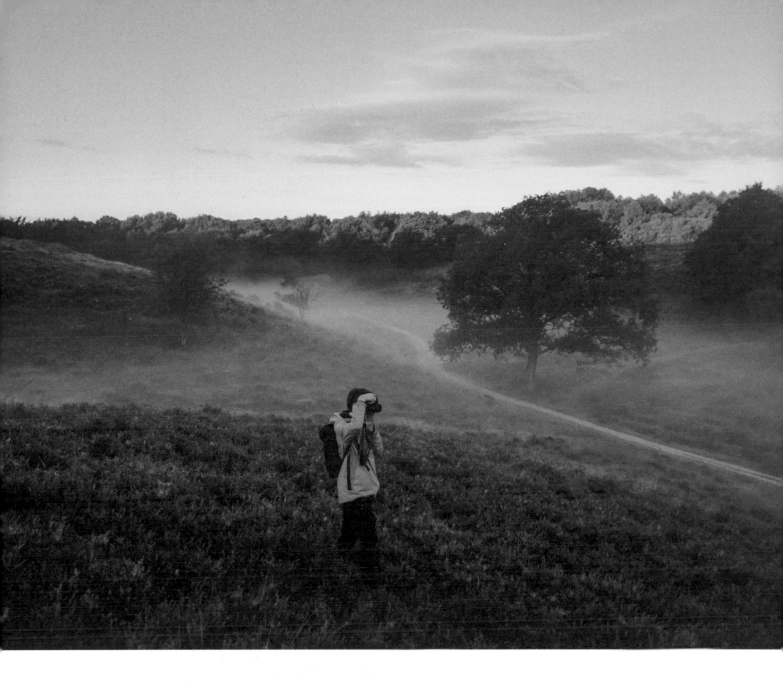

Bastiaan Sizoo is a content creator living in Amsterdam, The Netherlands. Together with his younger brothers, he's a member of the photography formation "The Sizoo Brothers". The three of them are very active as so-called "social influencers" on Instagram. "I love to connect with people, whether it is online or in person. It's the best feeling," Bastiaan says. Although he shoots a lot, he doesn't want to become a professional photographer: "in contrast to my brothers, I will always keep photographing in conjunction with my main focus, which is to learn as much about this world as possible. Photography allows me to share my experiences with my friends – and on larger scale with the world."

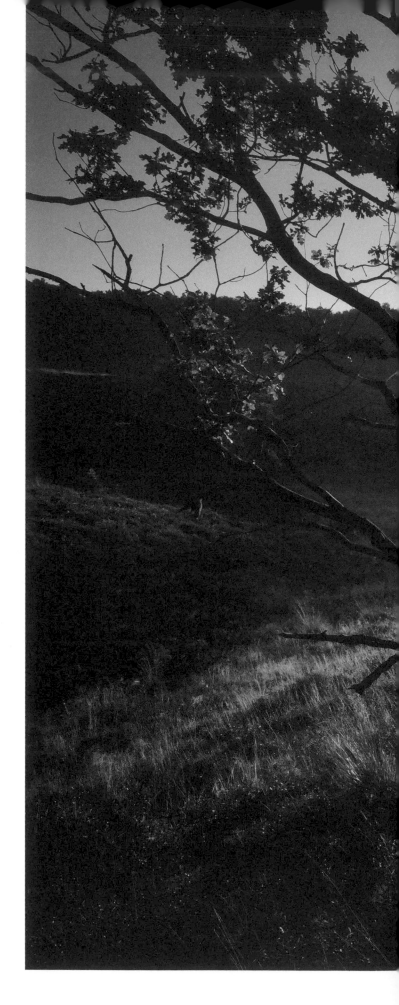

" We like to come to the park at 6 AM, when the birds are still whistling loudly and the animals aren't hiding from visitors."

– Bastiaan Sizoo

Hoge Veluwe The sun has finally risen, giving us amazing light. Time was short, though, so we had to act quickly.

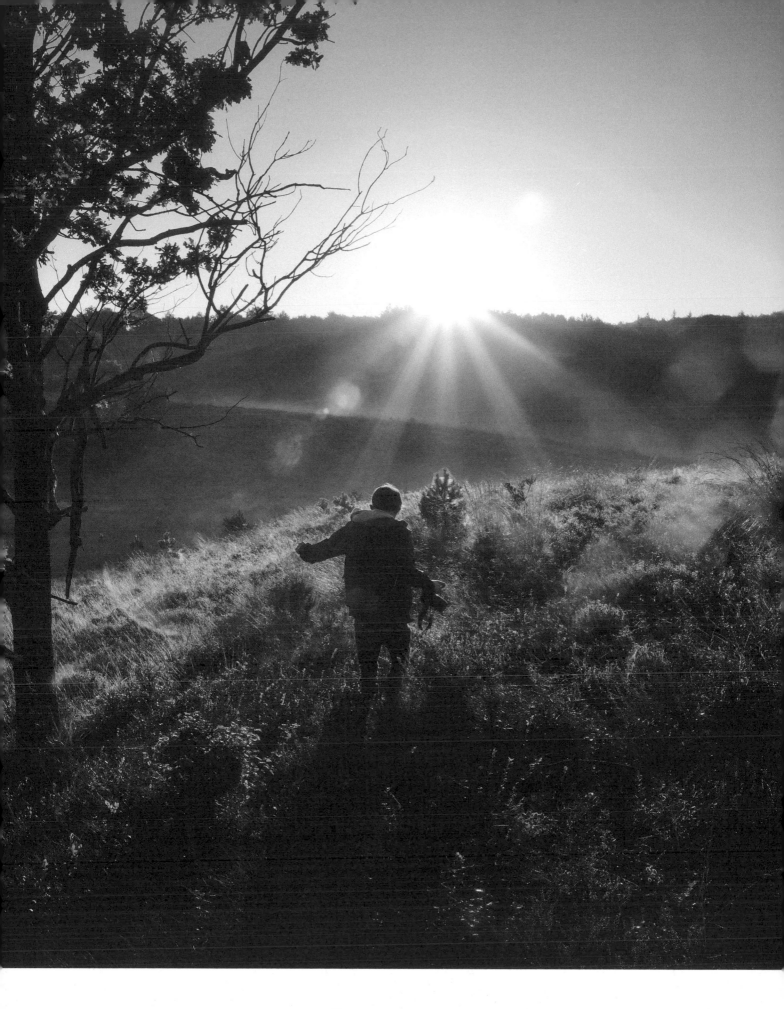

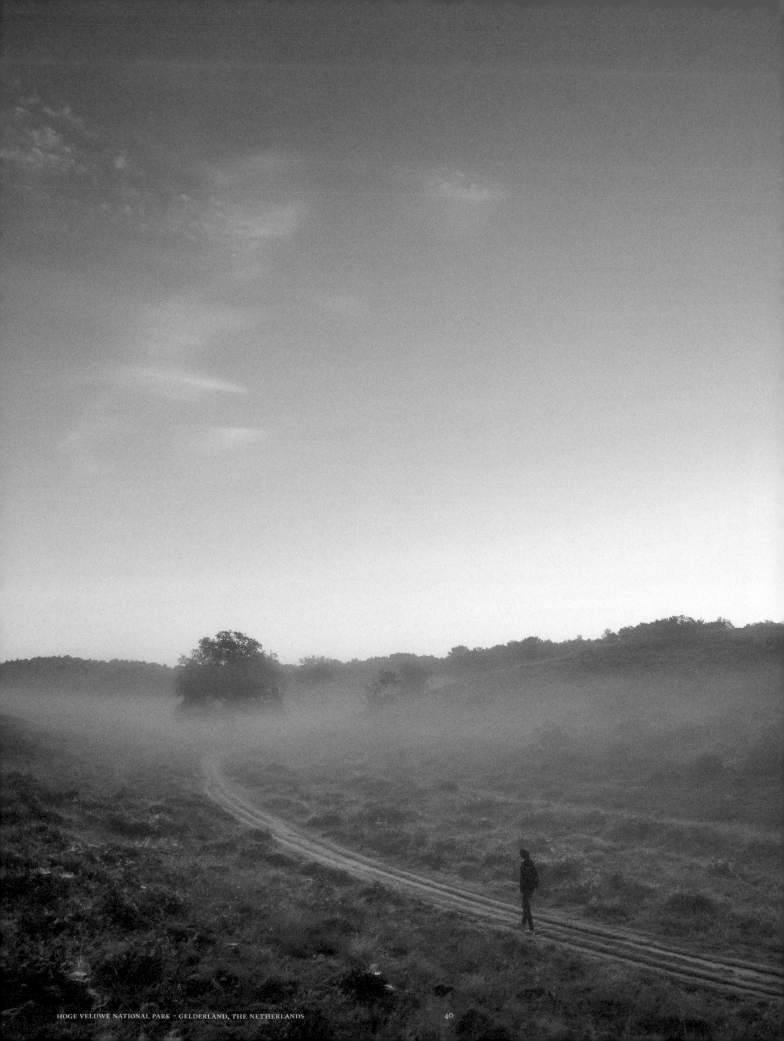

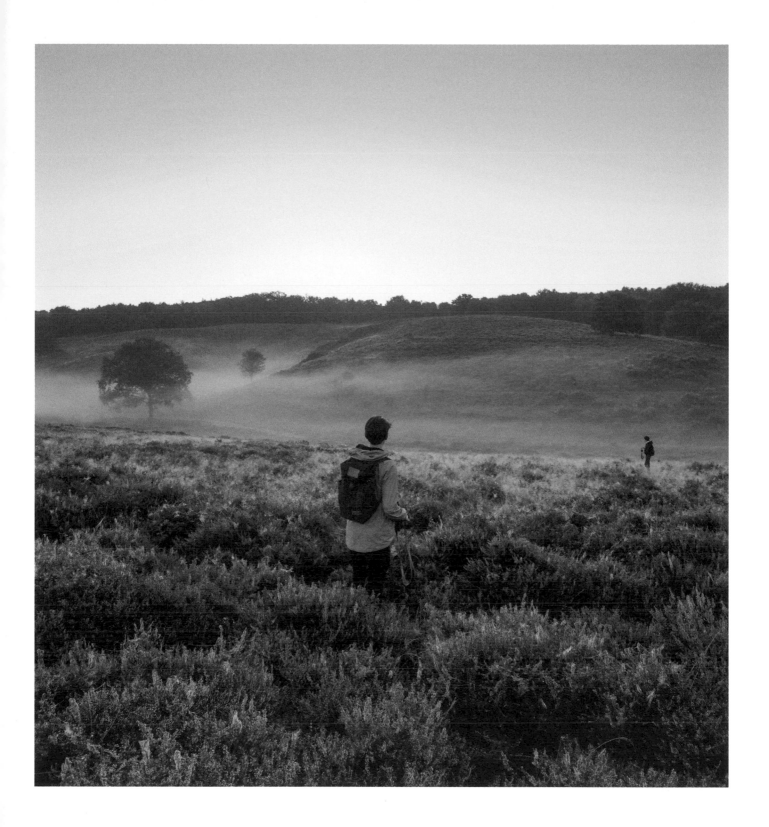

↑ **Hoge Veluwe** Bob and Willem are standing up to their waists in the grass, searching for the perfect shot.

← **Hoge Veluwe** A thick layer of fog covers the hills as the sun comes up, creating a surreal vibe.

Leap
of
faith

When searching for the perfect spot for that perfect shot, the new photographer often takes a leap of faith. A figurative leap, because that perfect spot is sometimes located on the tallest building of a city, or on a single, tiny rock above an eerie, deep canyon. These vertigo-inducing pictures are hard to make, but they always evoke on lots of startled reactions. This shot was taken by Alexander Kibble, during his Kasteelspoort hike towards Cape Town's Table Mountain top. "Even though the wind was blowing hard that day," Alexander says, "this view atop the Twelve Apostles was definitely worth it." Not every vertigo-inducing picture is worth the risk, though - it wouldn't be the first time that a thrill-seeking "Outlaw Instagrammer" could die during a "roof-topping" attempt.

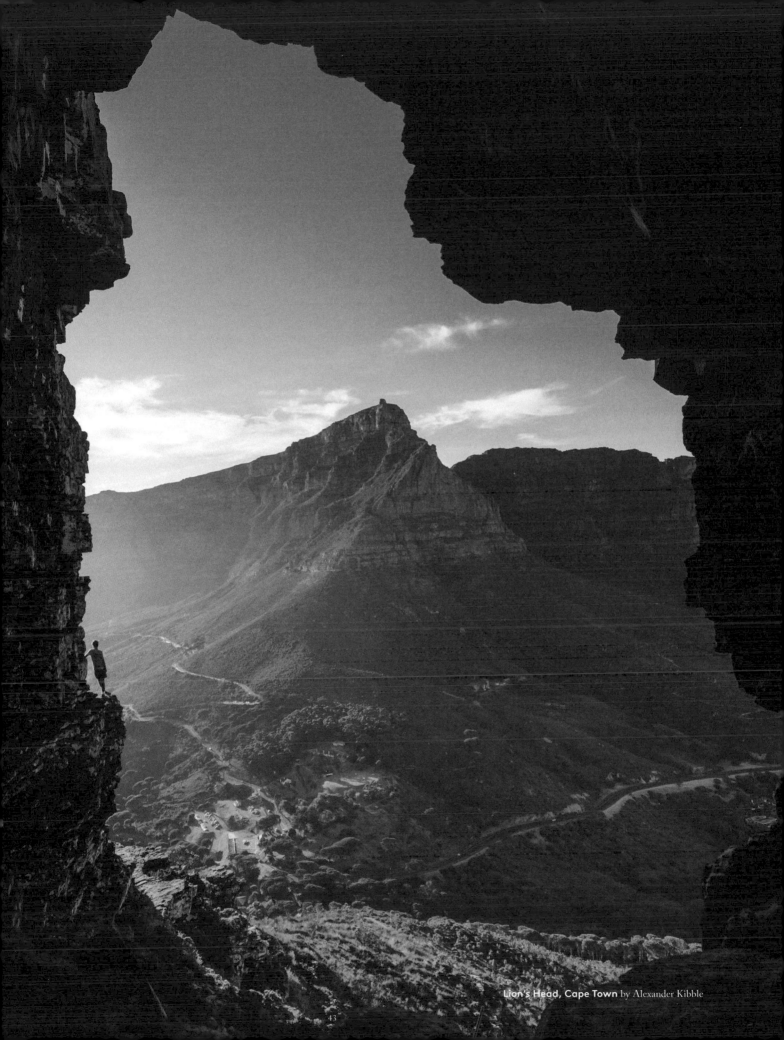

Lion's Head, Cape Town by Alexander Kibble

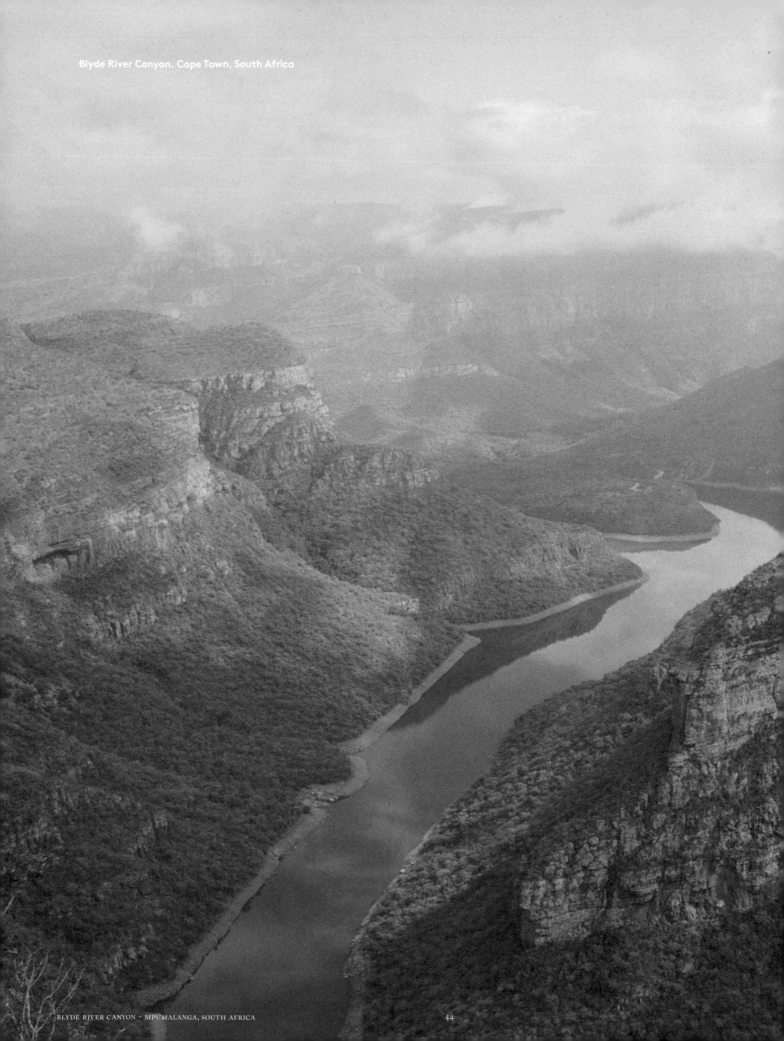

Blyde River Canyon. Cape Town, South Africa

Fran Venter @franventer

PICTURE
PERFECT

LOCATION Blyde River Canyon - Mpumalanga, South Africa COORDINATES -24.588620, 30.812800
PHOTOGRAPHER Fran Venter, Pretoria, South Africa @franventer

↑ **Buffalo Bay, South Africa**
→ **Karoo Sunset Drives, South Africa**

"I have never had to work so hard just to take one photograph." It took the South African photographer Fran Venter four months before he captured the photo he wanted. "I set out to go shoot the Blyde River Canyon on my 4th expedition," he says. "I was camping out there for a week and had no luck getting the shot I wanted. On the last day I packed up all my gear and was going home. It was a cloudy day and I thought: it's no use to photograph Blyde in this light." "I decided to give it one last chance before I went home. As soon as I got to the viewpoint, a beautiful, soft light broke through the clouds for a brief ten minutes and I finally got the shot I wanted." Fran says he thinks it's the most beautiful spot in South Africa. "It always blows my mind seeing how big it is. I highly recommend going there on your own, there is nothing else like it in the world."

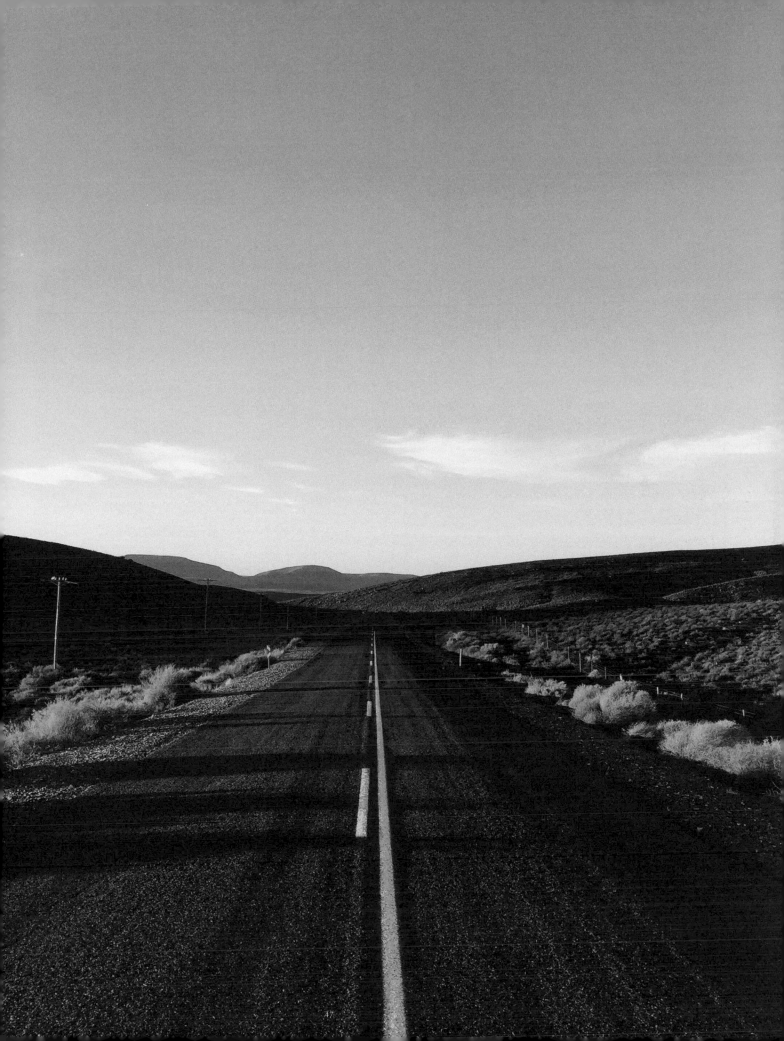

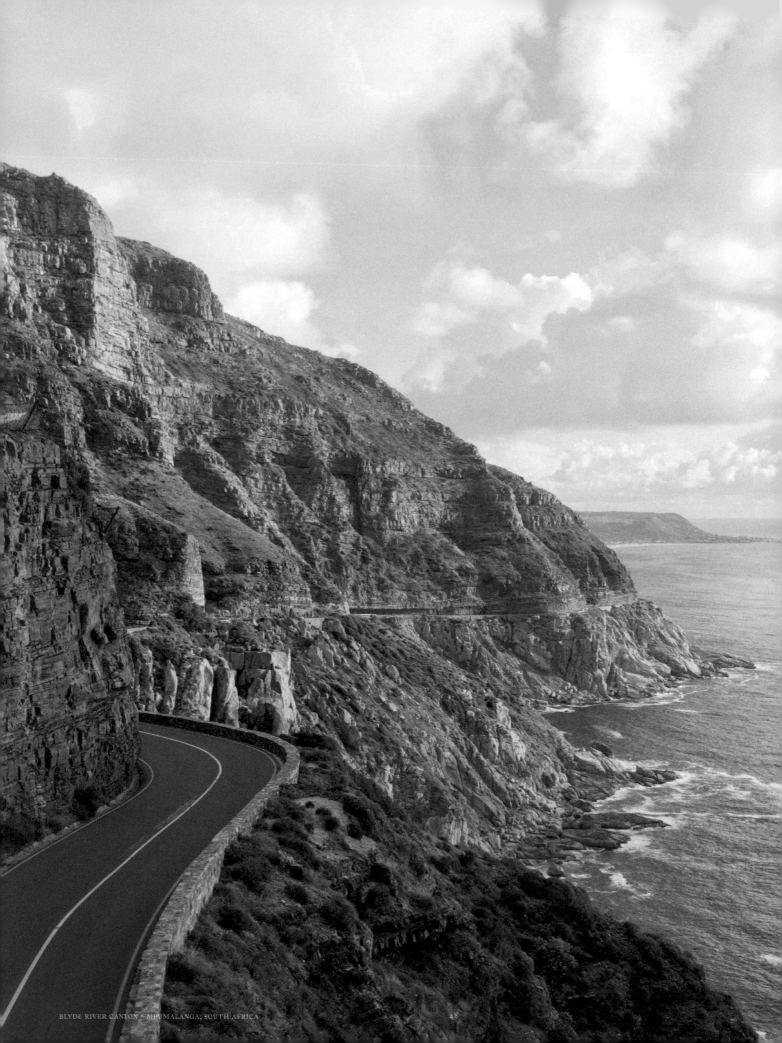

" It always blows my mind seeing
how big it is. I highly recommend going
there on your own, there is nothing else
like it in the world. "

– Fran Venter

Table Mountain. Cape Town, South Africa

Pretoria-based Fran Venter likes to stay off the beaten paths. "I grew up in a society where everybody had to go to school, go to university, and become a lawyer, accountant, engineer. And then marry and settle down. It just seemed ridiculous and small-minded to me. It's strange to me that in our culture, people are expected to decide who they want to be for the rest of their lives while they're still so young. It's such a huge decision," Fran says. That's why he went on to study music, and in that same period he taught himself to take pictures. He then gathered a growing follower count on Instagram and dreamt of becoming a travel photographer. Fran: "I eventually dropped out of music school to pursue my photography career. Traveling and taking pictures has been my life ever since."

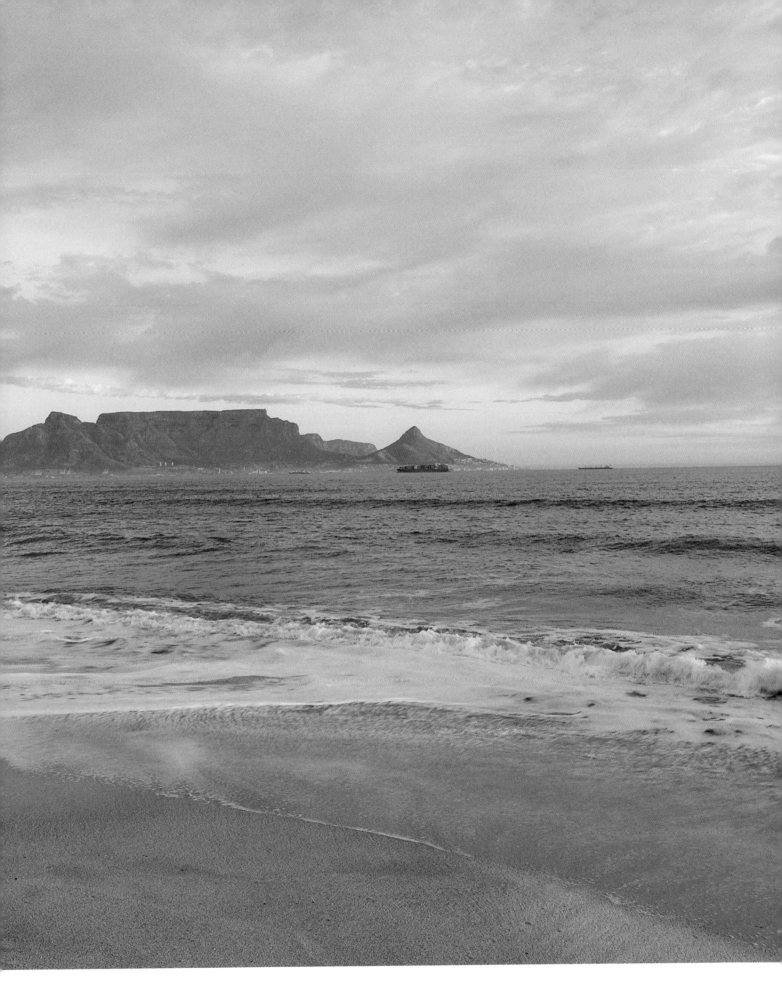

LAND
OF
SMILES

LOCATION Bangkok, Thailand **COORDINATES** 13.739285, 100.516780
PHOTOGRAPHER Chanipol Kusolcharttum, Bangkok, Thailand @rockkhound

"Everywhere I go, I always have my camera with me," says Bangkok-based Chanipol Kusolcharttum. He loves his work as a professional traveller, but he always comes back home to his Thai hometown. "I like to get out there, because I want to be a part of the city. I want to see it, understand it, and translate that to my photos. Because of photography I have found and experienced new things in the place that I thought I knew so well. When people depart, when they get on a plane, they always think of traveling to somewhere else," says Chanipol. "For me, the destination doesn't matter. I'd like to think that we're on a 'life journey,' every day. That's why my pictures here are pictures of ordinary, yet important people from Bangkok. People that embark on their 'life journey, every day.'"

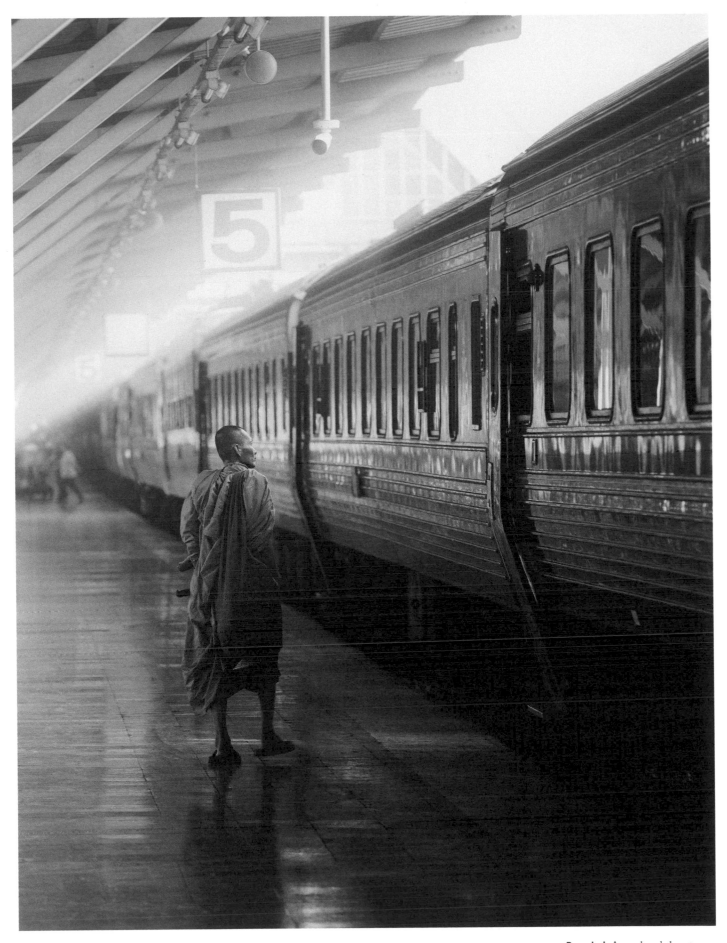

Bangkok A monk and almost
boarding a train at Bangkok's train station.

" For me, the destination doesn't matter. I'd like to think that we're on a 'life journey,' every day. "

– Chanipol Kusolcharttum

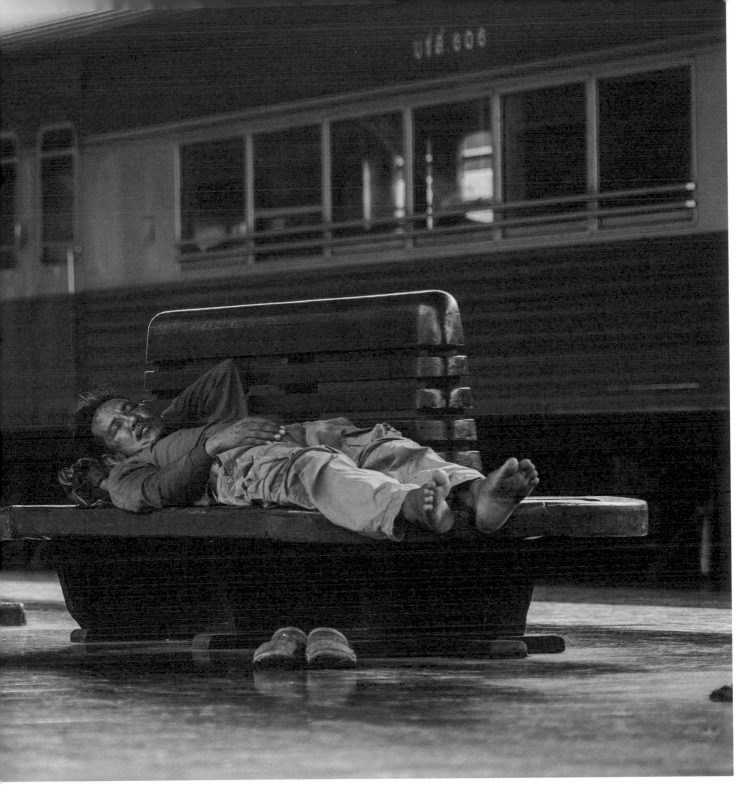

Bangkok A man taking a nap in Bangkok's train station.

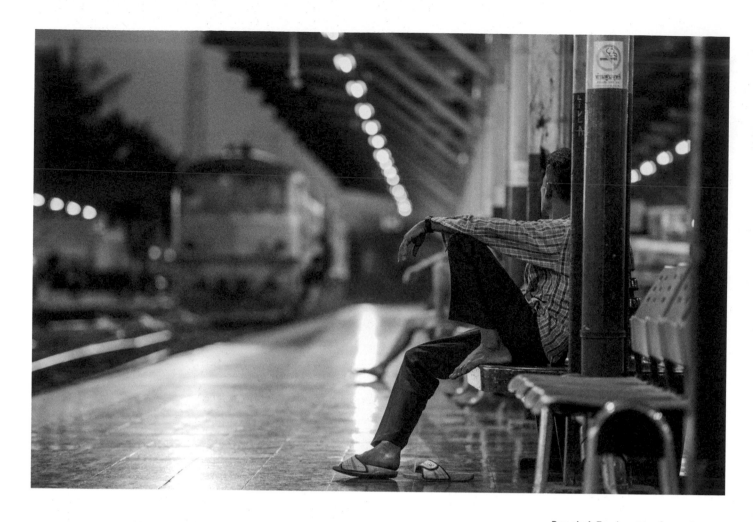

Bangkok People waiting for a train.

Chanipol Kusolcharttum combines his work as a cabin crewmember for a Thai airliner with taking pictures all over the world. On his Instagram account, there are photos from all kinds of different places – but his main focus is on Bangkok. "Bangkok is home to me, there's nothing that's more important to me. It's where I learn about life," he says. "I really feel like I am a part of the locals of Bangkok," Chanipol continues. "I am very comfortable with them and the places they go. I want to tell their stories through my pictures. As you can see, the Bangkok people are very kind. If you ask me, that's why our country is called "the Land of Smiles."

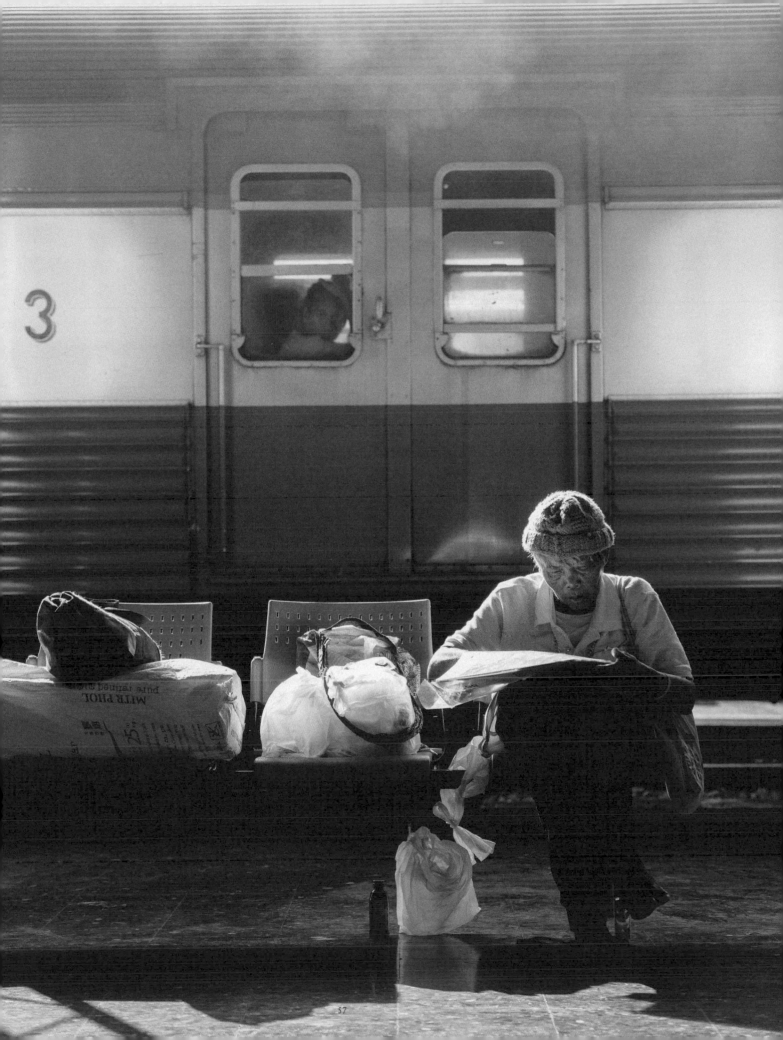

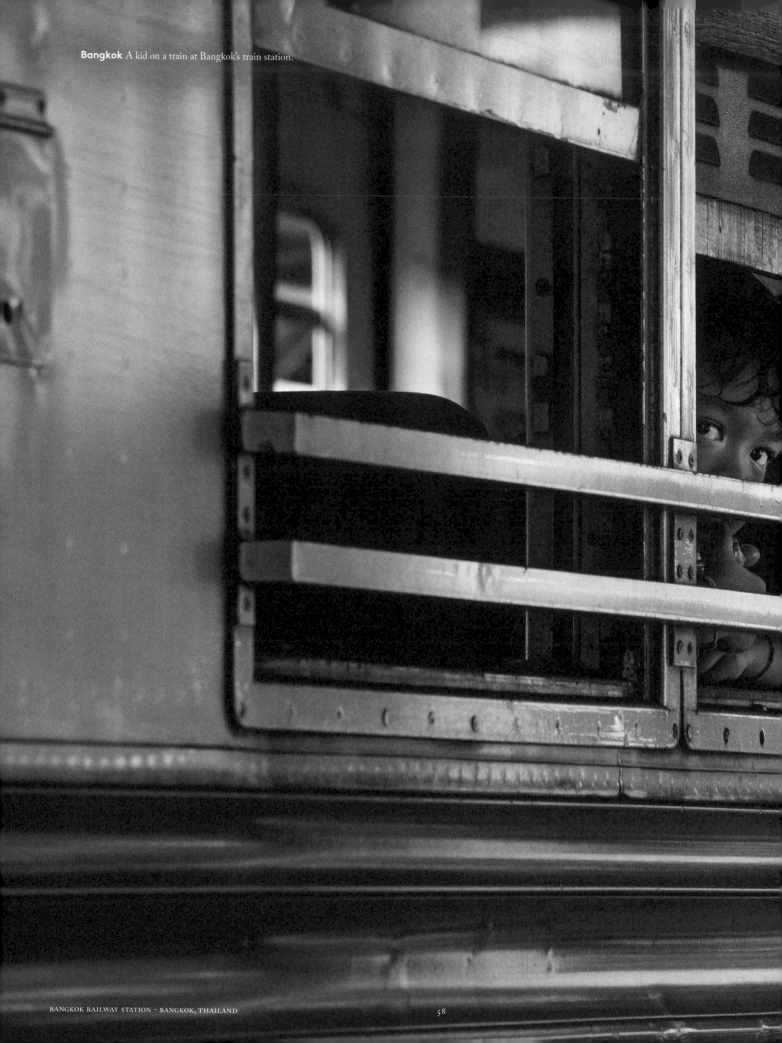

Bangkok A kid on a train at Bangkok's train station.

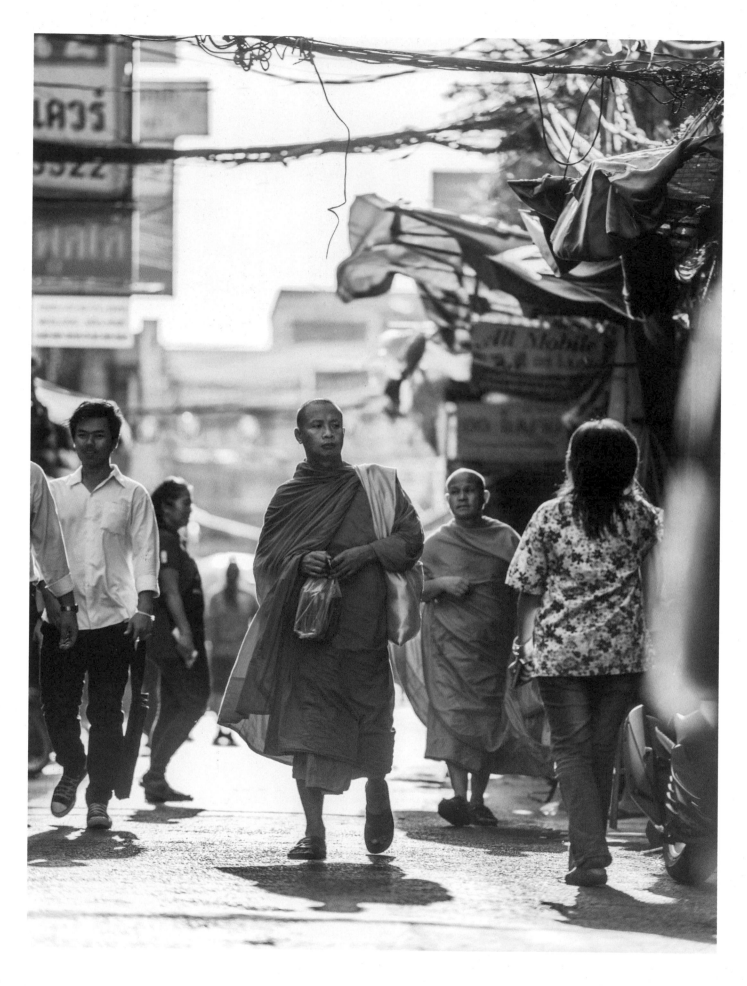

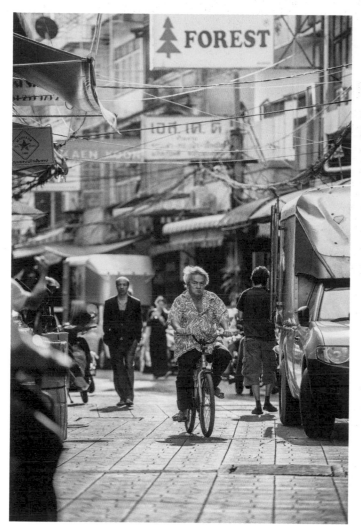

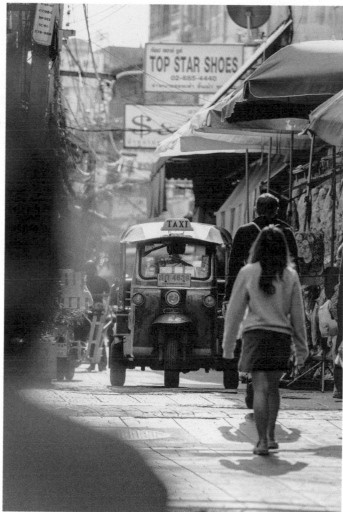

↑ **Bangkok** People on foot, in tuk tuk's and on bikes, in the streets of the Bangkok's China Town neighborhood.

← **Bangkok** A monk walking through Bangkok's Old Town area.

FOREVER CHANGING CAPETOWN

LOCATION Cape Town, South Africa **COORDINATES** -33.961540, 18.409883
PHOTOGRAPHER Alexander Kibble, Cape Town, South Africa @diaryofalex

"Often when I move around the city, it feels like I have departed to somewhere else," says South African photographer Alexander Kibble. Because the city and the expansive area around it are forever changing, Alex is able to keep exploring and discovering new places. To find the picture perfect moments he's looking for, he dives, hikes, surfs and climbs – sometimes he even shoots his photos from a helicopter above the city.

Alex combines street photography with nature photography. He's living in one of the most vibrant cities of the world, but there are plenty of wild adventures to be had in the area of Cape Town. "That's the single greatest thing about the city," Alex continues, "in one day you could go for a hike, visit the beach, go for a surf, eat lunch at a wine farm and go out to a bar or club in the city center."

Misverstand Dam After a day of wakeboarding on Misverstand Dam, a fellow photographer-friend and I decided to capture the glorious night sky. We took a few minutes to just look up in awe.

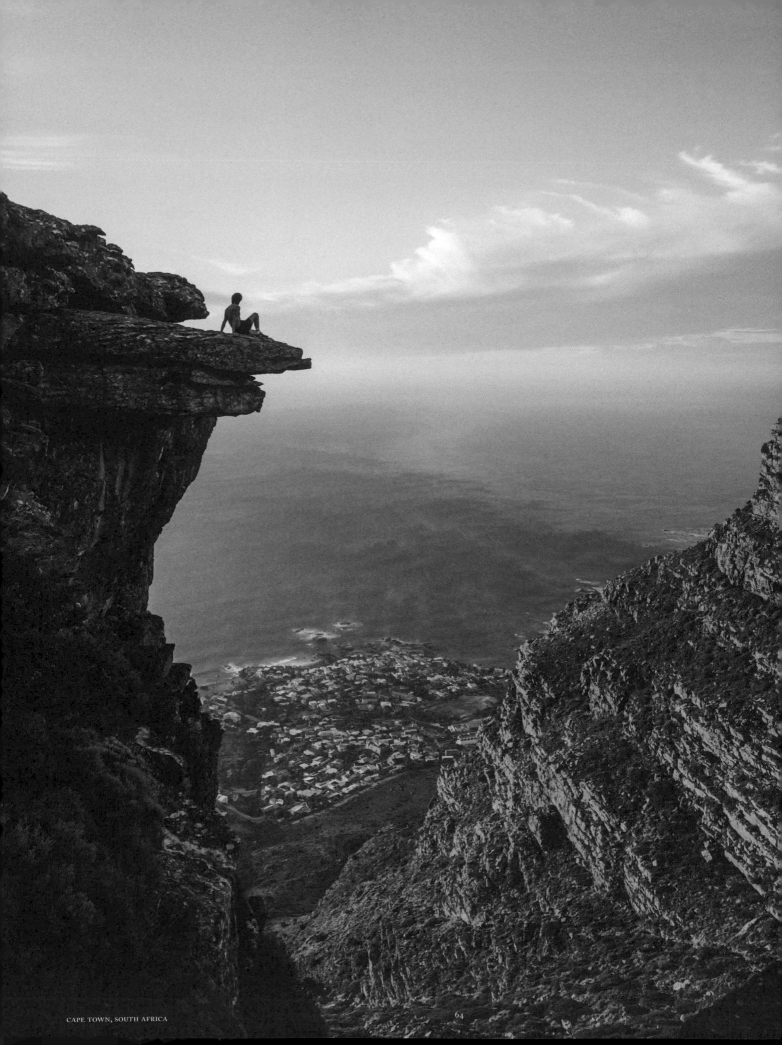

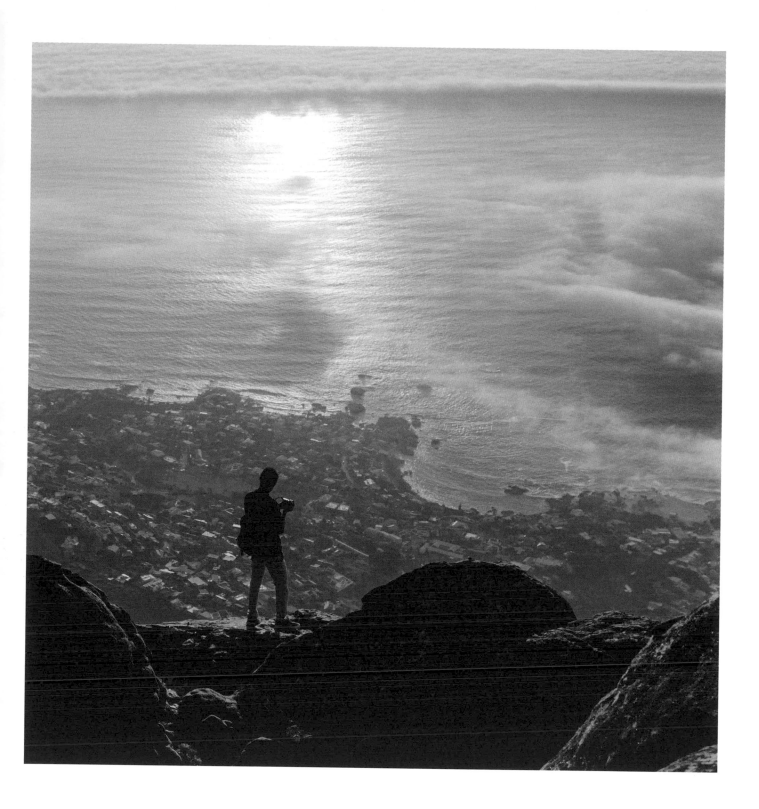

↗ **Table Mountain** Taken atop the Table Mountain, the beacon of Cape Town, during sunset as the fog started to roll in off the Atlantic Ocean. My friend Sam stands close to the edge as he captures the incredible scenery.

← **Kasteelspoort** This is the view atop the Twelve Apostles. It is about a 2-hour hike and the wind was blowing hard that day, but the views were definitely worth it.

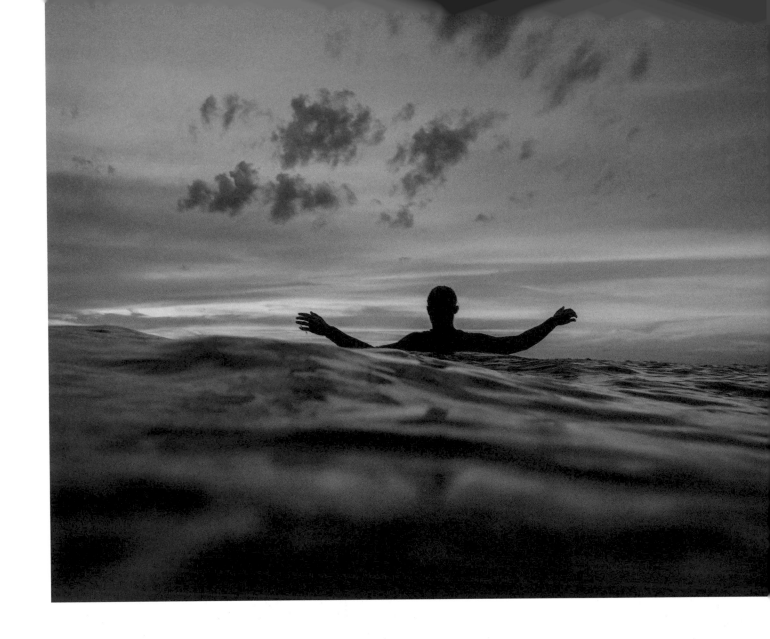

The first digital camera Alex ever used is a Sony Cybershot — it belonged to his family. Later, his father bought him a DSLR camera, and that's when Alex's passion for photography really took off. Through YouTube tutorials and photography forums, he taught himself how to use the device, and later he started posting his photos on Instagram. Alex's geo-tagged Instagram posts show that he shoots a lot in Cape Town's uptown neighborhood, but he's also often in the Camp Bay area and at the adjacent park around the city's Table Mountain. Alex is very happy with that variety. He says: "I can never really focus on one aspect, something I am extremely grateful for."

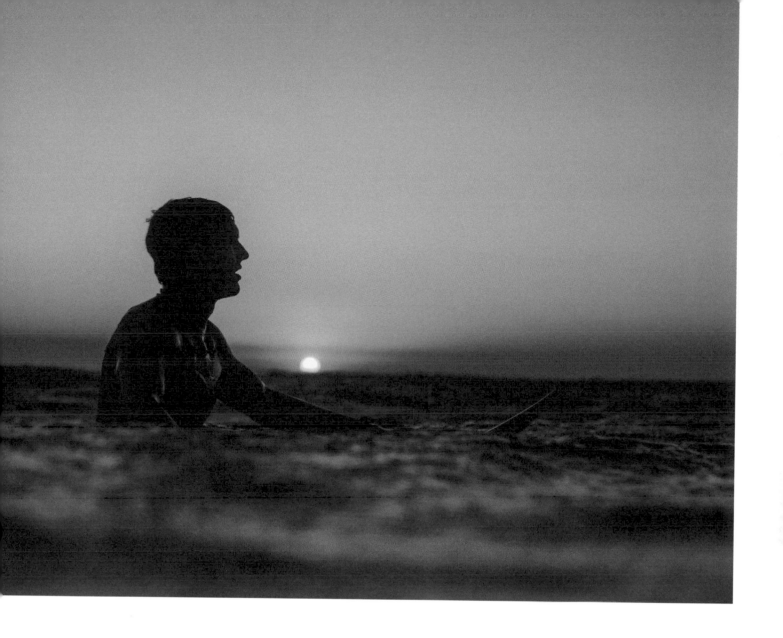

Clifton I captured this moment whilst I was photographing at one of the Clifton Beaches with a friend of mine. There weren't any waves around but the sunset made up for that.

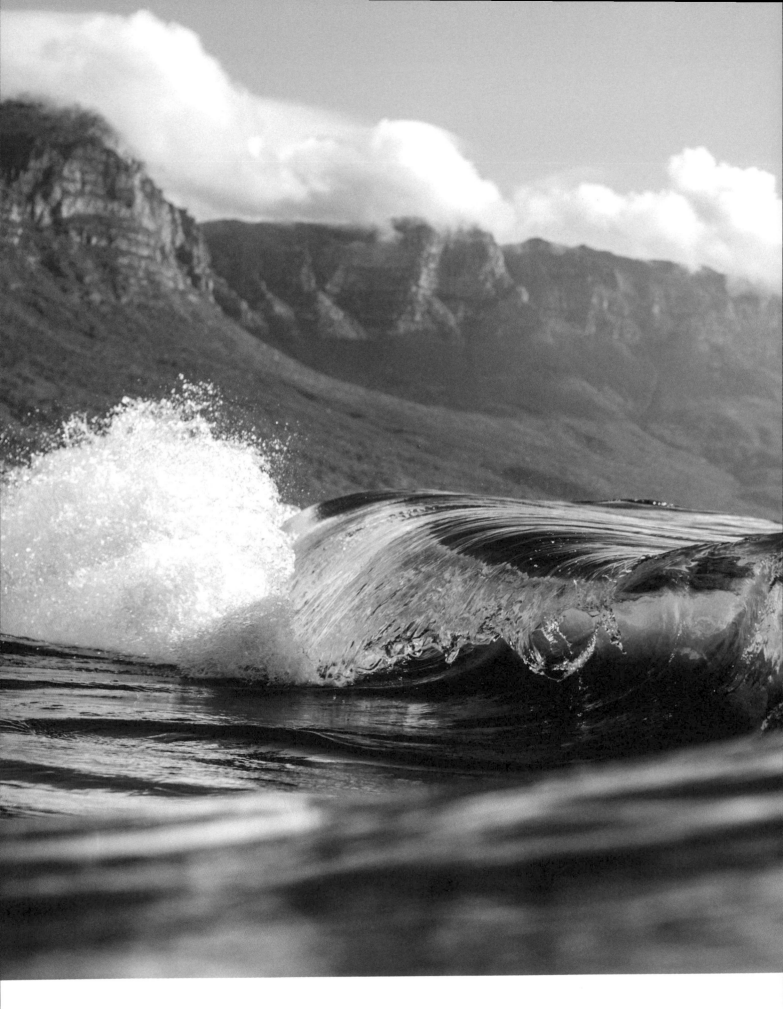

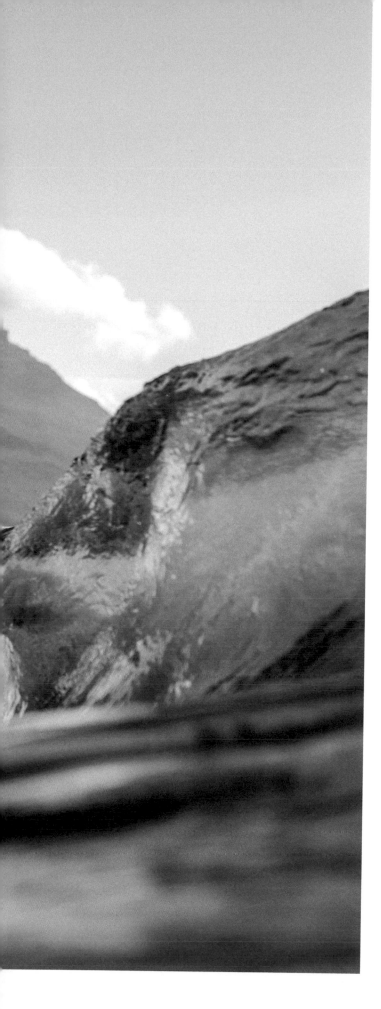

" In one day you could go for a hike, visit the beach, go for a surf, eat lunch at a wine farm and go out to a bar or club in the city center. That's the single greatest thing about the city. "

– Alexander Kibble

Llandudno Beach Perfect lights and crystal blue water at Llandudno beach, a surfer's dream despite the cold.

Stealing
portraits

Even though portraits might be the hardest photos to make, the Internet in general, isn't really into them. It doesn't matter how diverse an Instagram account is, portraits of people always receive fewer comments and likes than any other type of picture. There are some exceptions, of course: selfie-posting "fitgirls" and portrait-only photography accounts have a high "engagement ratio," even if they only post pictures of faces. If you're an occasional portrait-taker, you'll see that the subject of a portrait is often too specific, and that many people won't "double tap" it. All the more reason why the occasional portrait-uploader should garner more respect; it can be quite hard to take the perfect portrait. Photographer Jussi Ulkuniemi went on a trip to Albania with documentary photographer Stefan Bremer, and he says he learned in particular "that it's important to make deeper contact with your subject," rather than "just 'stealing' their picture." Photographer Roel Ruijs even met some members of an indigenous Ecuadorian tribe that didn't want to be photographed, because they believe that a photo captures their soul — they think that their reflection is their soul, and cameras capture reflections.

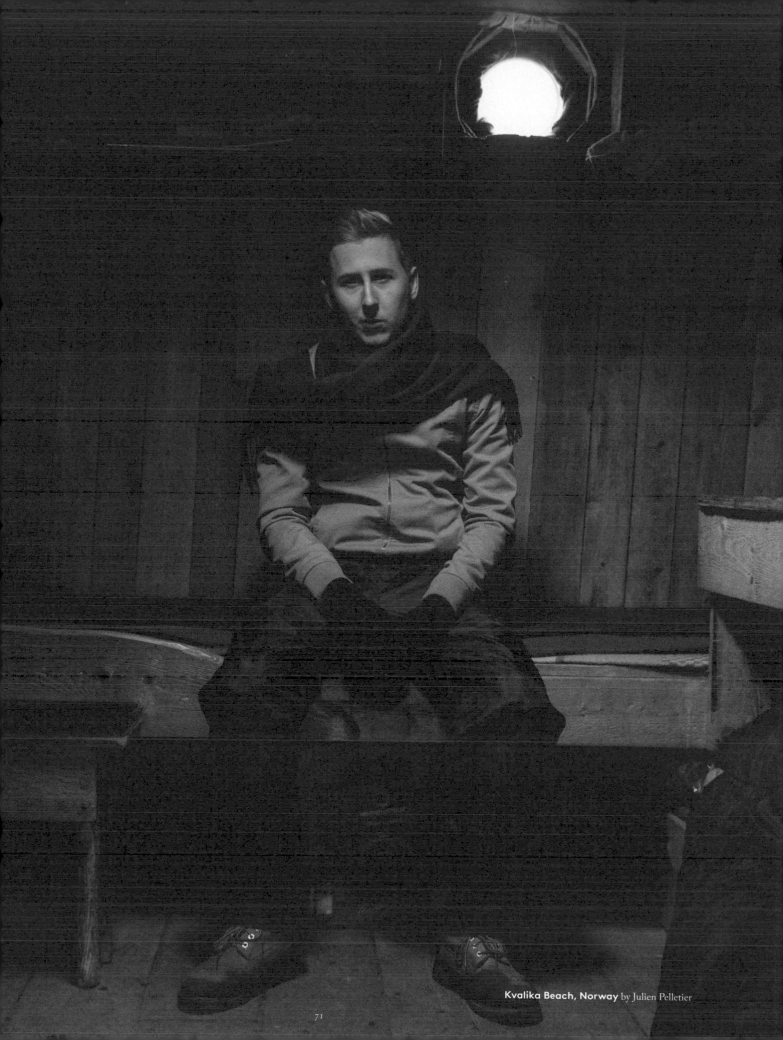

Kvalika Beach, Norway by Julien Pelletier

OFF THE RADAR

LOCATION Madeira Islands, Portugal **COORDINATES** 32.774770, -16.960873
PHOTOGRAPHER Ollie Nordh, Stockholm, Sweden @ollienordh

"I have to admit: the Madeira Islands weren't really on my radar," Swedish photographer Ollie Nordh says — he wanted to explore a not-so-typical travel location. "If you Google the place, it doesn't look that exciting. But places that look boring can be epic as well — from the moment I saw its mountain peaks from my plane window, I knew that Madeira was one of those spots." When I was on my way to the top of Madeira's highest mountain, I drove through eucalyptus forests completely covered in clouds. I stopped the car, because it gave me such a surreal feeling; it was super quiet and I really felt the moisture of the clouds in the air." Even though Madeira is a small island, there's a lot to explore, Ollie says: "I found high viewpoints, foggy forests, steep mountain roads and a coastline that's anything other than friendly. If you're looking for a real adventure, don't always visit the same place everybody else does. Explore the unseen, I can guarantee it'll take you to the most breathtaking locations."

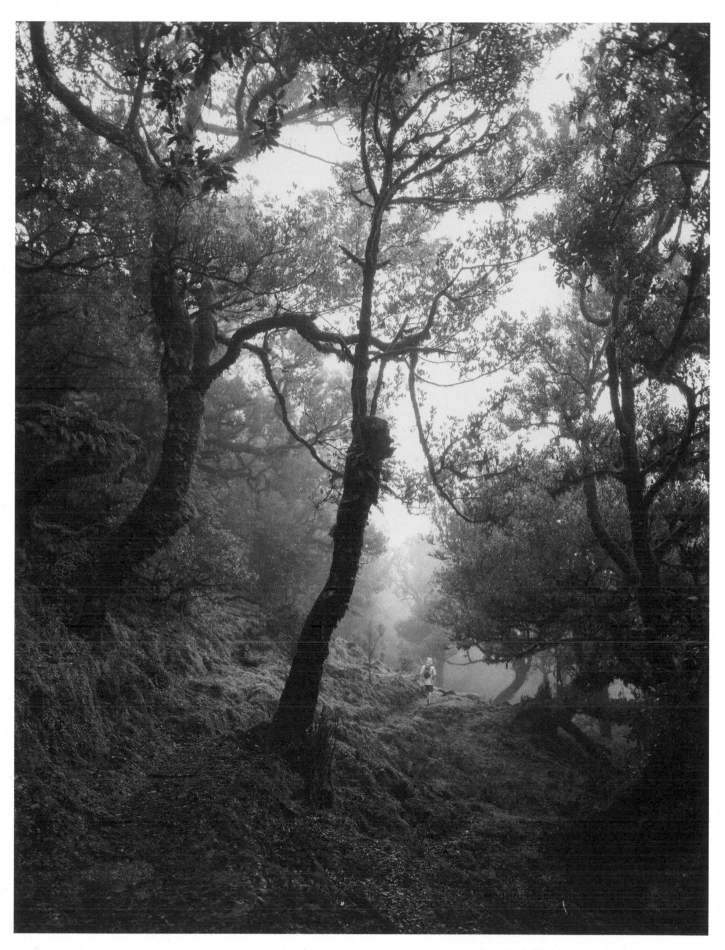

Madeira Islands My favorite place on the whole island
was this tiny path leading us deeper in to this forest.

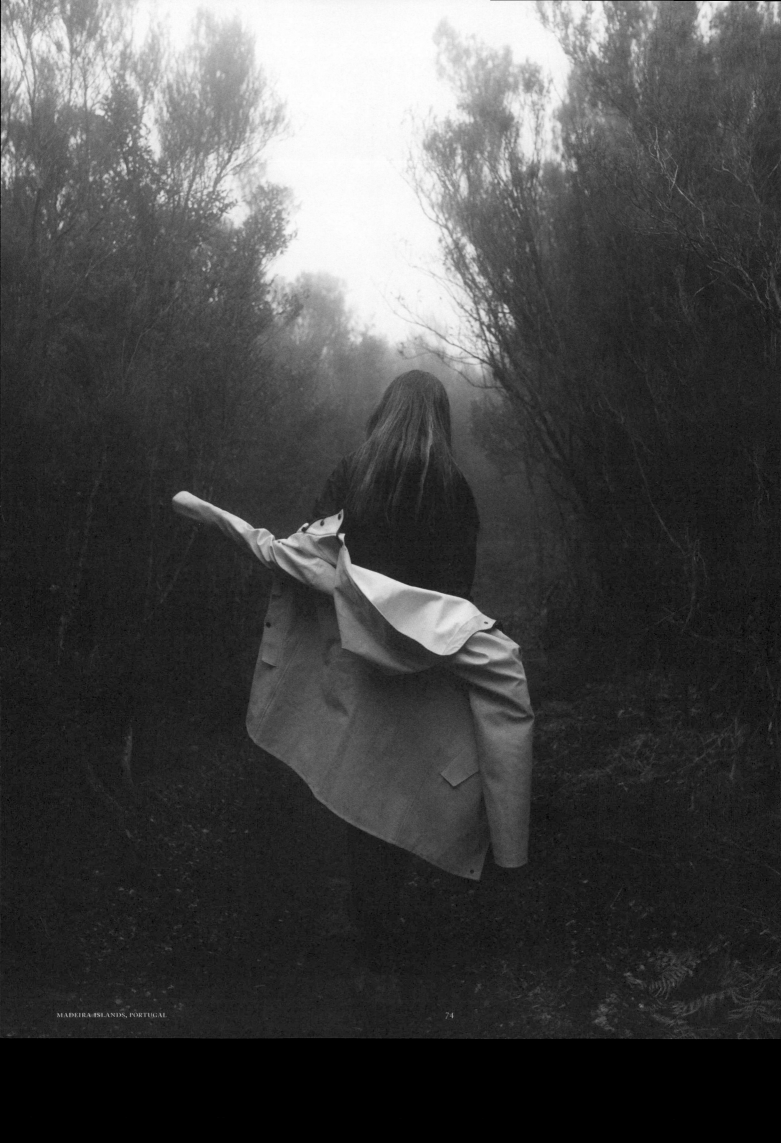

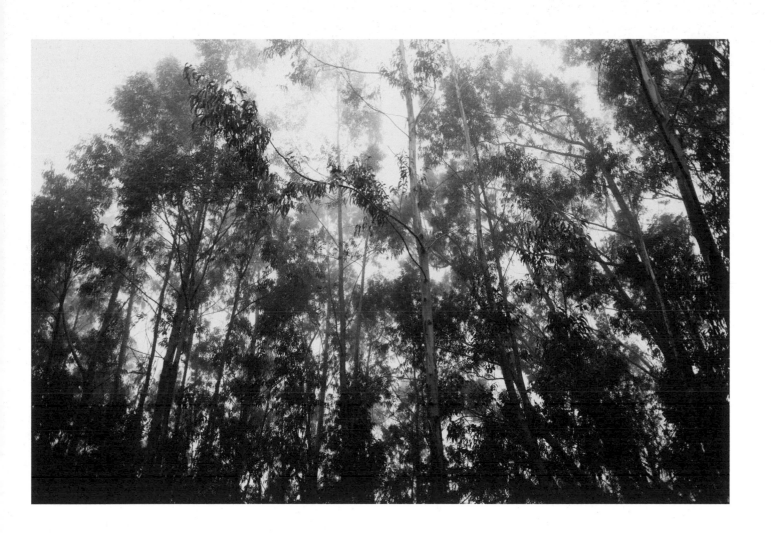

↑ **Madeira Islands** Madeira's eucalyptus forests.

← **Madeira Islands** A raincoat is a must while hiking
in the mountains of Madeira.

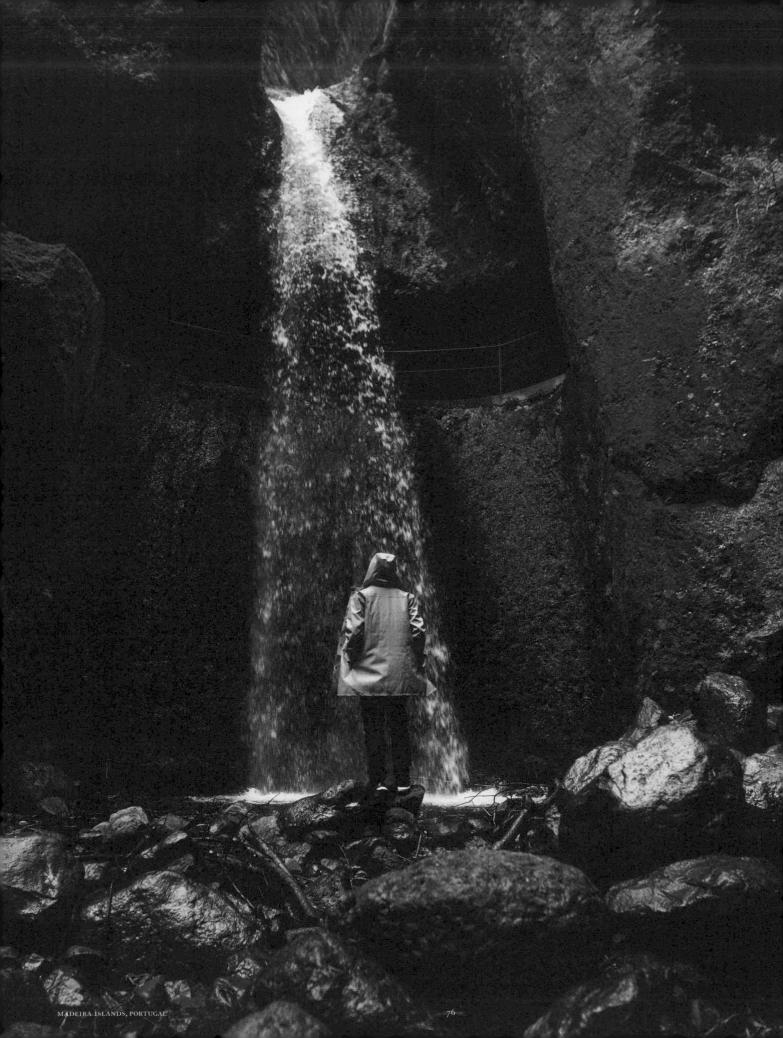

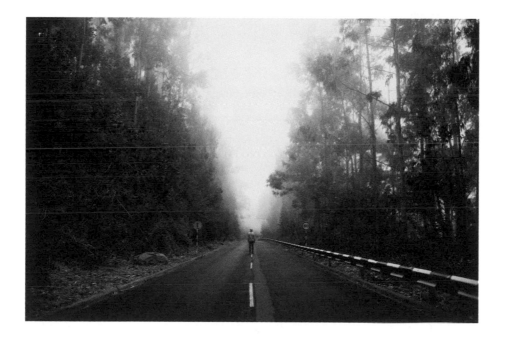

Madeira Islands
The endless mountain roads and the almost unreal
forests covered are in clouds.

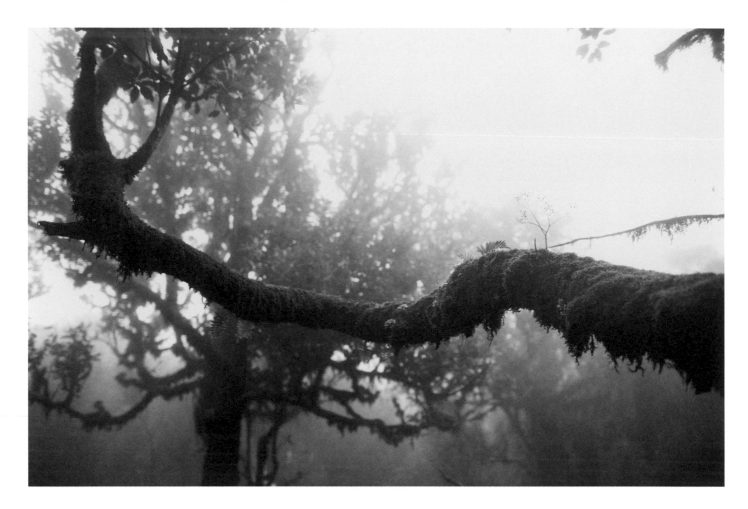

↑ **Madeira Islands** Mother Earth taking over.

**Places that look boring can be epic as well –
from the moment I saw its mountain peaks from my plane
window, I knew that Madeira was one of those spots.**

– Ollie Nordh

Stockholm-based photographer Ollie Nordh always focuses on "finding unseen angels, and locations to explore and photograph," he says. "I always want to surprise the viewer with my work, I want to inspire them to get out there and do just the same as I'm doing." He went on this trip to Madeira, "basically just traveling is my main inspiration — that's what I want to live for."

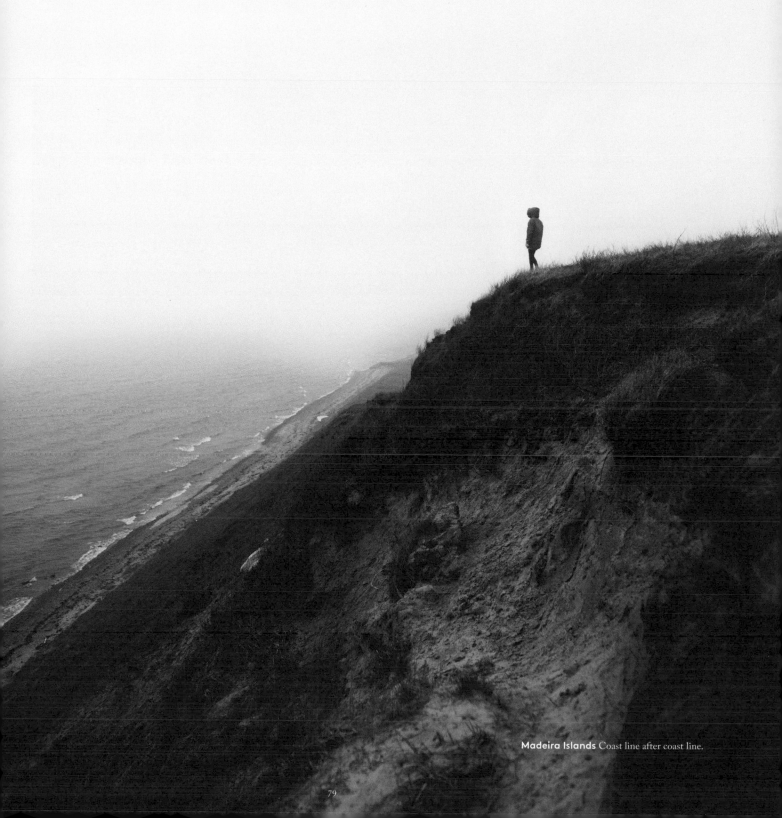

Madeira Islands Coast line after coast line.

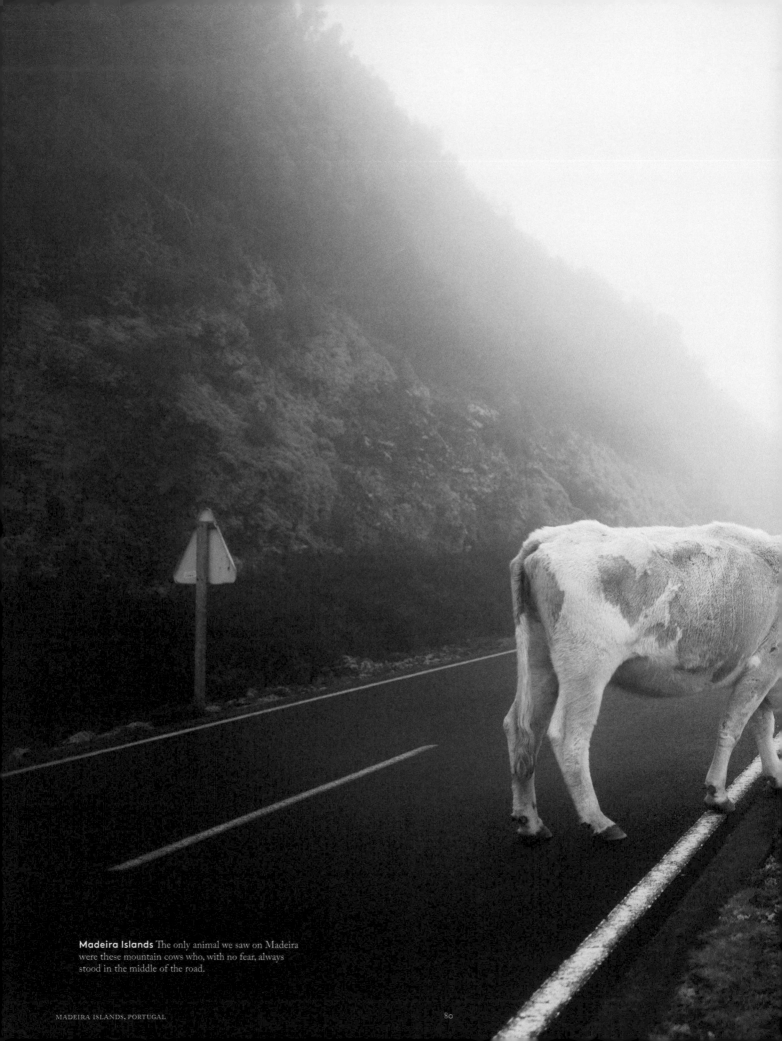

Madeira Islands The only animal we saw on Madeira were these mountain cows who, with no fear, always stood in the middle of the road.

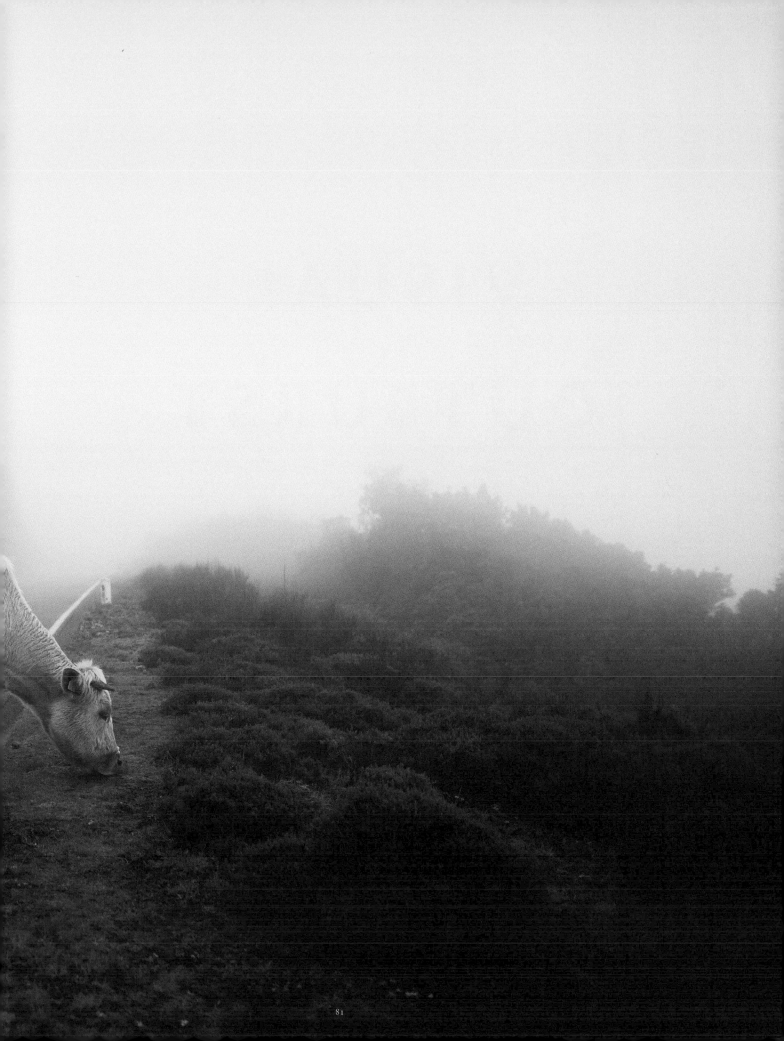

VISUAL
OUTBURST

LOCATION Bangalore, India **COORDINATES** 12.973365, 77.592478
PHOTOGRAPHER Curro de la Villa, Amsterdam, The Netherlands @ekkieboy

Even though Curro travels a lot through both Europe and America, his trip to India was his first encounter with the Asian continent. "And it was truly an adventure," he says. "I was there for my work, I had to dive into the Indian youth culture and discover as much as possible about the different aspects of life in one of the major cities of the country, Bangalore. I can definitely identify an overall feeling of chaos across the whole journey.

The insane traffic, the heat, the noise, the food and of course the visual explosion of colors and shapes of the Indian streets... two weeks hardly gave us enough time to scratch the surface of the city, although we definitely tried. We stayed in absurdly fancy hotels. We went to house parties, took night walks through the biggest slum of Mumbai and made motorbike rides along dusty roads."

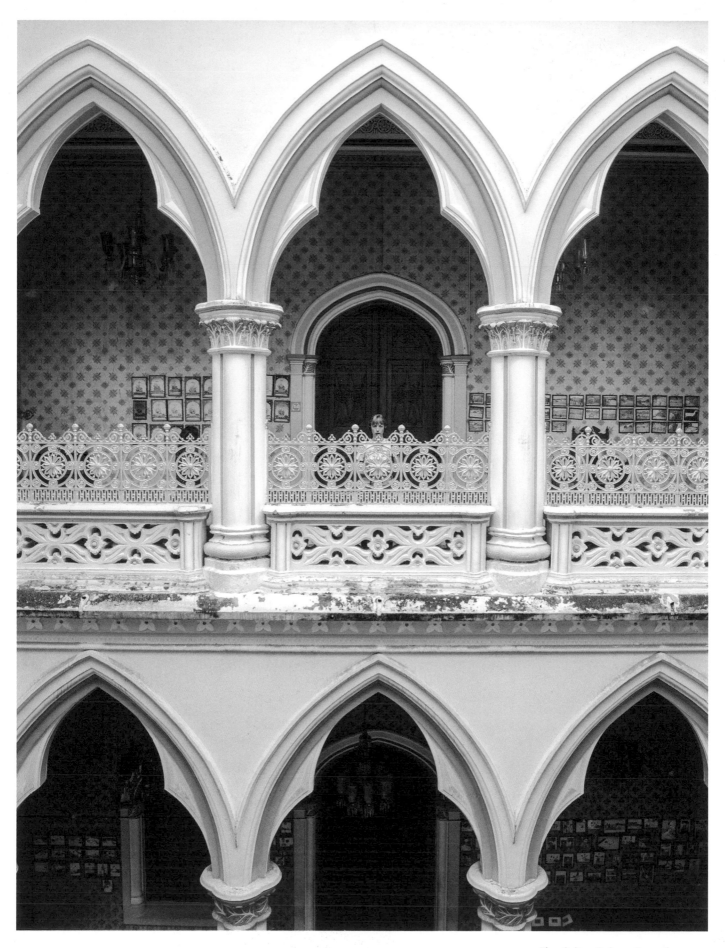

Tipu Sultan Palace, Bangalore
The teak pillars of the central space of Tipu Sultan's Summer Palace.

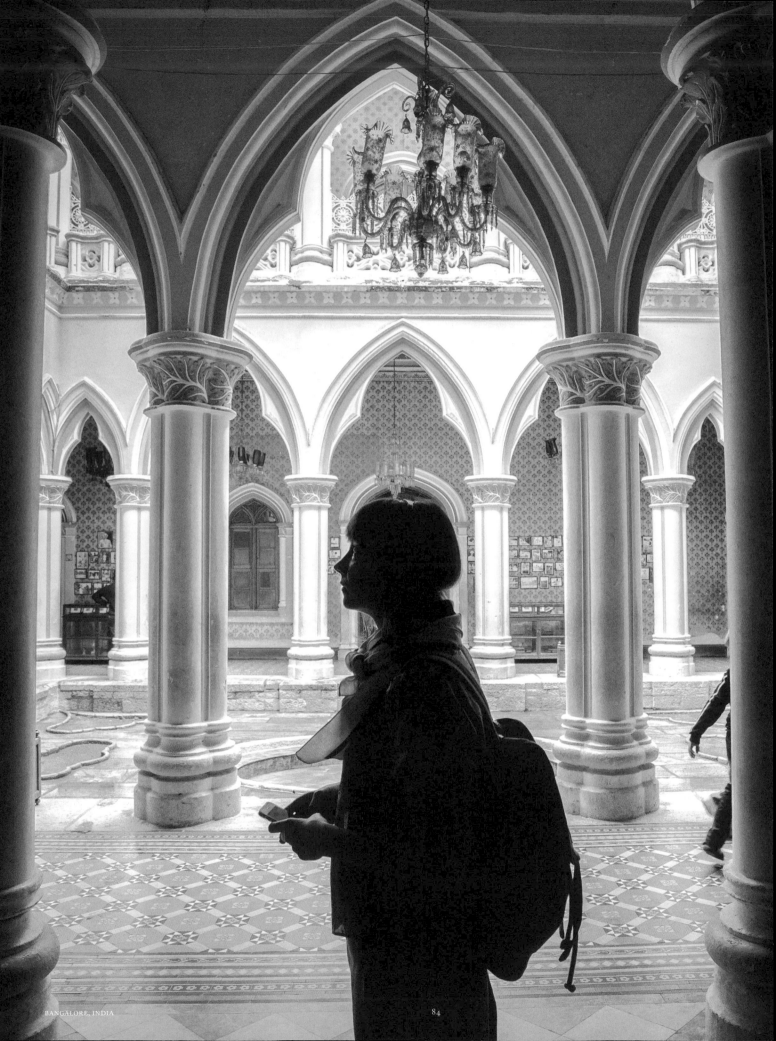

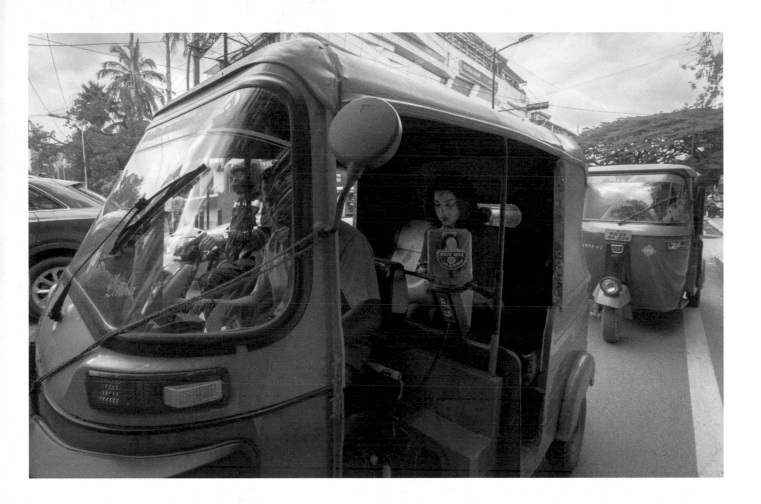

↑ **Bangalore** A woman waits inside a tuk tuk taxi
stuck in the crazy Bangalore traffic.

← **Tipu Sultan Palace, Bangalore** Resting in
the soothing shadows of the Tipu Sultan Palace in
Bangalore, below the Maharaja's chamber.

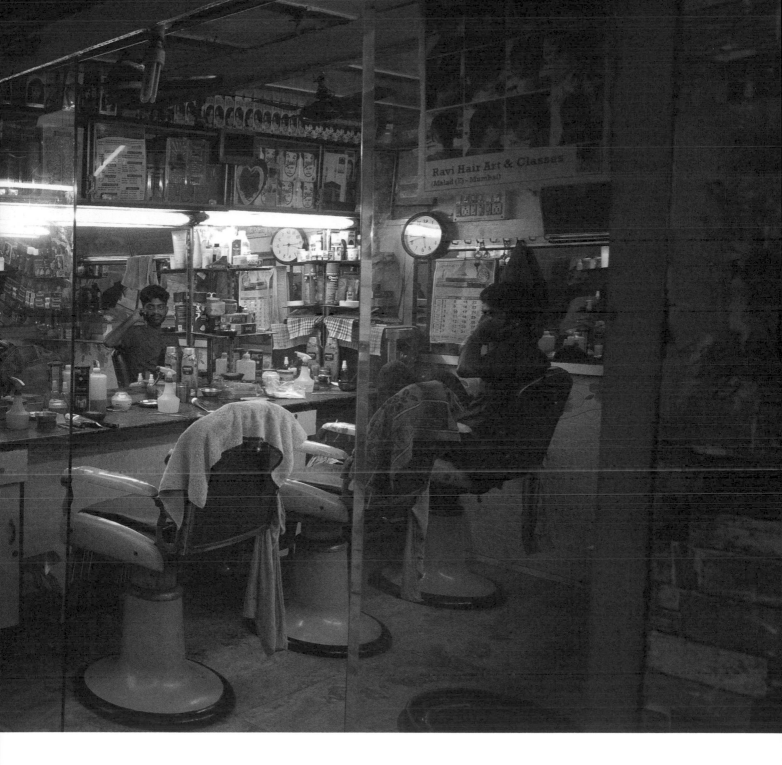

Karnataka, Bangalore A night barbershop right at
the edge of one of the largest slums in India, Karnataka.

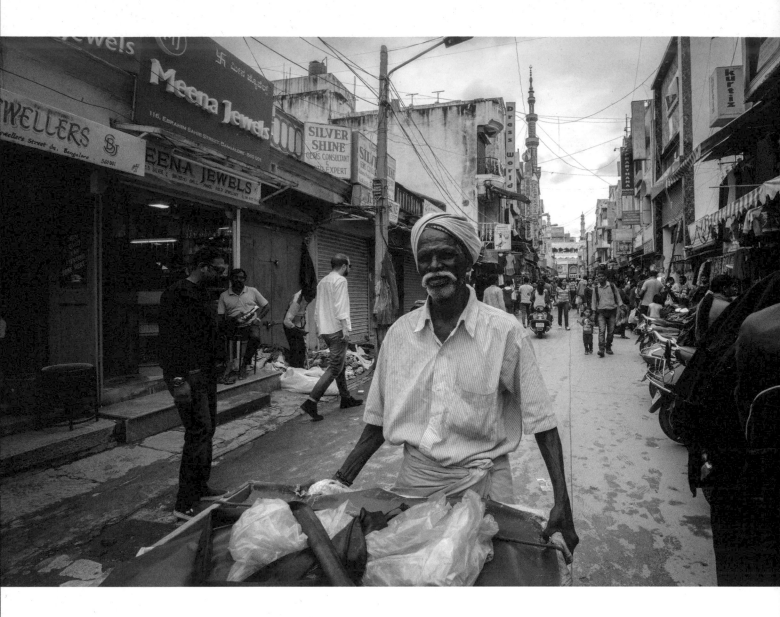

'@ekkieboy', also known as Curro de la Villa, is a designer and photographer who was born in a very small village in the Southern part of Spain. He left that region about 10 years ago, and has been traveling the world ever since. Although he's been hopping between the States and The Netherlands, he's recently visited Morocco, Slovenia, Germany and Austria. Curro is currently living in Amsterdam, The Netherlands.

↑ **Chickpet Market, Bangalore**
A local in the narrow streets of the Chickpet market.

↗ **Krishna Rajendra Market, Bangalore**
The colorful Krishna Rajendra Market.

" Two weeks hardly gave us enough
time to scratch the surface of the city,
although we definitely tried. "

– Curro de la Villa

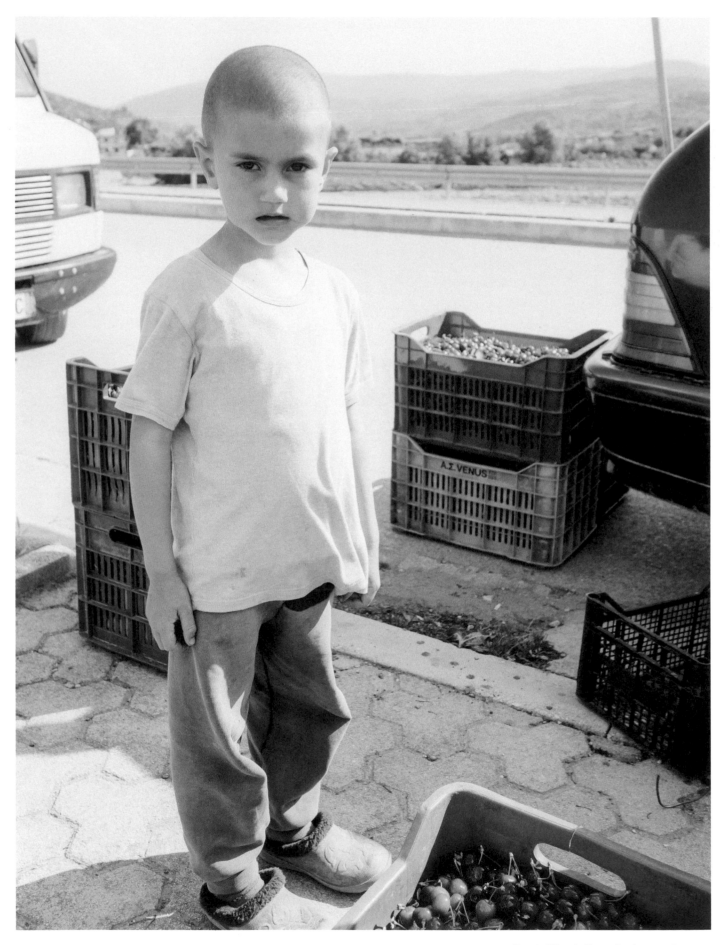

Berat, Albania Boy at the cherry market.

METROPOLIS IN THE MAKING

LOCATION Berat, Albania **COORDINATES** 40.708487, 19.943375
PHOTOGRAPHER Jussi Ulkuniemi, Lathi, Finland @skwii

"I want to make deeper contact with the people I photograph, rather than just 'steal' their pictures." When Jussi Ulkuniemi left Switzerland for a trip to Albania, he had a week to take street portraits for a photography school assignment. "It's uncommon nowadays that people on the street want to be photographed," Jussi says, "but in Albania you are welcomed with a wide grin. Pride and hospitality are a strong part of their culture, so if you respect them and smile there's not much that can go wrong." When a somewhat shady individual approached Jussi when he was alone in the middle of the night, though, he was a bit anxious. "But I immediately treated him like a friend, and we met up three times that week. His name is Coli, and he gave me a good idea of what it's like to live in Albania. It was the last European country under a dictatorship, one which fell just about 25 years ago." That's one reason there is still poverty and criminality, "but the country is changing at a fast pace," Jussi explains. "Tirana, in particular, is a metropolis in the making. If you keep both feet on the ground and prefer to travel like a local, then this country is for you."

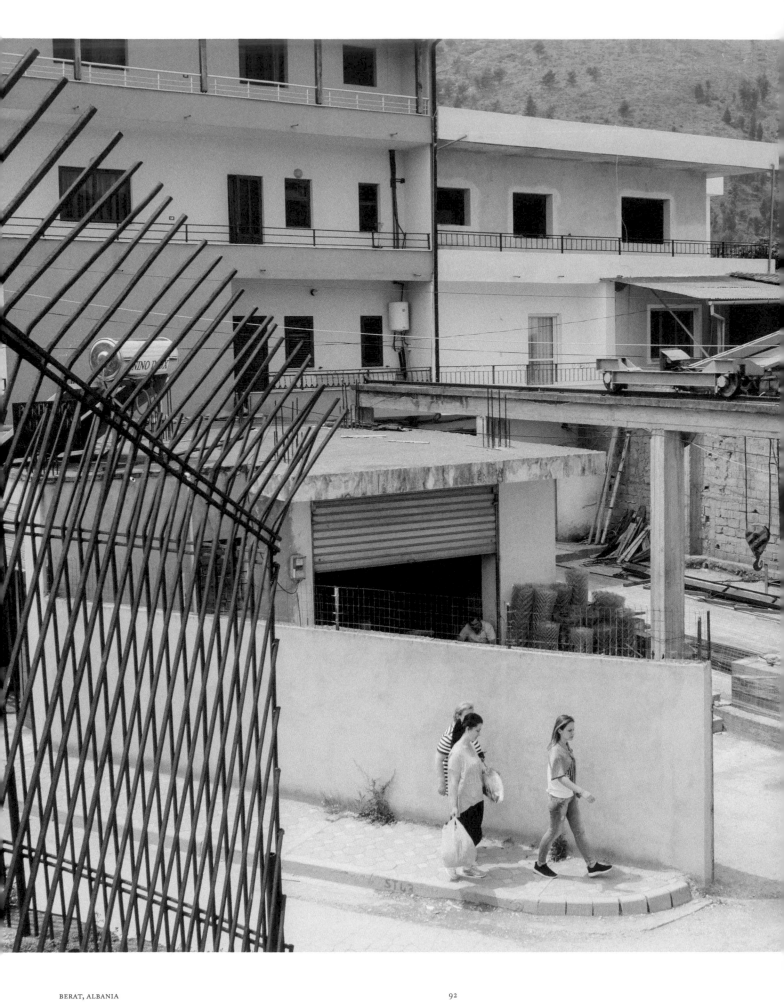

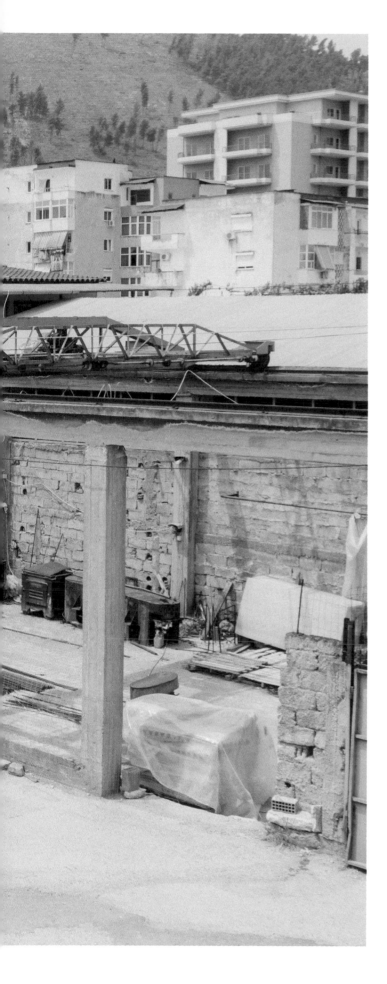

" Albania was the last European country under a dictatorship. That's one reason there is still poverty and criminality, but the country is changing at a fast pace. "

– Jussi Ulkuniemi

Berat, Albania Suburban life.
Women and men are still quite separate in Albania.

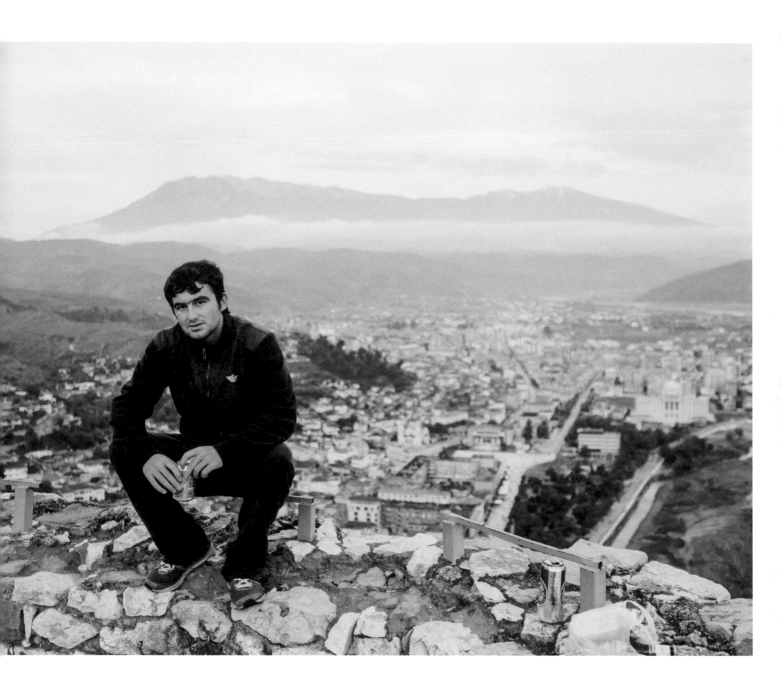

↑ **Berat, Albania** My friend Coli gave me a good
idea of what it's like to live in Albania.

↗ **Berat, Albania** Young thugs. Albania still has
poverty and criminality, but the country is changing at a
fast pace.

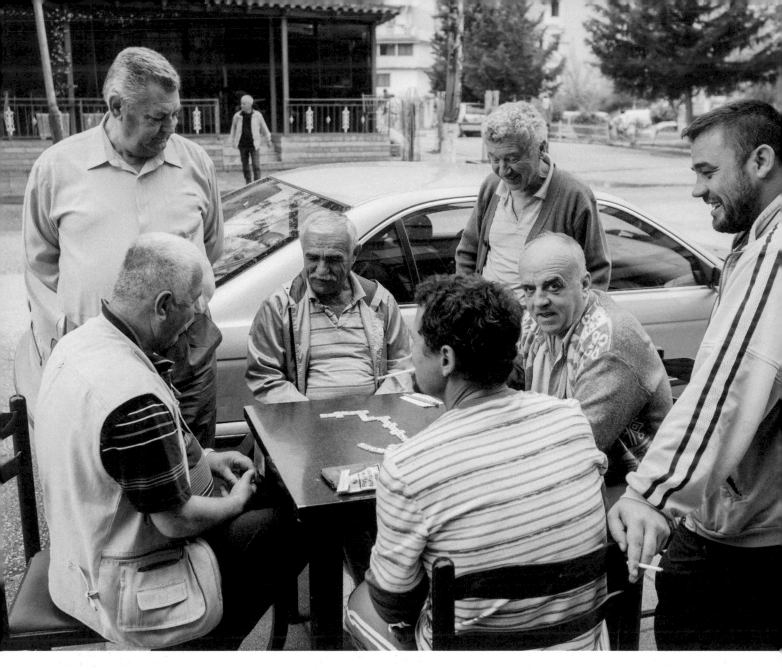

" I depart to gain perspective. I don't travel far to escape
anything; it's easier to understand what's important
when you keep experiencing the world all around you. "

– Jussi Ulkuniemi

↖ **Berat, Albania** Playing dominos.

↑ **Berat, Albania** A man's world. The cherry market.

97

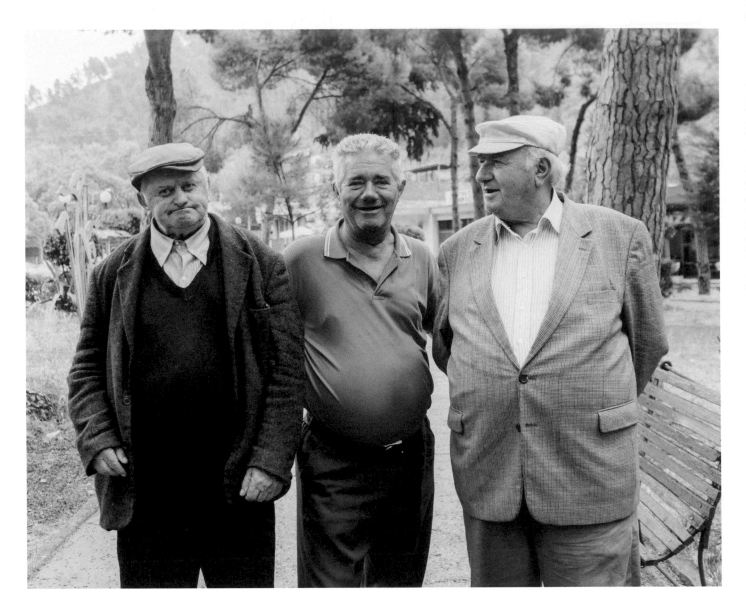

Berat, Albania Three Albanian men and a car repair shop owner at his garage.

"Basically, there's no better way to live than to use your skills to interact with, and hopefully affect, the people around you," says Jussi Ulkuniemi. The Finnish photographer doesn't wish to reach people only through his photography; he's also a dancer. "I live off creativity and freedom. I'm passionate about the whole range of human emotions, the ugly and beautiful, but mostly the thin line between. I depart to gain perspective. I don't travel far to escape anything; it's easier to understand what's important when you keep experiencing the world all around you."

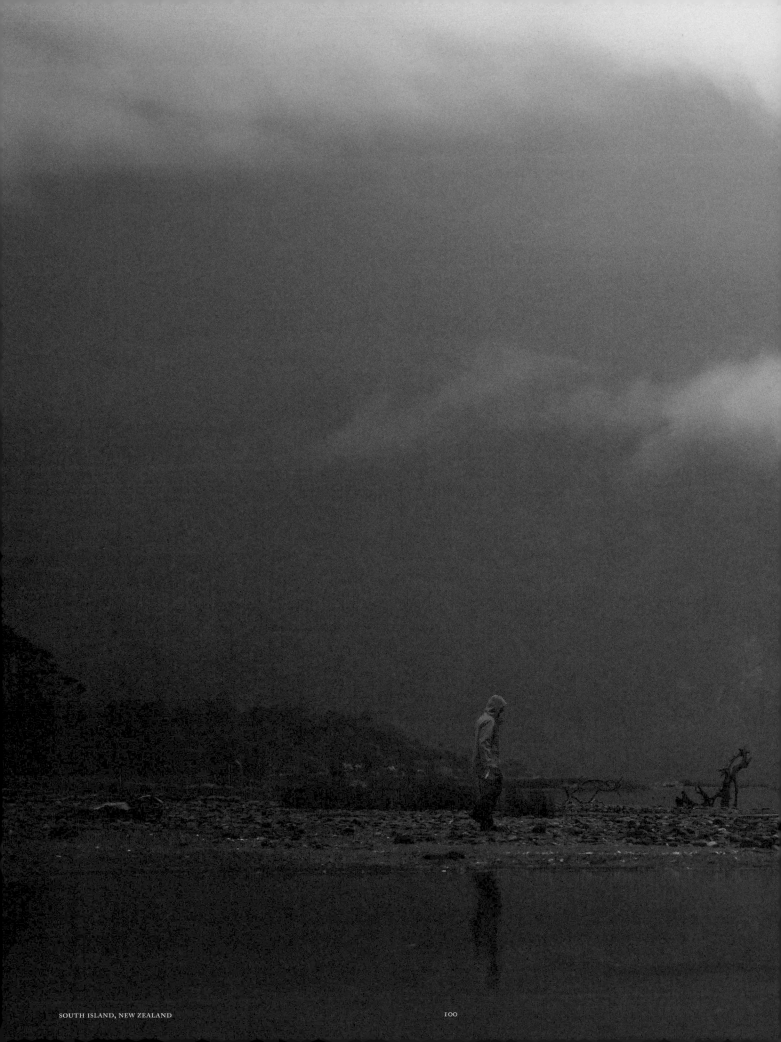

CINEMATIC SCENERY

LOCATION South Island, New Zealand **COORDINATES** -44.633888, 167.898579
PHOTOGRAPHER Victor Bergstedt, Stockholm, Sweden @vibesart

"After seeing movies such as *Lord of the Rings*, *King Kong* and *Avatar*, it became my dream to visit New Zealand." When Swedish photographer Victor Bergstedt saw the opportunity to fly to the other side of the world with his father, he took it with both hands. "I had gotten more and more into photography recently, so it made even more sense to go there," he says. Victor and his dad decided they wanted to see as much of the country as possible, so they rented a camper. They drove around New Zealand's South Island for two weeks. "I can easily say that New Zealand has the most beautiful landscape I have ever seen," Victor says. Traveling and living in a van made their trip even more special: "you can choose where you wake up, and if you like a place you can easily stay a bit longer. Ever since I got back to Stockholm I've been planning to go back for a longer journey."

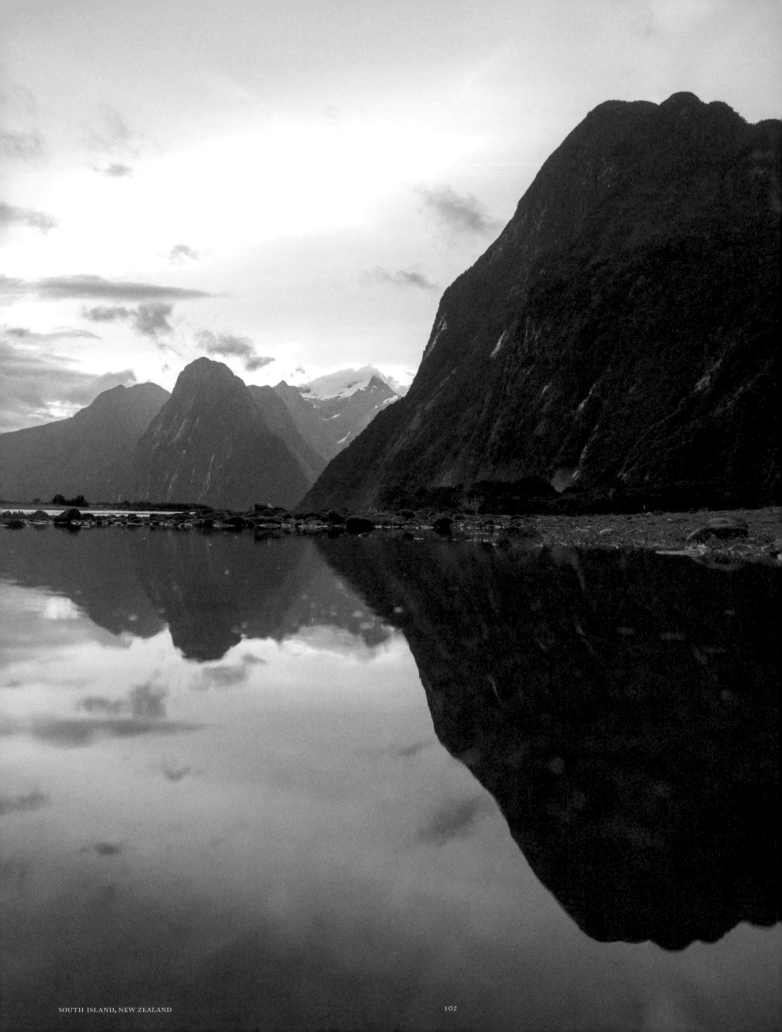

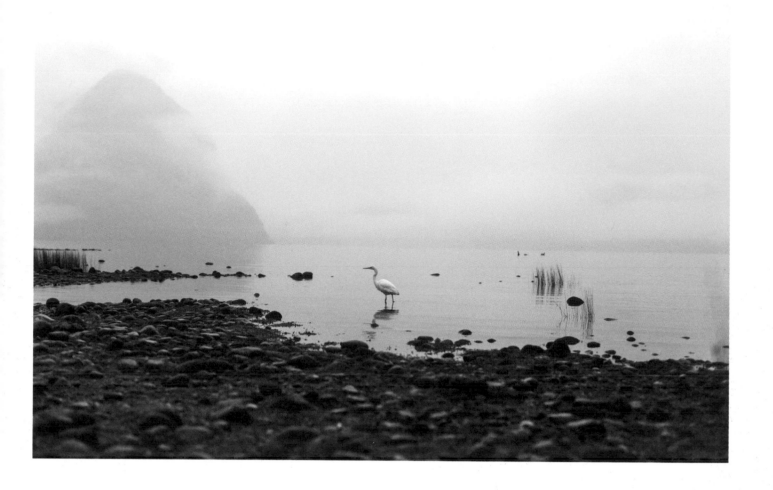

Forests, cities, mountains, decayed buildings — whoever follows Victor Bergstedt's photography feed can expect photos of all kinds of different places. It's the unknown, in particular, that draws Victor to certain areas — whether it's New Zealand or an abandoned building he passes when he walks through his hometown of Stockholm, Victor shares his vision of these locations through his camera's lens. "I strive to show people my view of things around the world," he says, "I want to show different perspectives and motivate people to do what they love."

↑ **Milford Sound** Early morning at Milford Sound.

← **Milford Sound** Words can't describe the surreal view of Milford Sound. You have to see it with your own eyes.

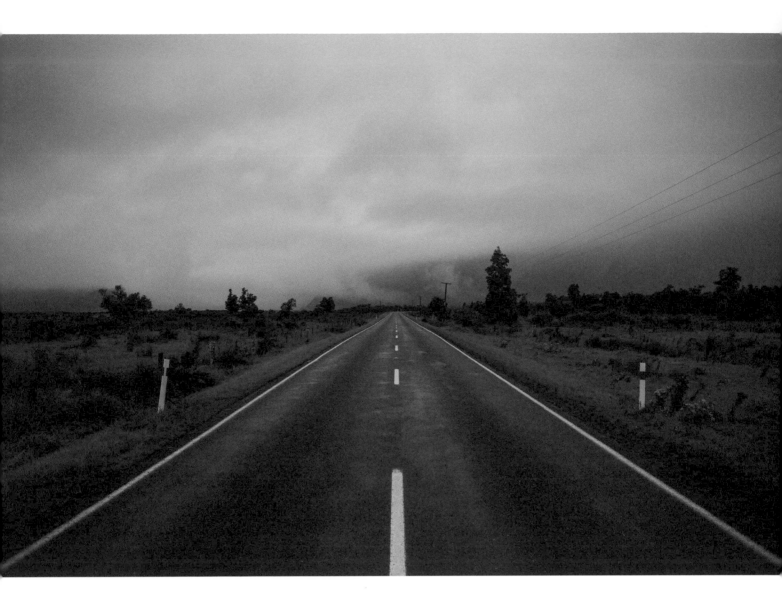

Haast, New Zealand It suddenly stopped raining just before sunset. These crazy clouds started rolling in. This perfect, straight road just drags you into the picture.

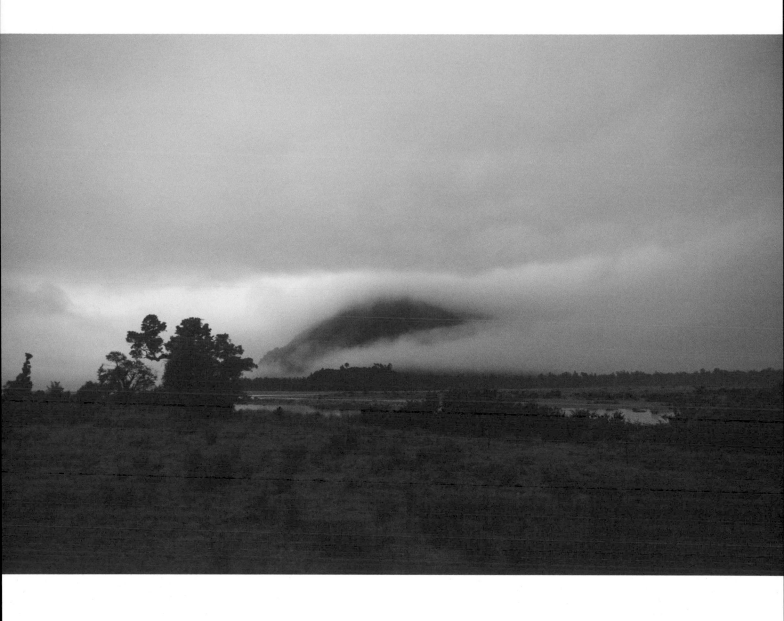

Haast, New Zealand This shot was taken a couple of minutes later. The clouds were really crazy, just clutching around the mountains.

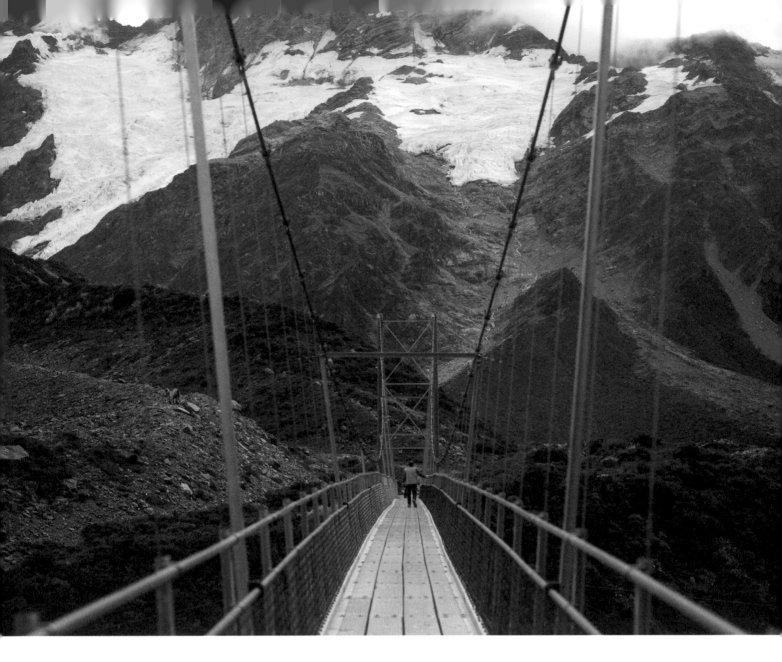

" I can easily say that New Zealand has the most beautiful
landscape I have ever seen. Traveling and living in a van
made the trip even more special. "

– Victor Bergstedt

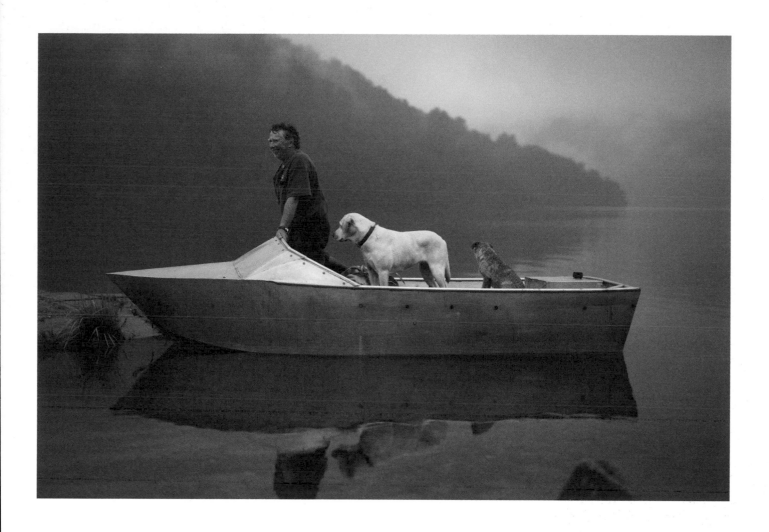

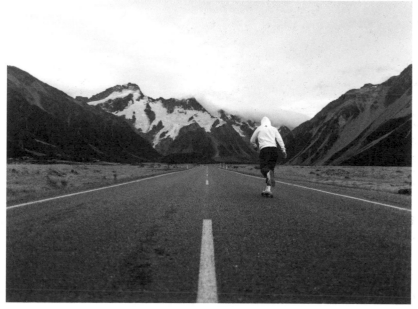

↗ Manapouri & Mount Cook, New Zealand
A fisherman out on the Manapouri lake with his two dogs, and me in an attempt to skate down the road into the Mount Cook area.

↖ Mount Cook, New Zealand Mount Cook is New Zealand's highest mountain. This old man was walking over the suspension bridge, surrounded by the mountain.

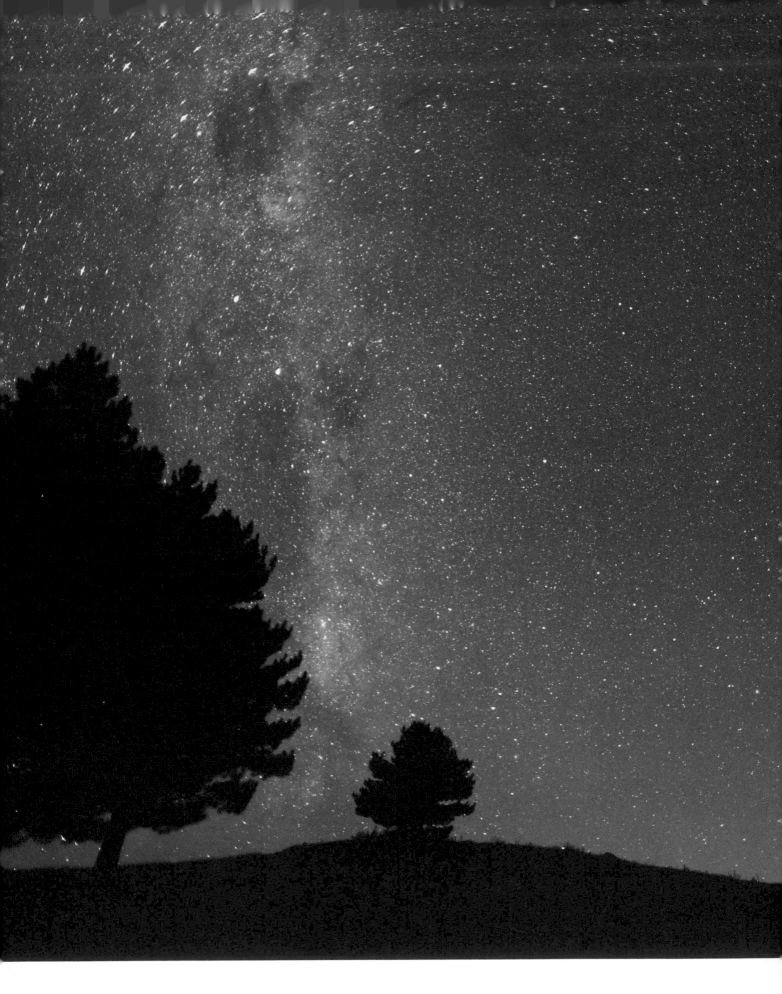

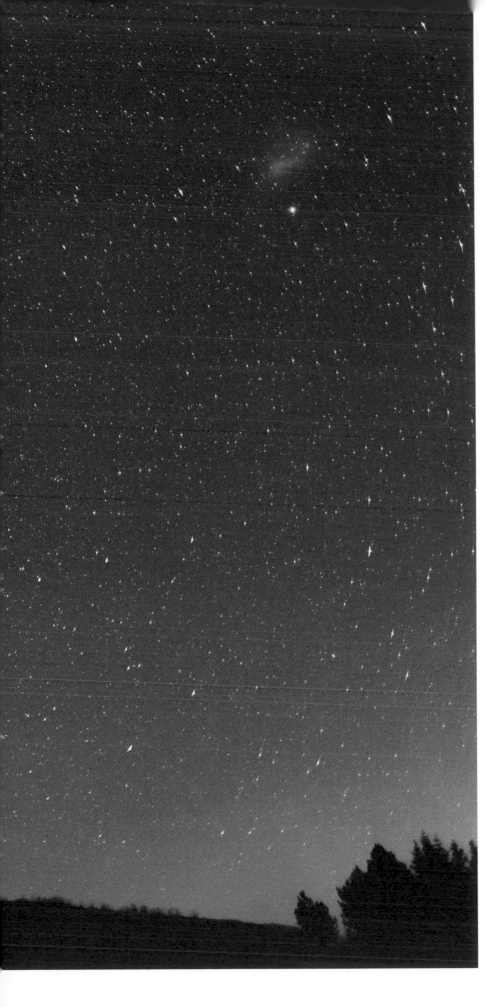

The night sky in New Zealand is one of the best in the world if you want to see stars. The amount of stars you could see with your bare eyes was just crazy. And a small glimpse of the southern lights made everything perfect.

Film
is not
dead

DSLR's, GoPro's, smartphones and drones - the new photographer can take a pick from a wide array of photography hardware. Some photographers, though, don't want to have anything to do with those novelties. They're using the cameras that belonged to their fathers and grandfathers, and they're proud of it. The big analog movement is also visible on Instagram, where one sees shots tagged with "#isstillshootingfilm" and "#filmisnotdead". An old camera is very hipster-fähig, but according to the "new photographer with old equipment," there's more to it than just acting cool. A couple of reasons people are photographing the old-fashioned way: the dynamic range is better, shooting film is cheaper, you have physical prints, the colors are livelier, it helps to hone your skills and — and this might be the best reason — shooting film slows you down. You have to think twice before taking a picture, and that makes you more aware of the moment.

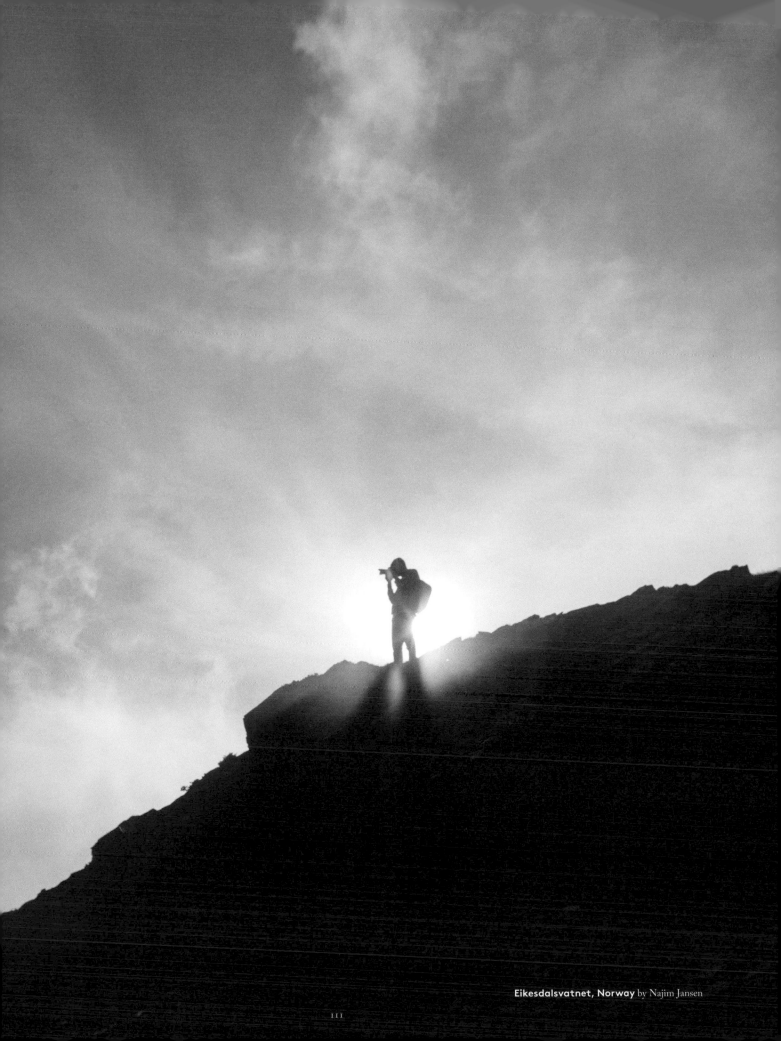

Eikesdalsvatnet, Norway by Najim Jansen

REUNITED IN LOFOTEN

LOCATION Kvalvika Beach - Lofoten, Norway **COORDINATES** 68.079548, 13.032383
PHOTOGRAPHER Julien Pelletier, Oraison, France @buchowski

French photographer Julien traveled to America with his three of his best friends. They took pictures of the US desert and shared them on their Instagram accounts. "Back then, we only had 20 followers and still edited our pictures in the Instagram app itself," he laughs. Five years and many Instagram followers later, the quartet reunited for a trip to the Norwegian Lofoten Islands. Julien: "I hadn't seen them in quite a while, so this journey was particularly important for me." Julien, Alex, Quentin and Lyes were up for an adventurous reunion. One morning, Julien and Lyes were excited to witness the sunrise. "Actually, nothing magical happened with the light. The very soft pinky sky has quickly shaded away to a classic clear weather," Julien says. "But the landscape surrounding us was impressive enough to make us speechless. We will never forget the colors of the deep blue sea and the dark rocks meeting at the shore. I am truly waking up every morning to experience these kinds of moments."

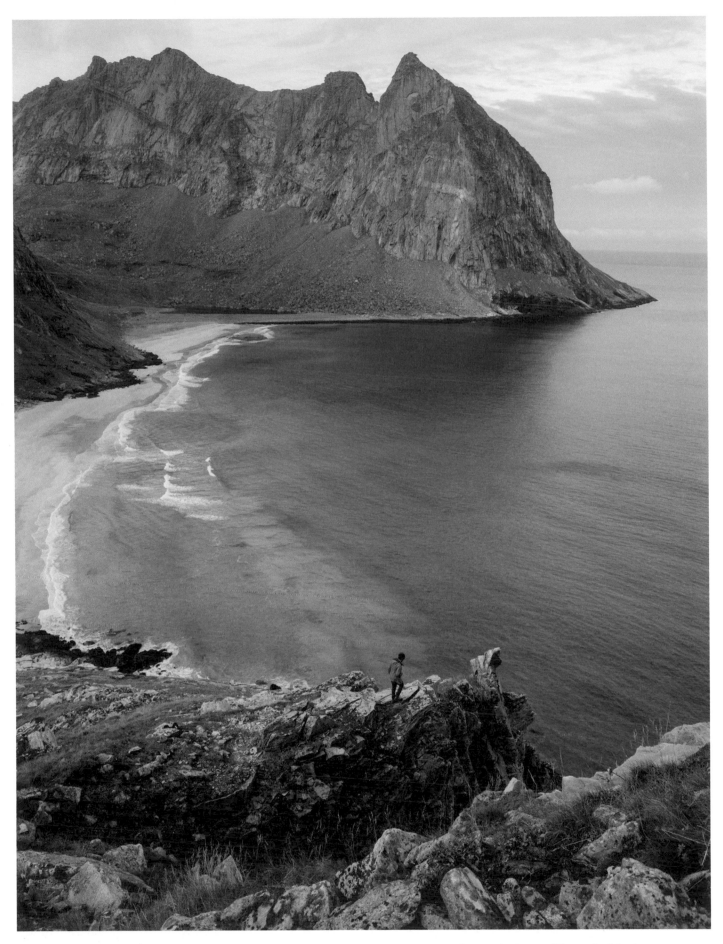

Kvalvika Beach, Norway We started to hike the mountains surrounding us, seeking epic views of the place. I think we found one.

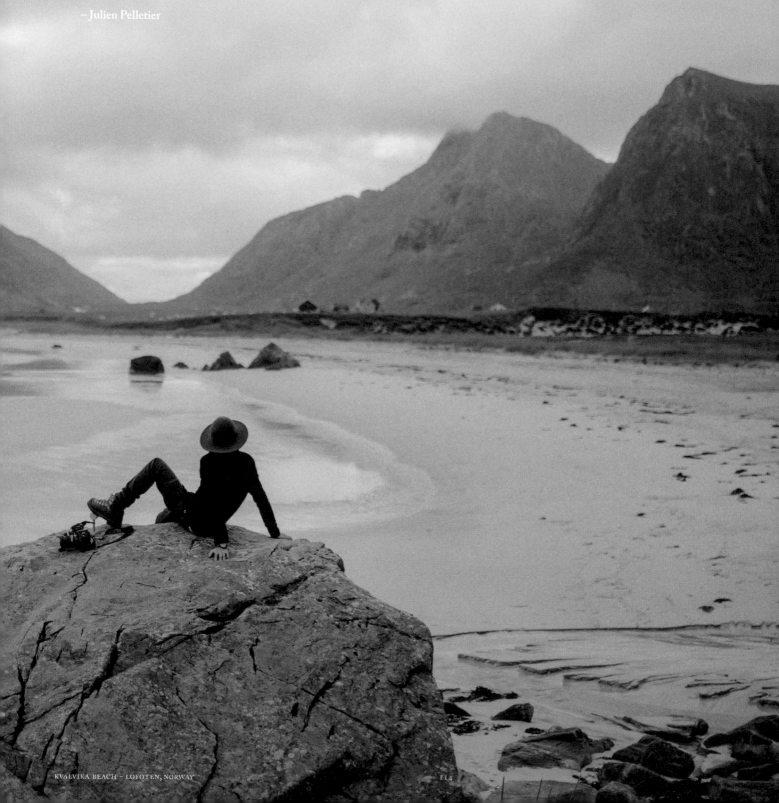

" The landscape surrounding us
was impressive enough to leave
us speechless. We will never forget
these colors of the deep blue sea
and the dark rocks meeting
at the shore. "

– Julien Pelletier

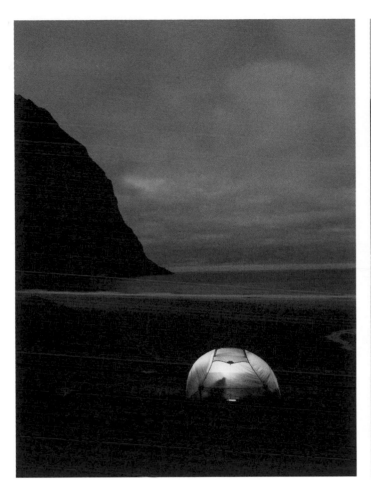

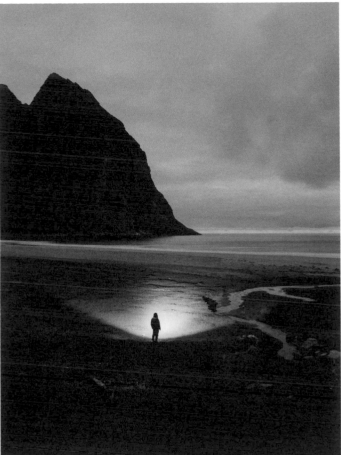

↖ **Kvalvika Beach, Norway** Time to sleep on the
peaceful beach.

↗ **Kvalvika Beach, Norway** Hoping for a clear sky
at night to shoot stars I carried my heavy tripod…
as the weather was not on my side I decided to do some
selfie experiments.

← **Kvalvika Beach, Norway** After camping over-
night at Kvalvika beach, we took to the road, roaming
around tons of amazing beaches and mountains.

Kvalika Beach, Norway
A reunion of close friends living all around the world
is a magical moment.
↓

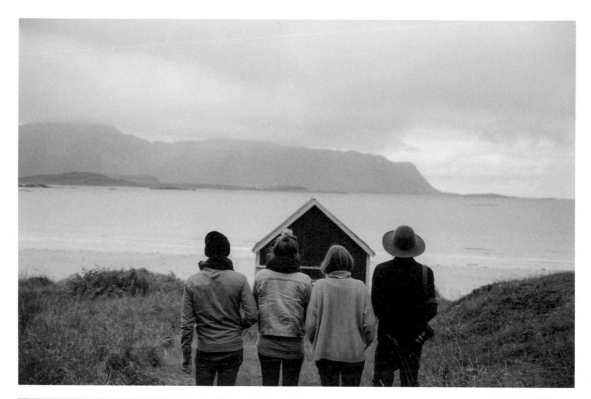

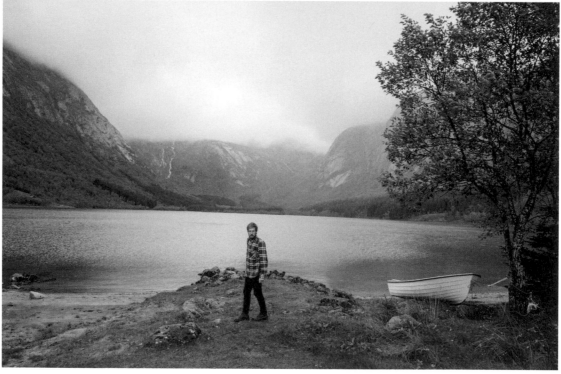

↑
Kvalika Beach, Norway
We had several stops aside the road.
Here, Alex was looking for a nice spot to stop for lunch.

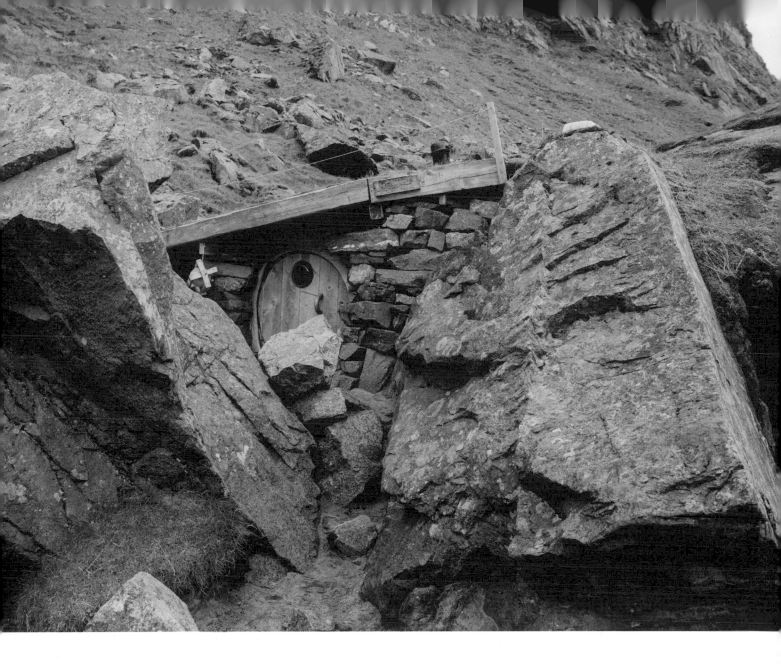

↑ Kvalika Beach, Norway There is an interesting story about Kvalvika. Hidden between dunes, you can find a cabin built out of stones and driftwood by two young Norwegian guys who lived here for nine months a few years back. It's open to everyone and still holds a number of the items these men used when they lived there. You can see the full story in the movie "North of the Sun".

Together with friends Adrien, Luc and Romain, Julien Pelletier is part of the travel photography collective "French Folks." Born in France, the digital creative and influencer travels the world and uses the Instagram alias "Buchowski." He has gathered over 100k followers on Instagram, and although he specializes in editorial, lifestyle and wedding photography, he focuses on adventure photography.

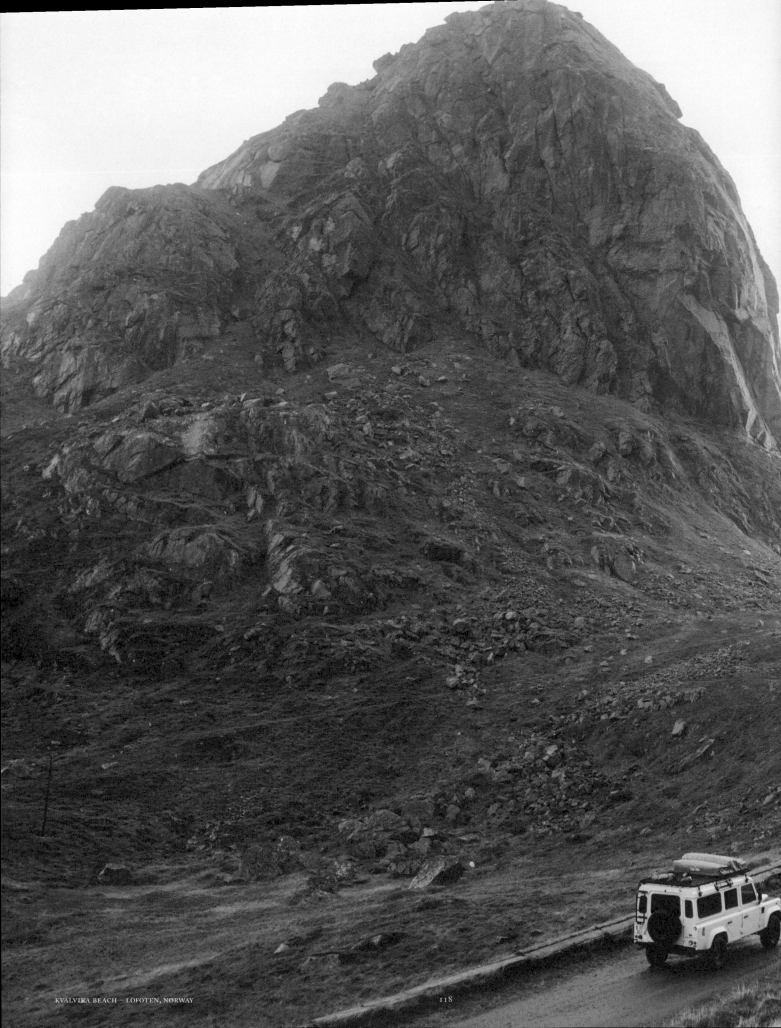

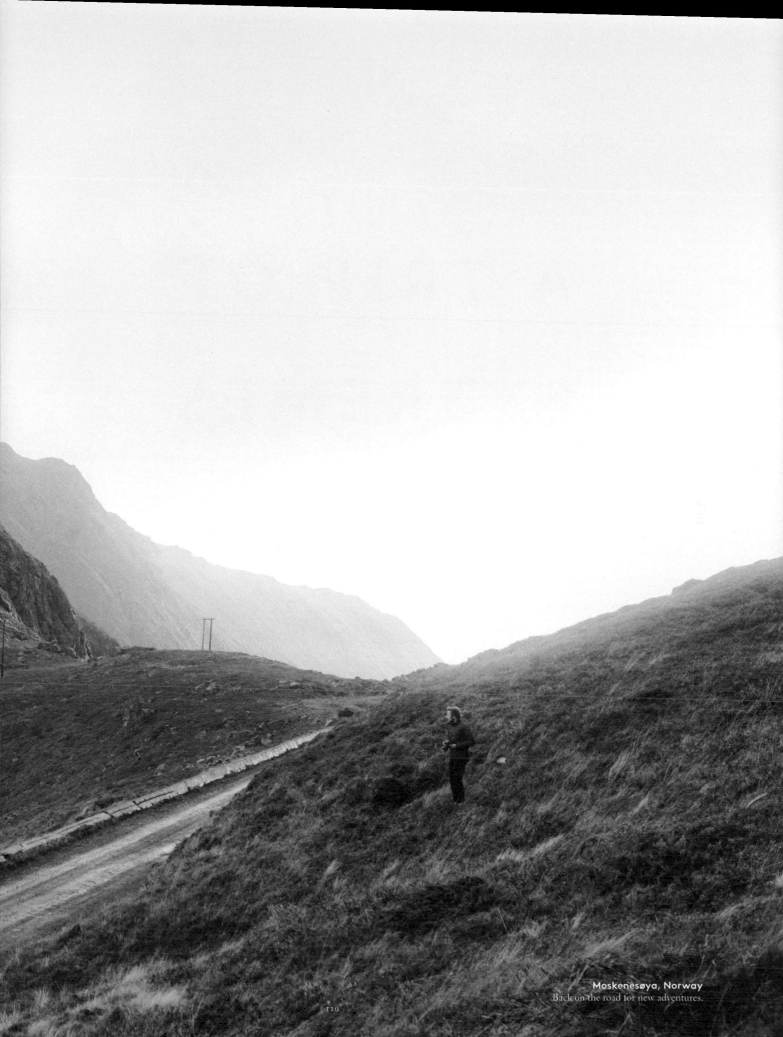

Moskenesøya, Norway
Back on the road for new adventures.

Joost Bastmeijer @joostbastmeijer

A TRIP OF EXTREMES

LOCATION Jordan, Israel and Palestine **COORDINATES** 30.322181, 35.451387
PHOTOGRAPHER Joost Bastmeijer, Amsterdam, The Netherlands @joostbastmeijer

When Amsterdam-based Joost Bastmeijer planned a trip to Jordan, Israel and Palestine, he didn't really know what to expect. "And as it turns out," he says, "such an approach is the best way to start any journey - those three countries really blew my mind." Joost and his girlfriend Saskia made a "public transport only" itinerary: they would land in Amman, travel to Petra and the Wadi Rum desert and cross the border at Aqaba. "From there, we traveled to Eilat and Jerusalem," Joost continues, "and visited Palestine's Ramallah and Nablus.

Then, before we had to head back to Amsterdam, we stayed a couple of days in Tel Aviv." It turned out to be a trip of extremes. "The chaos of Amman's traffic contrasted with the quietness of the Wadi Rum desert; the ugliness of dissolute Eilat was the opposite of the beauty of religious Jerusalem and there was a bizarre difference between Jordan's cheap, bulging minivans and Israel's air-conditioned buses outfitted with Wi-Fi. Our trip on that relatively small and contentious piece of land made quite an impression," Joost says.

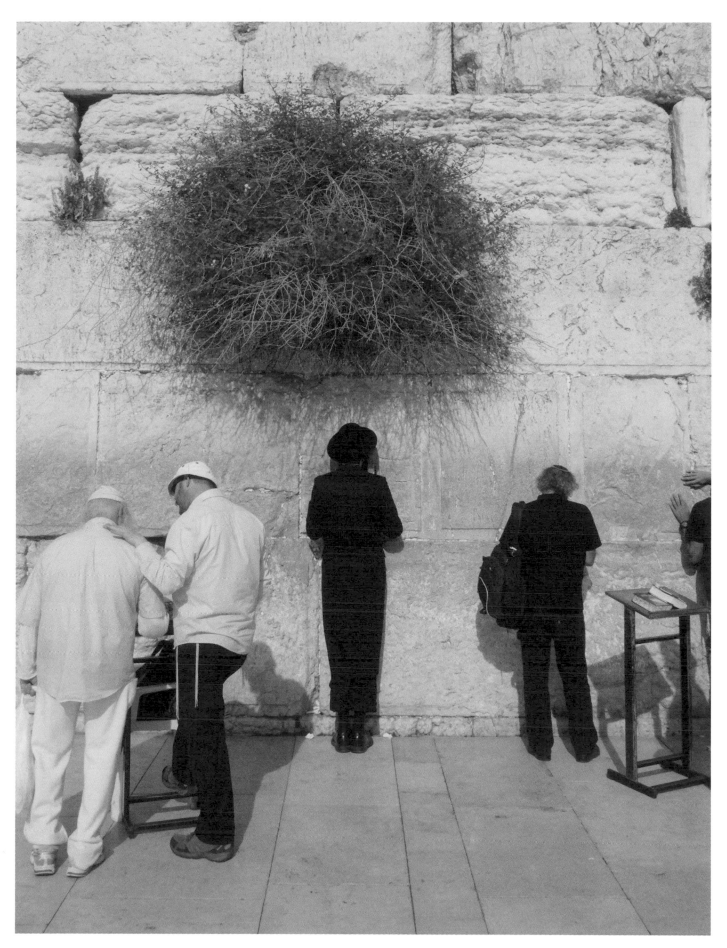

The Western Wall, Jerusalem Israel Jerusalem is beautiful and confusing. It's an important religious place where people live next to each other, but not with each other.

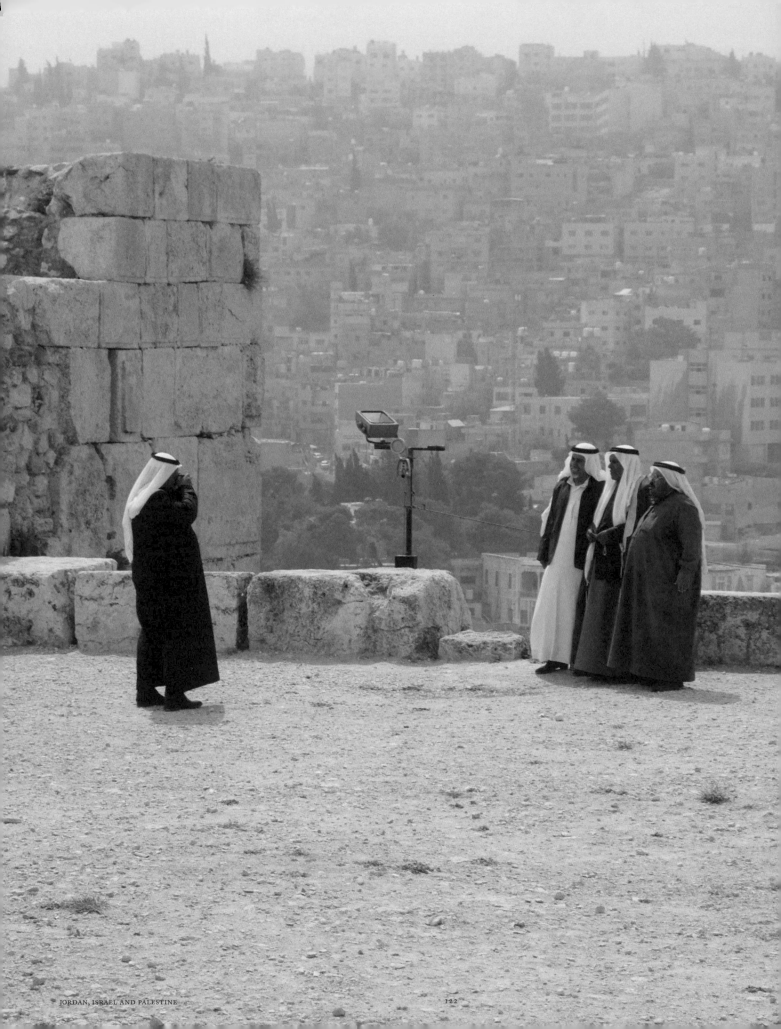

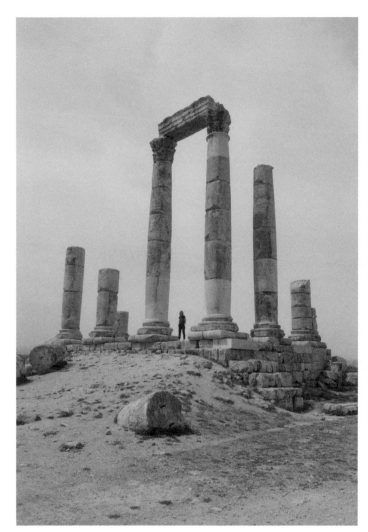

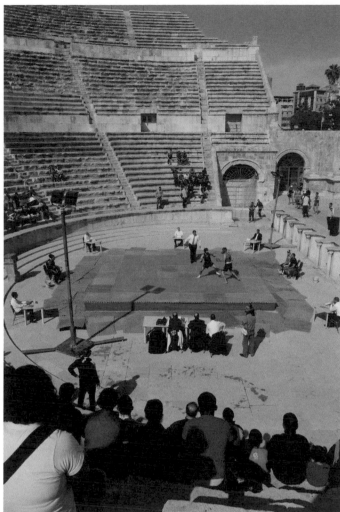

↑ **The Old Citadel, Jordan** My girlfriend Saskia, standing on the ruins of the Temple of Hercules, one of the most significant Roman remnants of Amman's "Jabal al-Qal'a," the old citadel that offers a panoramic view over the rest of Jordan's capital.

↗ **The Roman Theatre, Amman** Lots of locals sat in this almost 2000 year old structure to organize a pretty kickass boxing match.

← **The Old Citadel, Jordan** Amman is situated on the so-called "East Bank Plateau" and has many "wadis" (valleys) running through it, which makes it quite hilly. The Jerusalem historian al-Muqaddasi once called it "a harbor for the desert."

↑ Wadi Rum Desert Obeid placed his hand on top of the roof while his 16 year old son Abdellah drove like crazy through the vast desert plains of Wadi Rum. Meanwhile, we were in the back of the ancient 4x4 truck, clinging to the bench and trying not to land head first in the red sand.

↗ Wadi Rum Desert Before we slept in a small Bedouin camp, we took a camel ride to a big rock in the middle of the desert. It's the quietest place I have ever been — when you're out of the wind you can't hear a thing. Truly, an otherworldly experience.

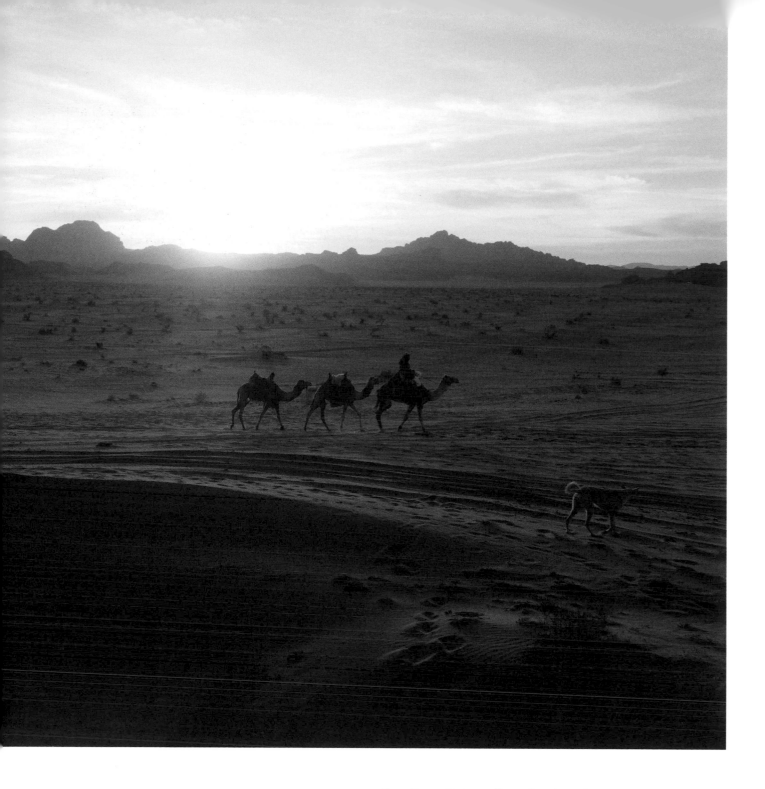

Joost Bastmeijer is an all round media maker, currently working for the online division of Dutch public radio station NPO Radio 1. "What I love about online media, is that you can easily combine text, video and audio in order to tell a story," Joost says. Photography has run through his family's veins for several generations. "My father and grandfather showed me some tips and tricks when I grew up, but I really got into photography when I started experimenting with mobile photography," he says. "Especially Instagram is a great platform. I love to take a picture and write a small story to go along with it, to add a bit more context to a certain situation. I guess that has a lot to do with my journalism background."

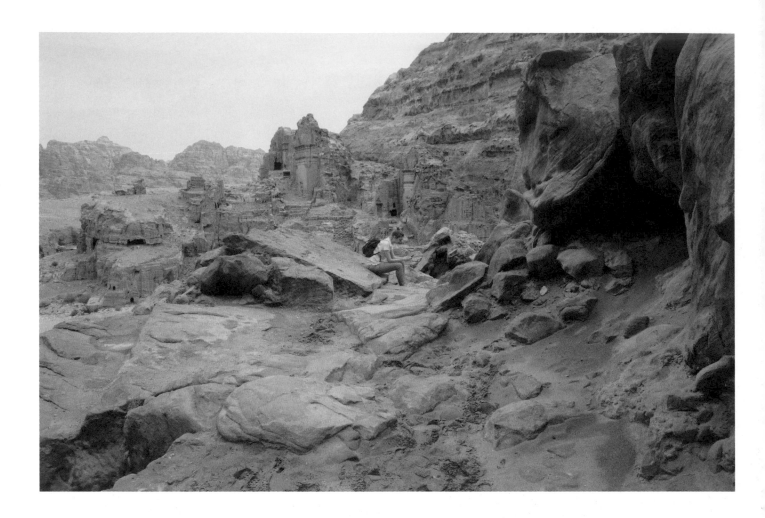

" Our trip on that relatively small
and contentious piece of land made
quite an impression. "

– Joost Bastmeijer

↑ **Jabal Al-Madbah, Petra** When we climbed over
the Jabal Al-Madbah mountain, Saskia and I shot so
many pictures of deserted temples we often had to sit
down and delete some photos, in order to take some
more.

→ **Treasury, Petra** Petra's Treasury reveals itself when
you're walking towards it through the narrow "Siq," a
path through a split, 80 meter-high rock. Though the
Treasury and the Monastery are quite famous, Jordan's
old valley village is way bigger than those two attractions,
and it offers some magnificent hidden gems.

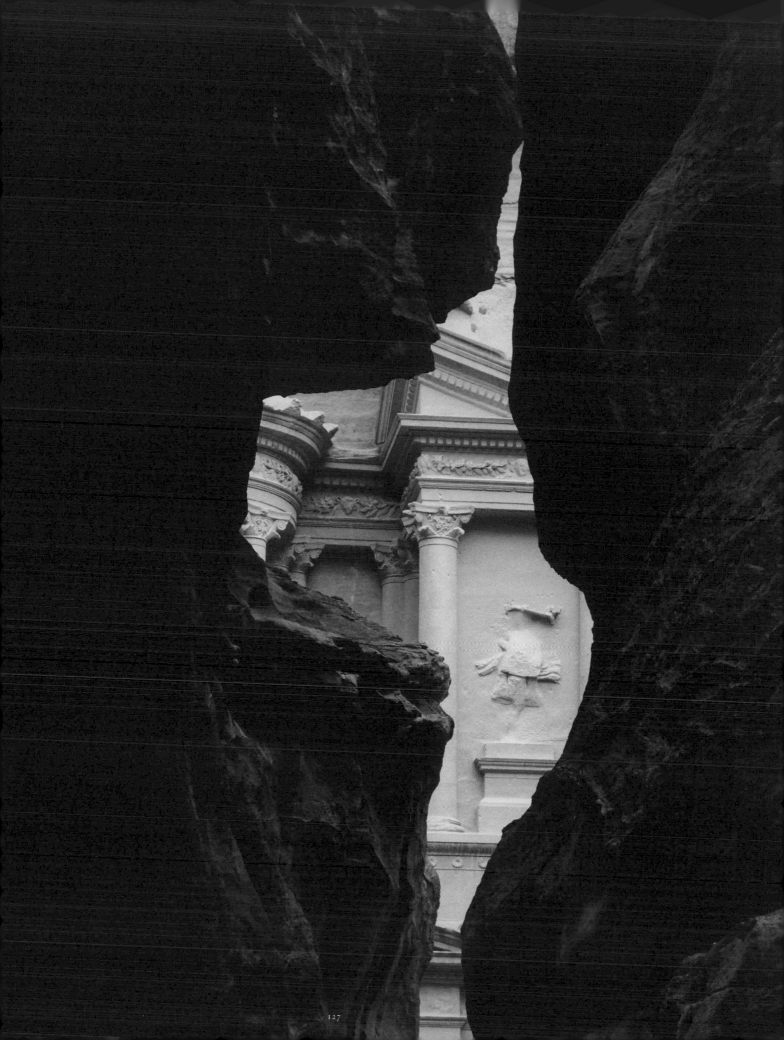

Lawrence Michael Thomas @Lmt_

ROAMING

THE ALPS

LOCATION The Bavarian Alps, Germany & Austria **COORDINATES** 47.478461, 10.815842
PHOTOGRAPHER Lawrence Michael Thomas, London, United Kingdom @Lmt_

When Lawrence and his friends embarked on a 15,000 mile long road trip through the Bavarian Alps, their main goal was "to discover some of the more remote and undiscovered places in and around the German Alps," Lawrence says. "For me, this part of the world signifies freedom and nature in its purest and most extreme form. Whenever I'm roaming the Alps, I feel alive. Almost as if the autopilot switch has been turned off and I'm truly in the moment."

Lawrence continues: "This was the first time I'd been to this district of Germany, but I will be back there as soon as humanly possible. Everyone should experience the Bavarian Alps at least once in their life, there is something truly incredible around every corner. The scale of the looming mountains and reflections on the perfectly still lakes are truly something to behold. I honestly believe the best way to experience this place is to grab a bunch of your best friends, pile into a car and simply get lost in this beautiful part of the world."

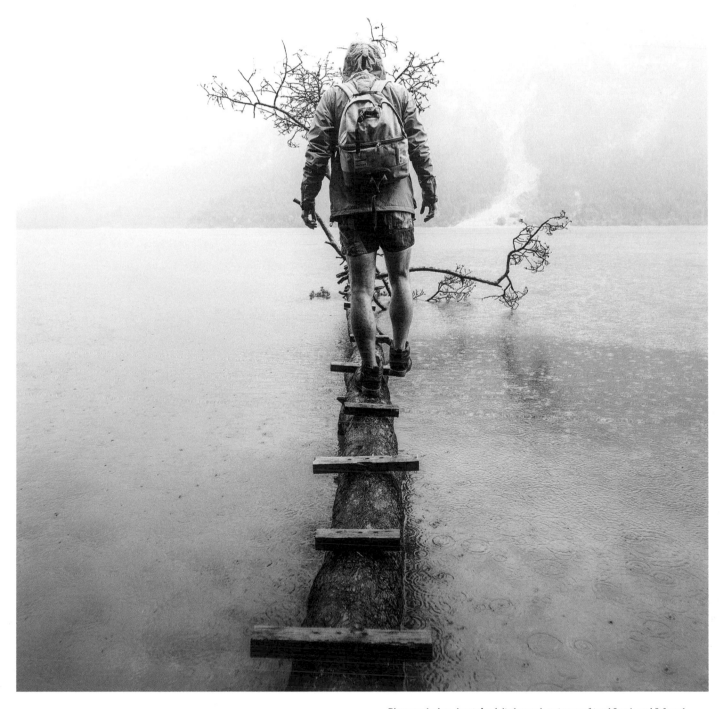

Plansee Lake, Austria A little perch point my friend Jacob and I found overlooking Plansee Lake on a cold Sunday afternoon — one of my favourites.

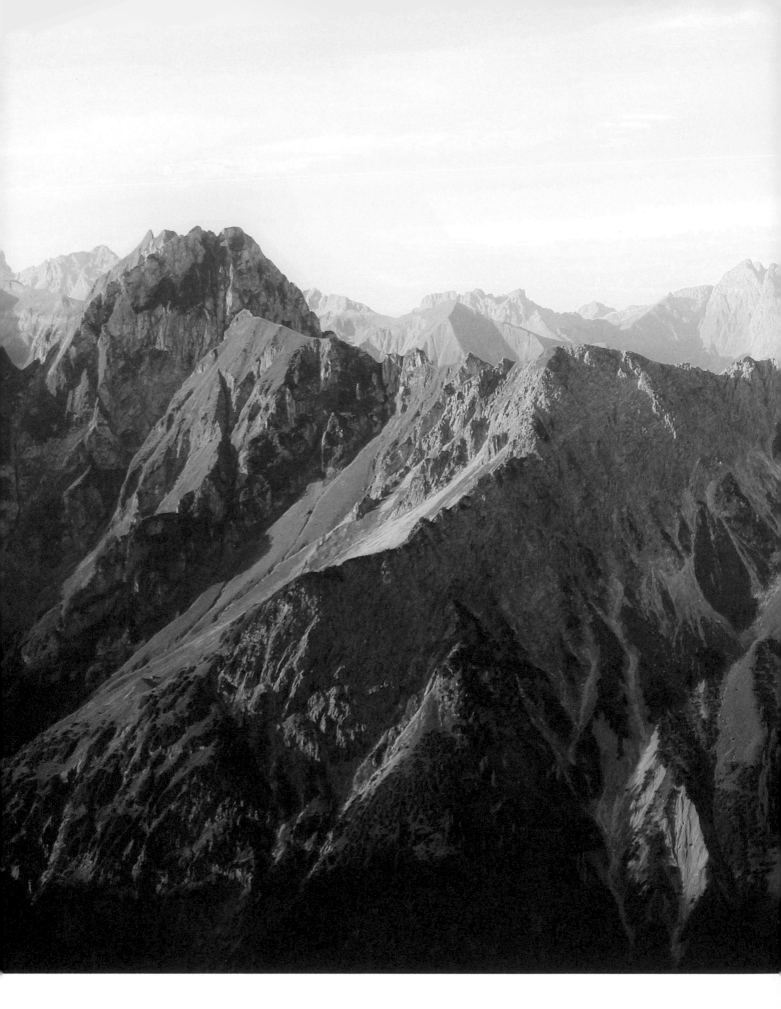

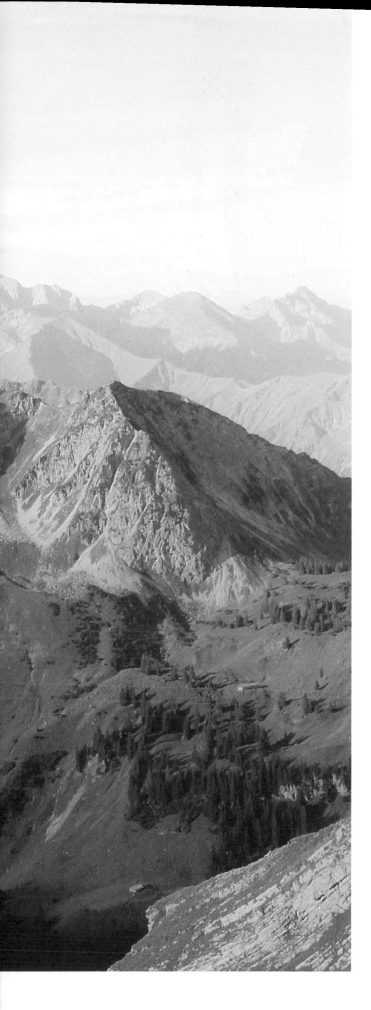

" I honestly believe the best way to experience this place is to grab a bunch of your best friends, pile into a car and simply get lost in this beautiful part of the world. "

– Laurence Michael Thomas

Allgäuer Alpen, Germany From this particular view, the mountains went on as far as the eye could see, with the the menacing peaks of the Alps in the Allgäu region covering the valleys below. For me, this shot just encompasses why I got into photography, and why I always will be: the mountains.

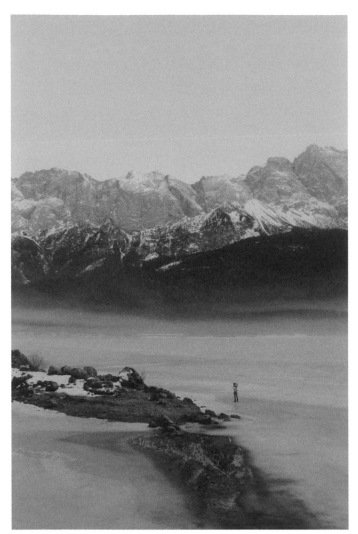

↖ **Elbensee Lake, Germany** My friend Max, standing on the frozen sheets of ice that covered the Eibsee Lake on one of the coldest days of the year. The last light from the sun lingers on the peaks of the Zugspitze and the perfect reflection appearing from below.

↑ **Plansee Lake, Austria** A very risky shot of Jacob standing on a very sketchy crack in the ice covering the Plansee Lake.

→ **Plansee Lake, Austria** Max, surrounded by snow capturing the Plansee Lake's crystal clear waters, with omnious reflections of the mountains.

"I love photography because it allows me to share my view of the world, as well as capturing a particular moment in time for ever," says London-based photographer and Marketing student Lawrence Michael Thomas. "I love exploring nature and the wilderness, and I'm always trying to capture nature's beauty, as well as her brute power. I'm also incredibly passionate about risk and the role that plays in one's life."

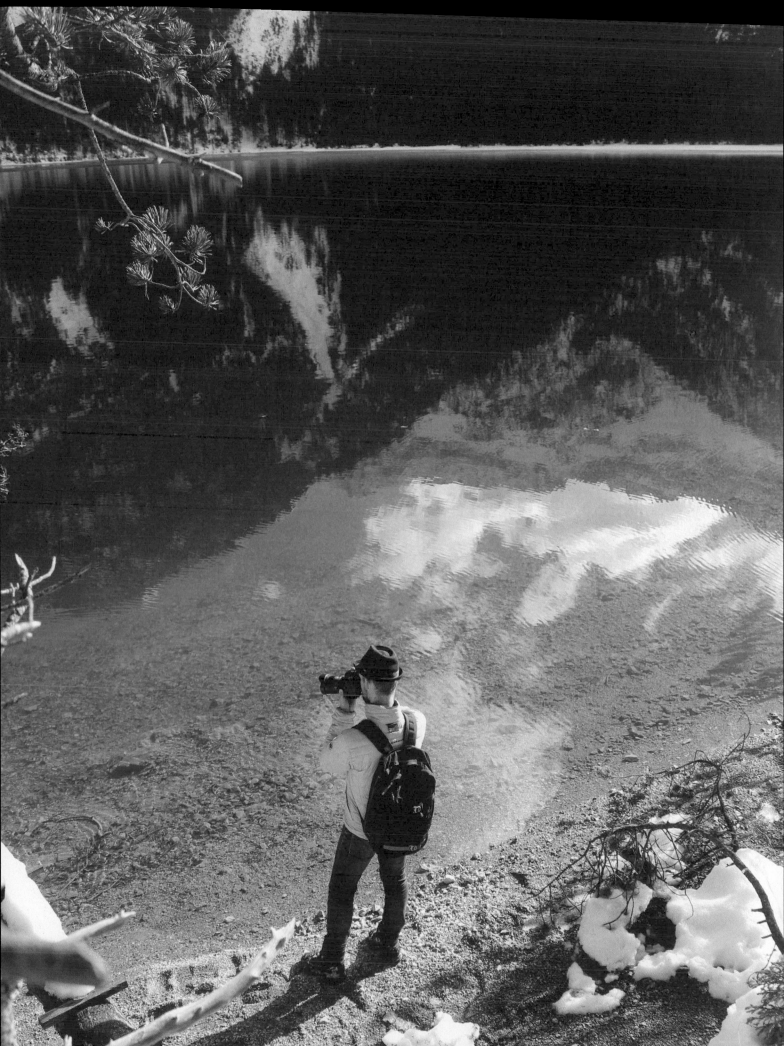

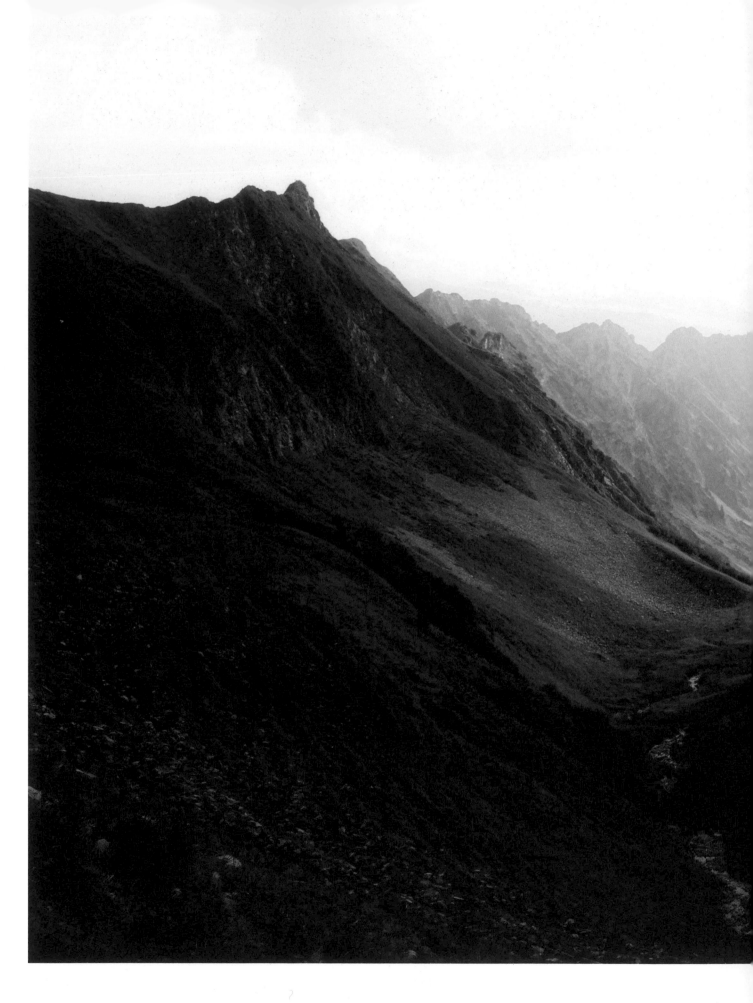

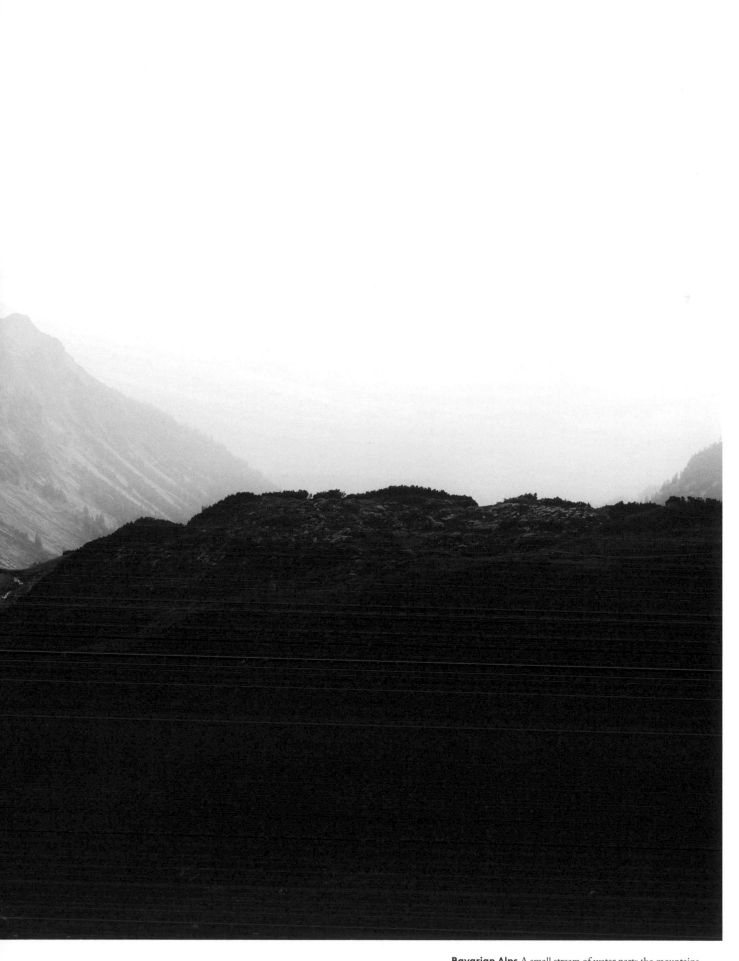

Bavarian Alps A small stream of water parts the mountains
as the mist from the north begins to envelop the peaks of the Alps.

The
hippy
dream

It's an old but sturdy hippy dream: driving to that one beach famous for the perfect waves to surf on — with the Beach Boys pealing through the speakers, and the sun on your face. For that perfect form of hippy transportation there's only one way of getting from A to B, and that's with an old VW Transporter-bus from the sixties. The original hippy-bus of Volkswagen is officially known as the "VW Type 2," and became an icon of America's trippy counterculture movement. The van was the brainchild of Dutch car importer Ben Pon. He saw there was a market for "small buses" and reportedly provided the first sketch for what later would be the Type 2. The van still is a camper's and photographer's dream vehicle, as is evident in this book. If you can't get enough of those van pictures, make sure to look up the #vwbus hashtag on Instagram!

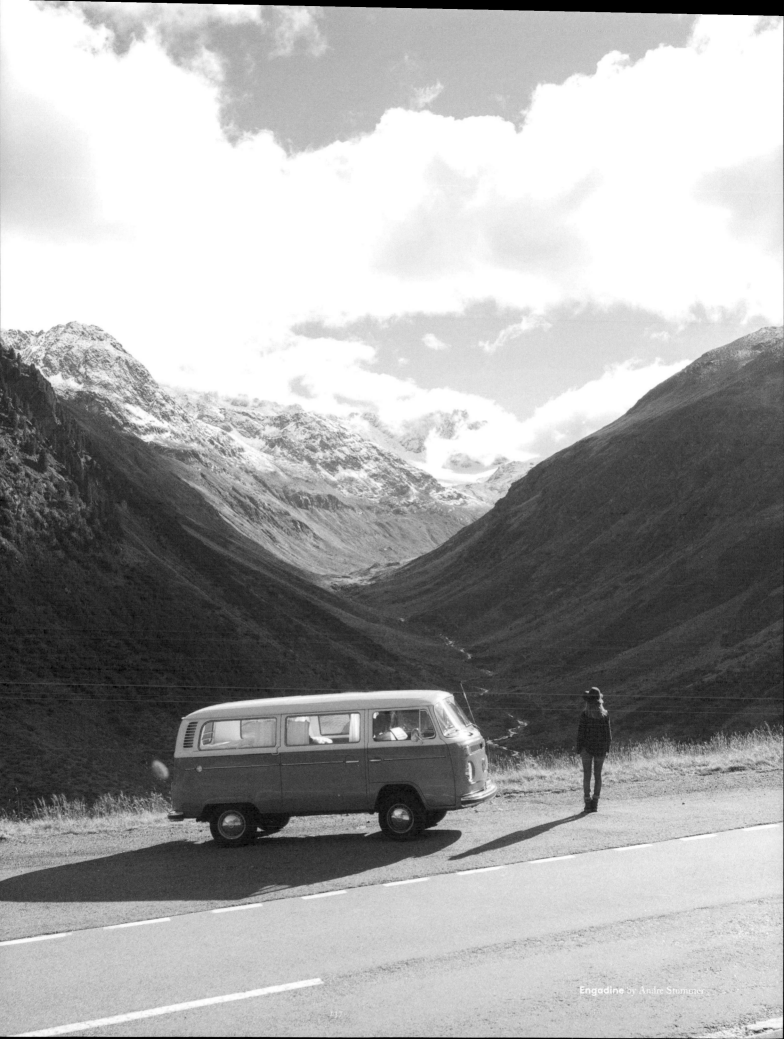

Engadine by André Stummer

Ryan Hill @ryanmcmahill

A
PHOTOGENIC
PLAYGROUND

LOCATION Big Sur, USA **COORDINATES** 36.270674, -121.808280
PHOTOGRAPHER Ryan Hill, San Luis Obispo, California, USA @ryanmcmahill

Watching over the Pacific Ocean, the rough coastline of America's central coast is what Ryan Hill calls "his playground." The Californian surfer slash photographer often cruises from his San Luis Obispo apartment to the lightly populated Big Sur area, to get out there with his slackline and hanging tent. "It may not have the perfect white sand beaches or the beautiful mountains of up north," Ryan says, "but the green hills of the Central Coast sure know how to welcome you." The Big Sur area, that roughly starts at the Carmel River to the southern San Carpoforo Creek, offers numerous photogenic sights. There are lots of coves and beaches along the coastline. The Santa Lucia Mountains rise dramatically out of the water and the impressive Bixby Creek Bridge connects the Big Sur with the rest of California. "The Central Coast is apparently not as beautiful as up north, and not as perfect as down south. Or so I've been told by people who've never been," Ryan says. "This stretch of coast doesn't show it's hand as readily as the rest of California's coastline, but there are too many gems on the way up to Big Sur to recount, you just have to know where to look."

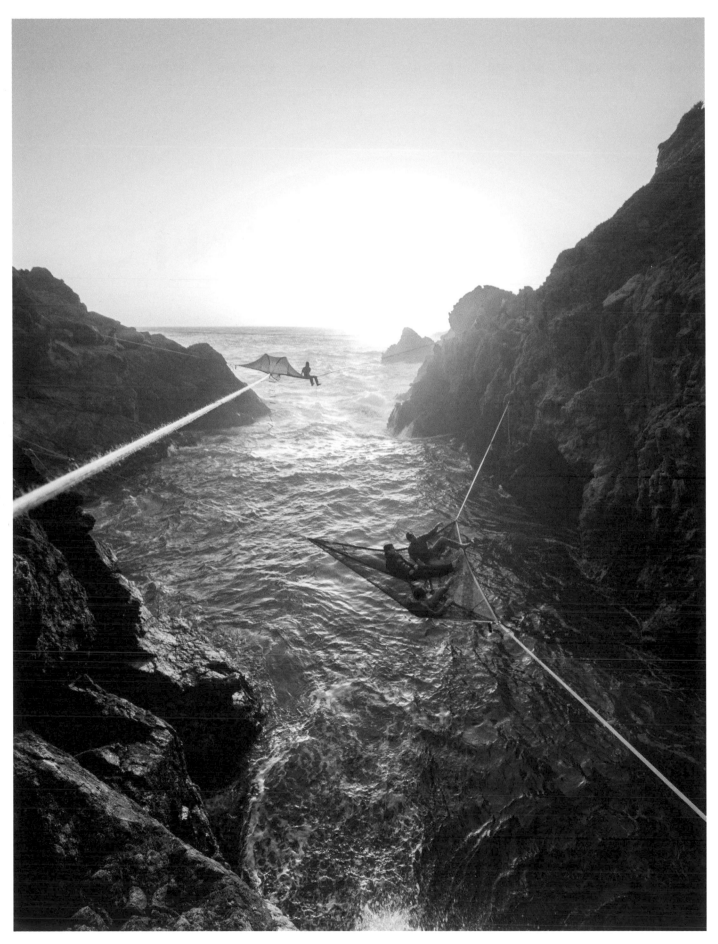

East Coast, USA Big Sur is a playground, plain and simple.
With a slackline, hanging tent, and net, I'd say we were taking advantage.

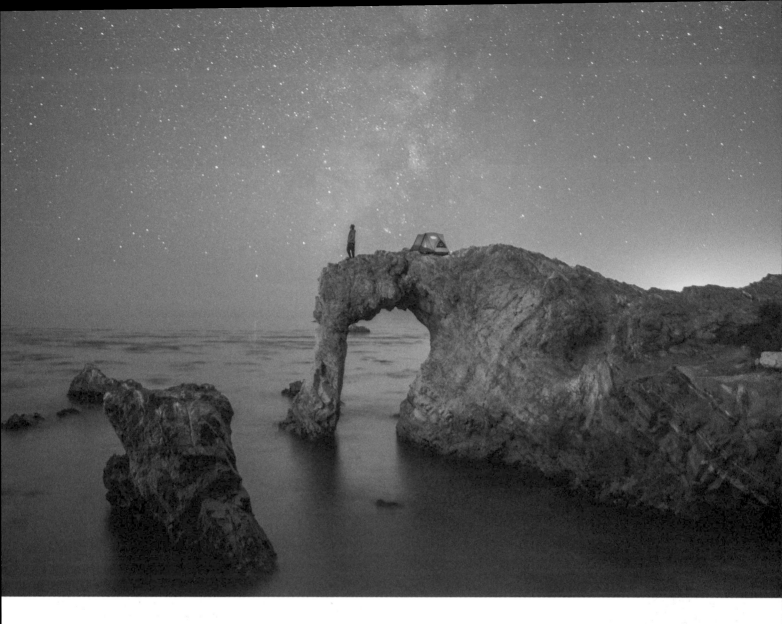

↑ **East Coast, USA** Starry nights on the Central Coast. Located just outside of SLO, it's a must-stop place on your way up the coast. Just ask where the magical arch is between Pismo and Morro.

↗ **East Coast, USA** Jumping off things you shouldn't. It's a thing I do far too often.

"I find myself going to Big Sur more often than my wallet likes," American photographer Ryan Hill says. "I surf. I take photos. I eat too many breakfast burritos and I edit photos. I guess I actually do that for a living." Ryan works for the company of "Insta-famous" nature photographer Chris Burkard, who has gathered over 1.8 million followers on Instagram. The photos printed here are some Ryan's favorites, "from what would be a typical trip to Big Sur from my apartment in San Luis Obispo."

" I surf. I take photos. I eat too many breakfast burritos and I edit photos. I guess I actually do that for a living. "
– Ryan Hill

East Coast, USA Soaking it up above Sand Dollar Beach. Located at the southern end of Big Sur, it's just a taste of what this stretch of coast has to offer.

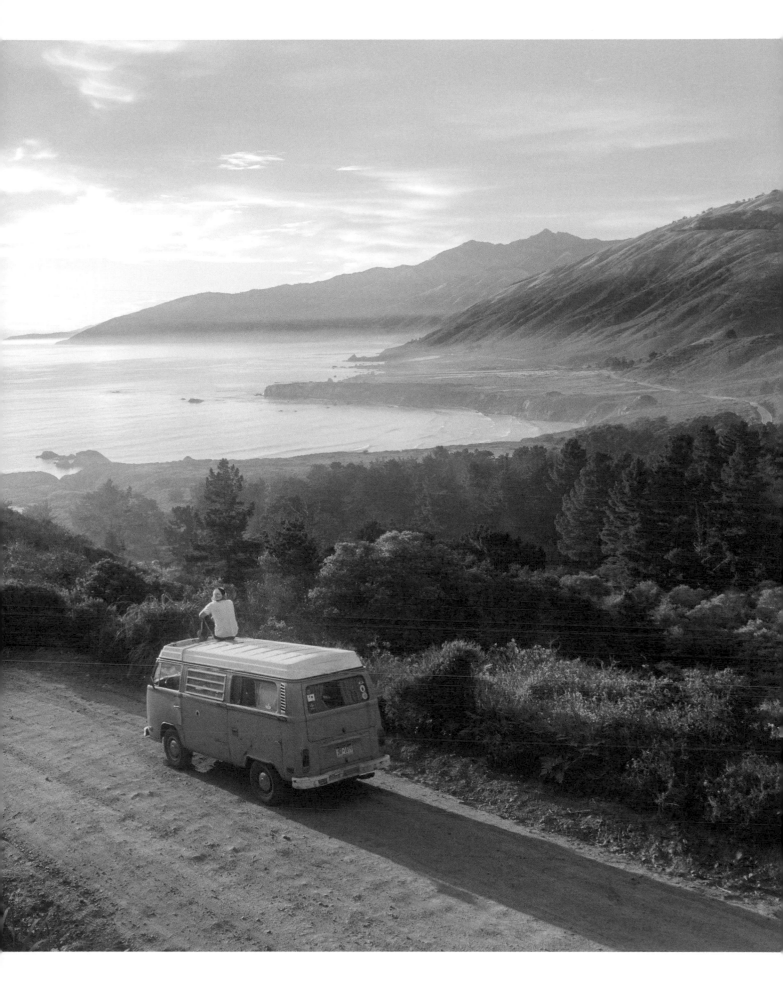

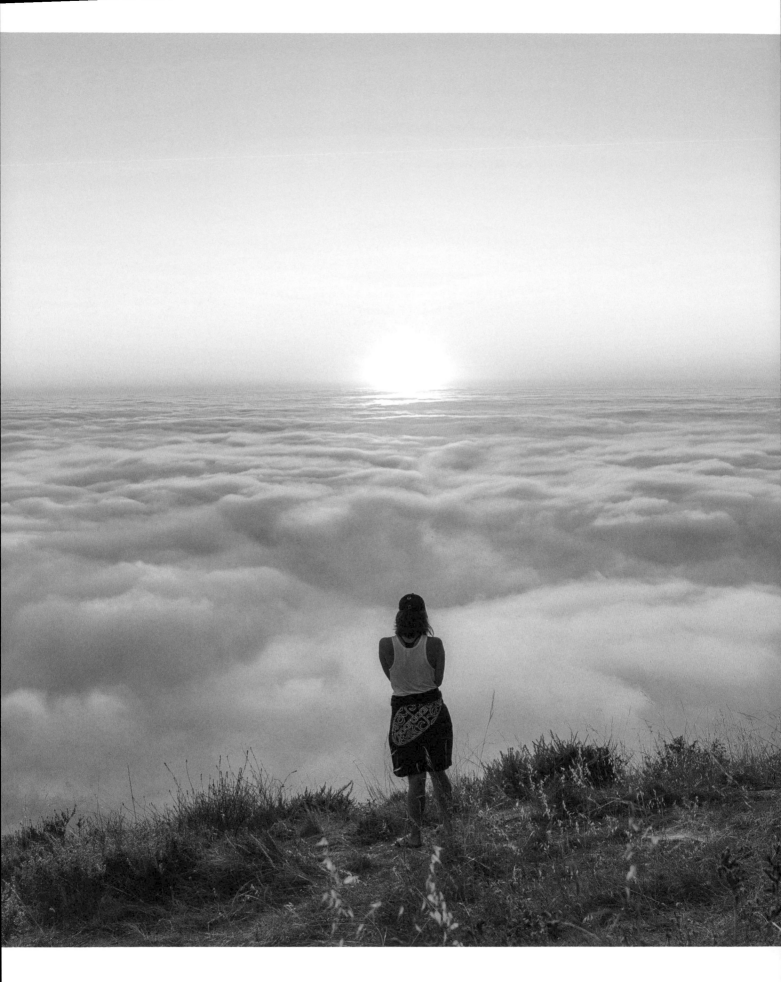

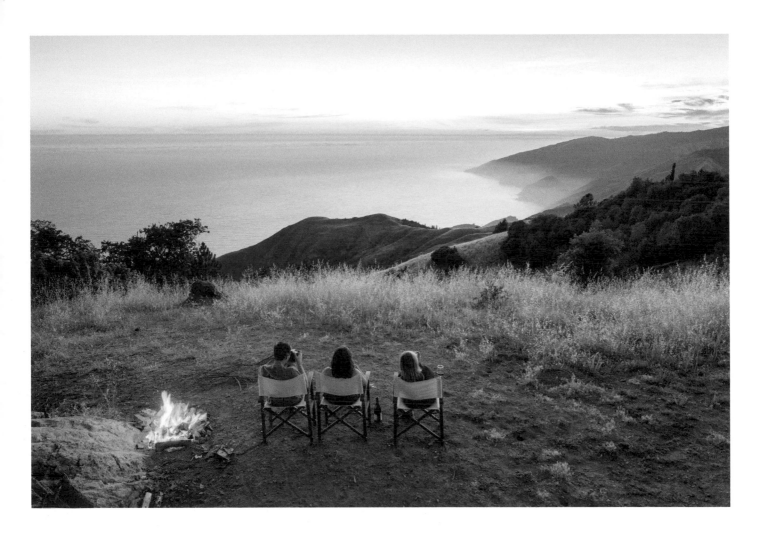

↑ **East Coast, USA** Often it's the people that make the trip, not the destination. But the destination does help. High up above Big Sur.

← **East Coast, USA** Low clouds often cover much of Big Sur. Sometimes your best bet is to get above them and simply enjoy the show.

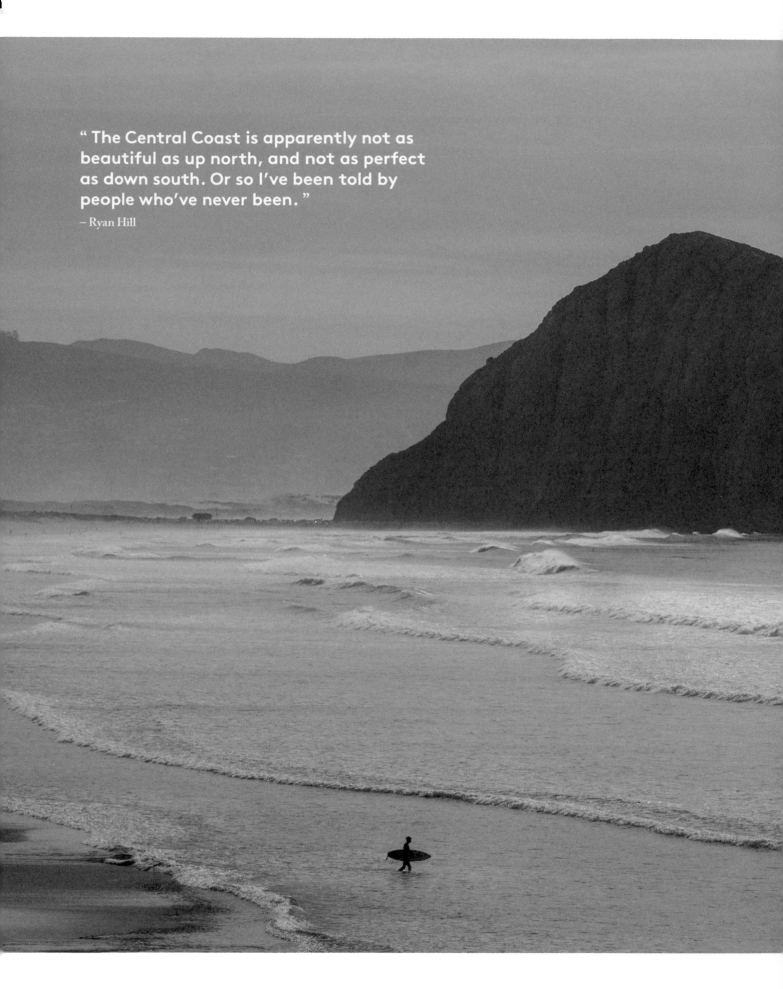

" The Central Coast is apparently not as beautiful as up north, and not as perfect as down south. Or so I've been told by people who've never been. "
— Ryan Hill

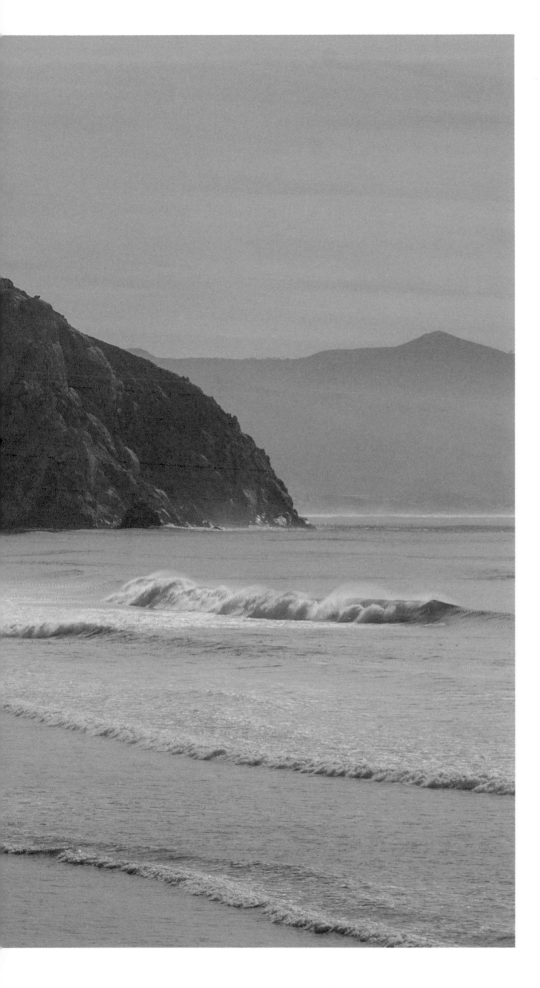

Morro Bay, East Coast, USA

SHARED HAPPINESS

LOCATION The Faroe Islands **COORDINATES** 62.063179, -7.230420
PHOTOGRAPHER Michiel Pieters, Beringen, Belgium @michielpieters

Belgian photographer Michiel Pieters had never thought of visiting the remote Faroe Islands until a friend invited him and two other guys. Michiel had already been to islands such as Iceland and New Zealand, so he "didn't expect to see a lot of new things," he says, but he already was wrong about that when he arrived at the airport. "I only realized how small the Faroe Islands are when my plane landed. The Vágar airport has only one landing strip and is only open when a plane lands or departs, and that doesn't happen too often."

Michiel and his friends traveled around the archipelago and were amazed by the versatility of the island group. "Each island is spectacular in it's own way. We heard various legends, and saw multiple fjords, waterfalls and huge cliffs dropping straight into the Atlantic Ocean." Michiel loves to travel with friends. He says: "I like to share my adventures with others. Most of the time we end up doing some really stupid, but epic things. To quote Alexander Supertramp: 'happiness is only real when shared.'"

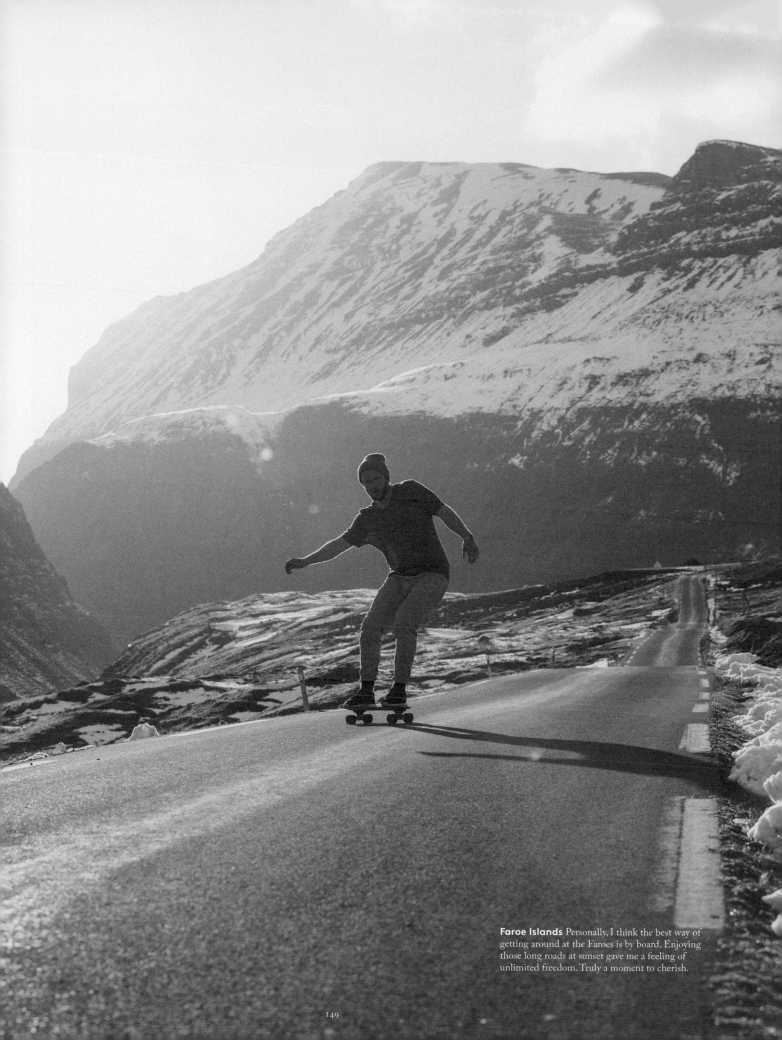

Faroe Islands Personally, I think the best way of getting around at the Faroes is by board. Enjoying those long roads at sunset gave me a feeling of unlimited freedom. Truly a moment to cherish.

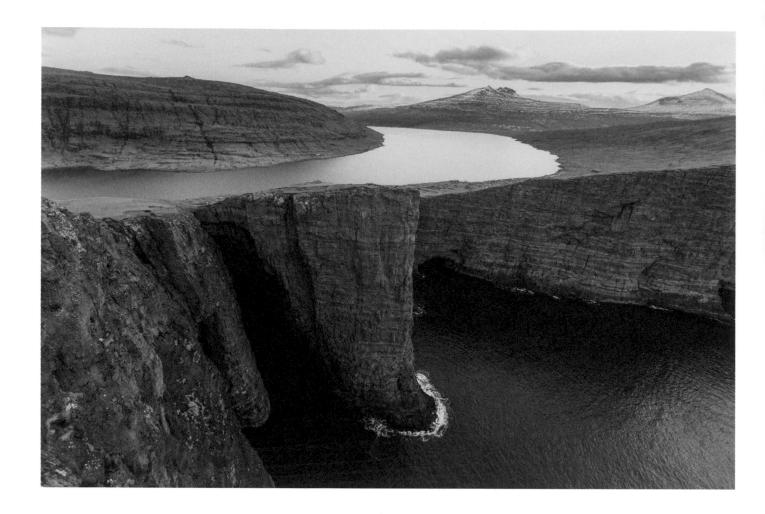

↑ **Sørvágsvatn lake, Faroe Islands** The view at lake Sørvágsvatn is just incredible. Imagine a lake, steep cliffs and the ocean all in one picture: that's exactly what you'll get. We woke up at 4 o'clock in the morning to be here at sunrise, but sadly the sky was at its best while we were still hiking to this point. But trust me, the view was still jaw-dropping.

↗ **Gásadalur waterfall, Faroe Islands** This is the archipelago's most iconic waterfall. A small river drops straight into the ocean here, not your everyday view.

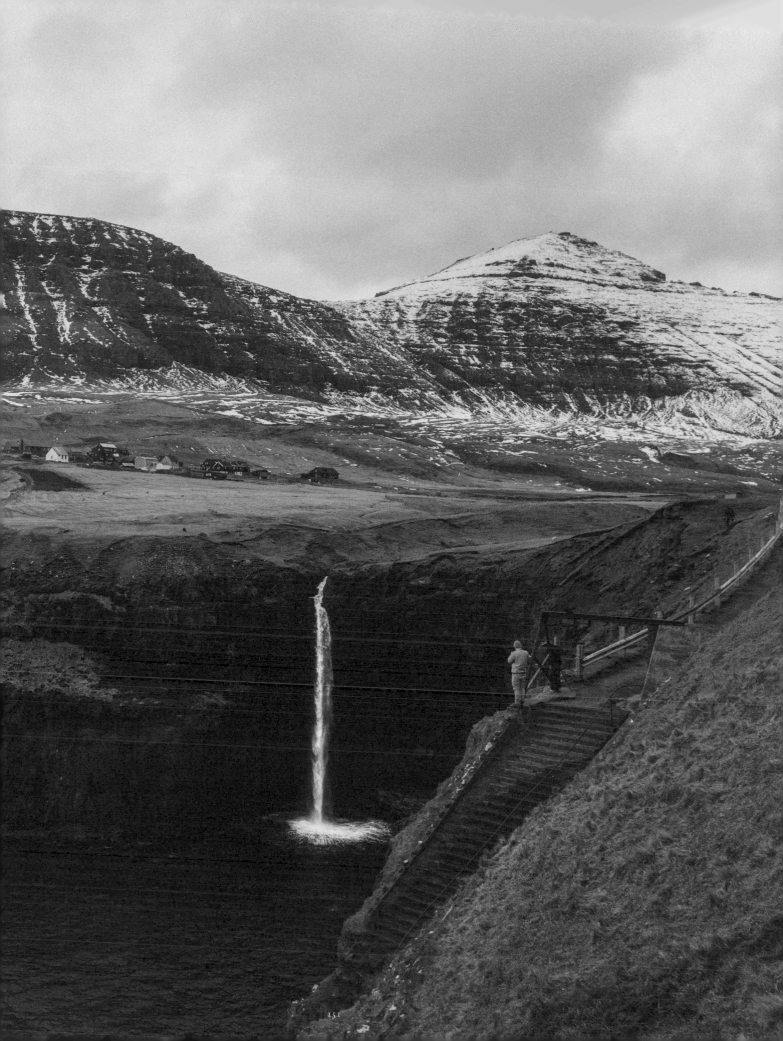

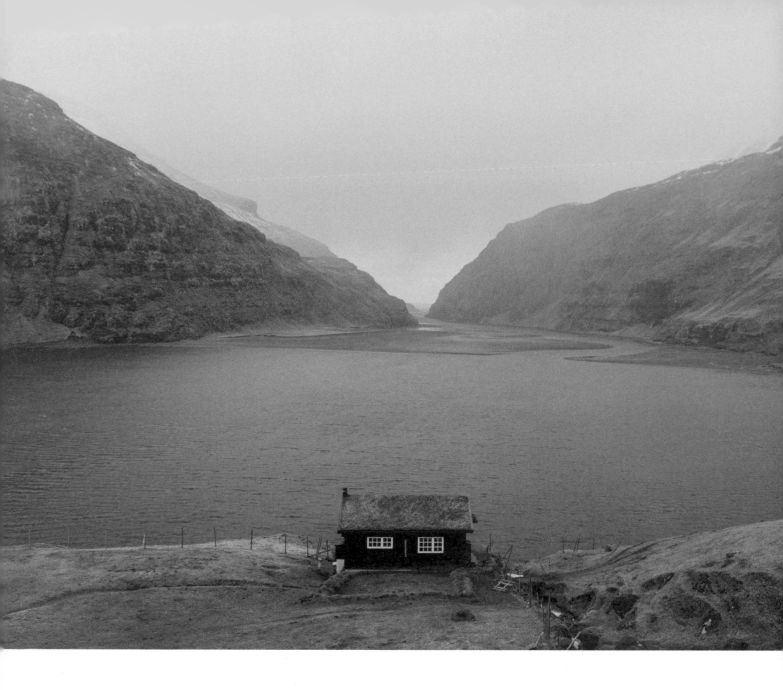

↑ Saksun, Faroe Islands Probably the most
photographed cabin on the whole island is this one at
Saksun. You can easily see why: the grass roof, the fjord,
the mountains and the symmetry. It's funny how those
mountains on the side of the photo never seem big
until you actually witness them with your own eyes.

↗ Sørvágsvatn lake, Faroe Islands
My good friend Lennart Pagel sitting on the edge, also
at Sørvágsvatn lake. I must admit that I was shaking
really hard while I sat on that same spot out of fear of
falling 200m down. But still, it was worth it.

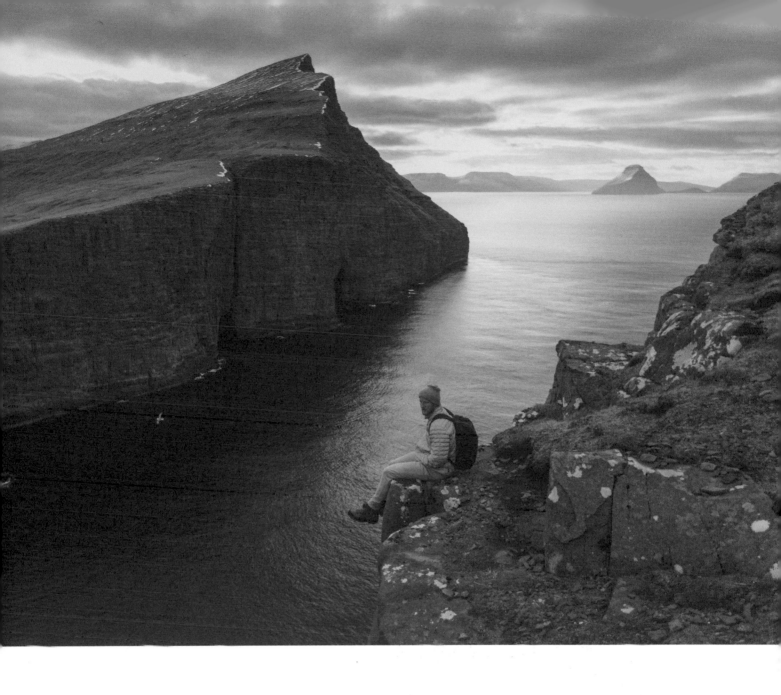

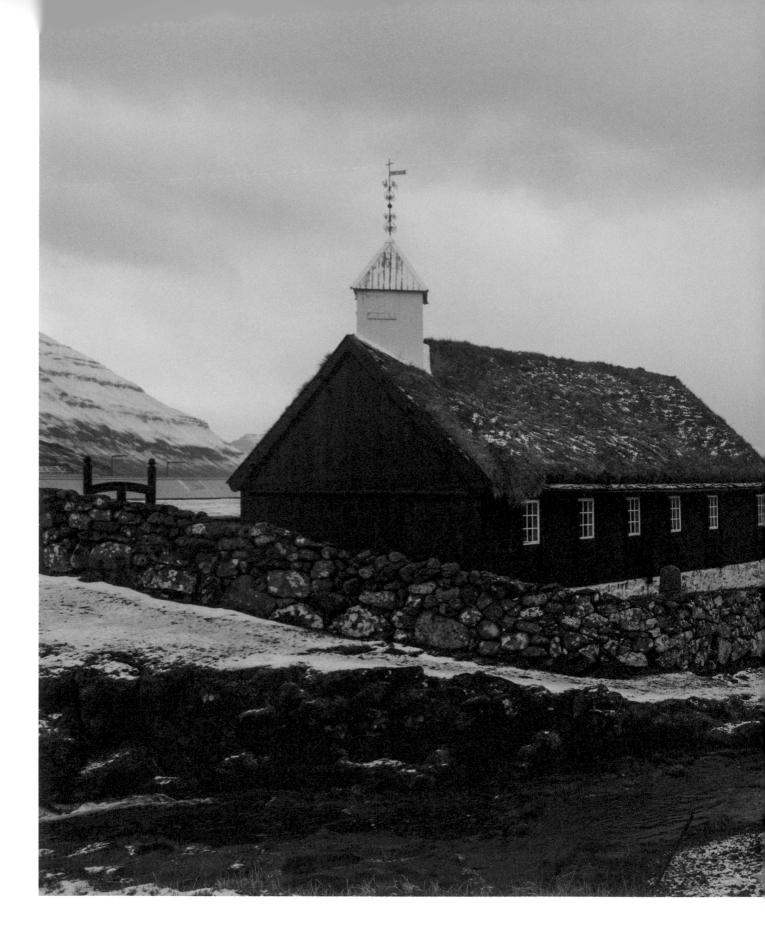

Funningur The small church of Funningur is a nice sight. It hadn't snowed for weeks, but upon our arrival it snowed very heavily.

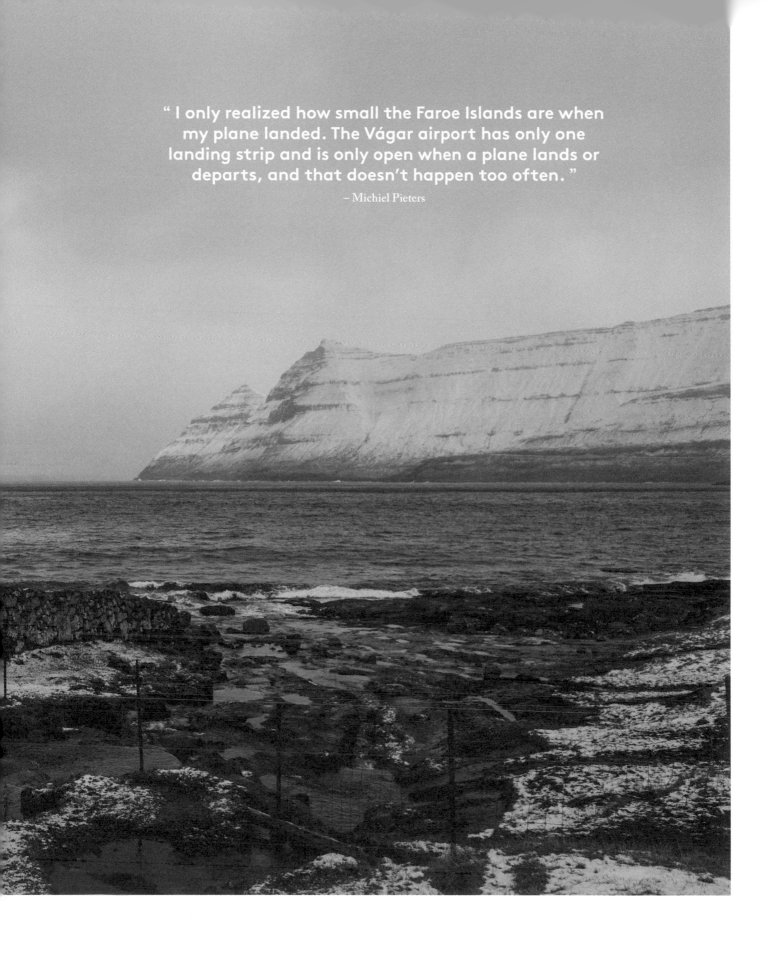

" I only realized how small the Faroe Islands are when my plane landed. The Vágar airport has only one landing strip and is only open when a plane lands or departs, and that doesn't happen too often. "

– Michiel Pieters

Faroe Islands To conclude: probably the perfect curves of a perfect road.

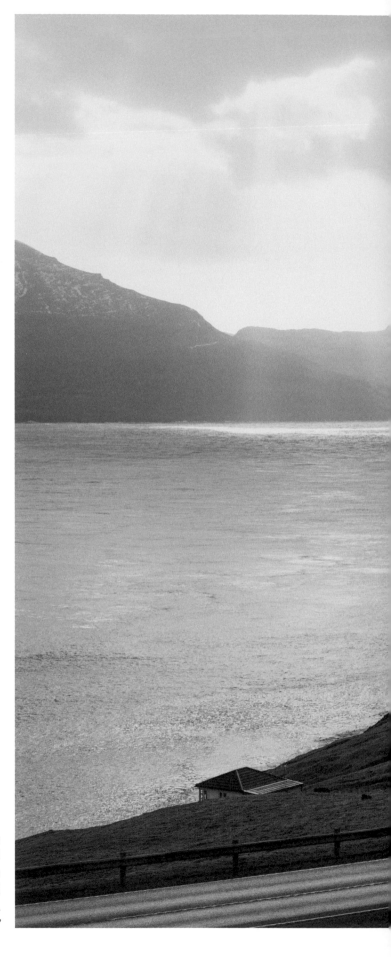

"I live in Belgium, and that's probably one of the most boring countries in the world," Michiel says. That's why the 25 year-old engineer and soccer player likes to leave his hometown of Beringen and get on the road. "Taking a photo is just a small part of the whole process. To travel means to experience new things and to learn from situations and people. It lets you grow as a person, something that lots of people are forgetting."

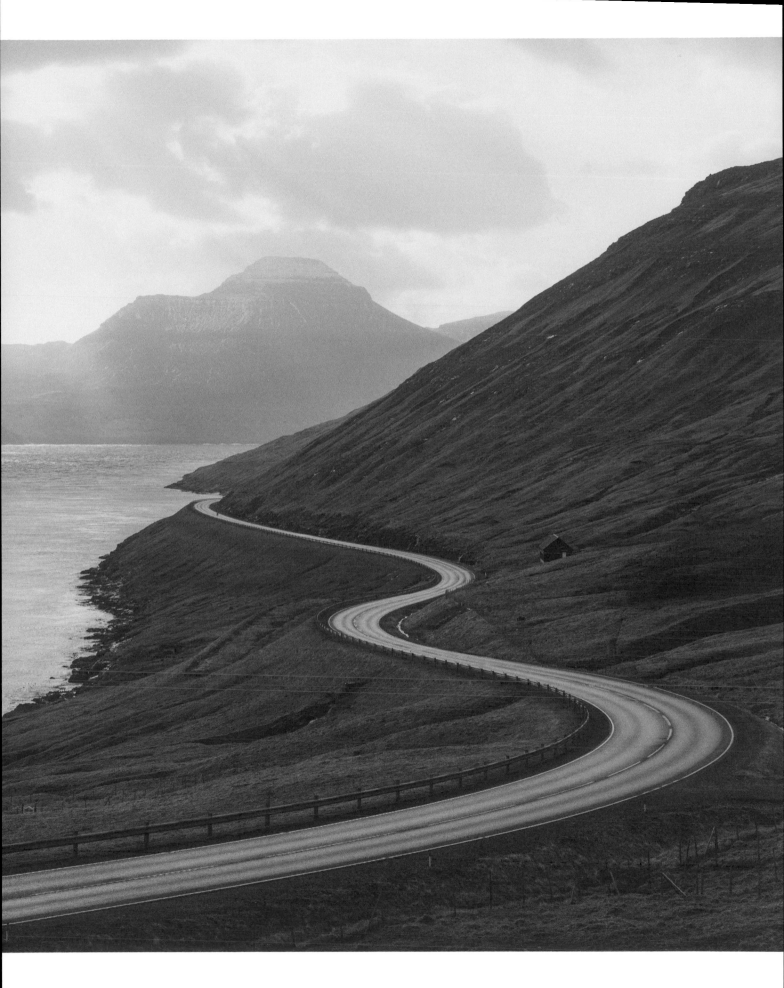

MEANDERING BEAUTY

LOCATION IJssel River, The Netherlands **COORDINATES** 52.147486, 6.185838

PHOTOGRAPHER Bob Sizoo, Zutphen, The Netherlands @bobsizoo

"The Netherlands is more than just the canals of Amsterdam," says Zutphen based photographer Bob Sizoo. "I would like to show that there's more to The Netherlands than it's capital city. Beauty can also be found in less famous rural areas." Bob shoots many of his pictures in the "Achterhoek" area, which literally translates to "Rear Corner" because of its topographic location. The region is especially photogenic during sunrise, Bob says.

"I only have to wake up early, but apart from that it doesn't take much preparation. I love the area because there's no such thing as pollution and there's a lot of green nature which is perfect for photography. You should go to the Achterhoek's watery areas in autumn; that's when the leaves are colored and if you're in luck, you can take photos of them with thin layers of fog around them."

Eefde, The Netherlands

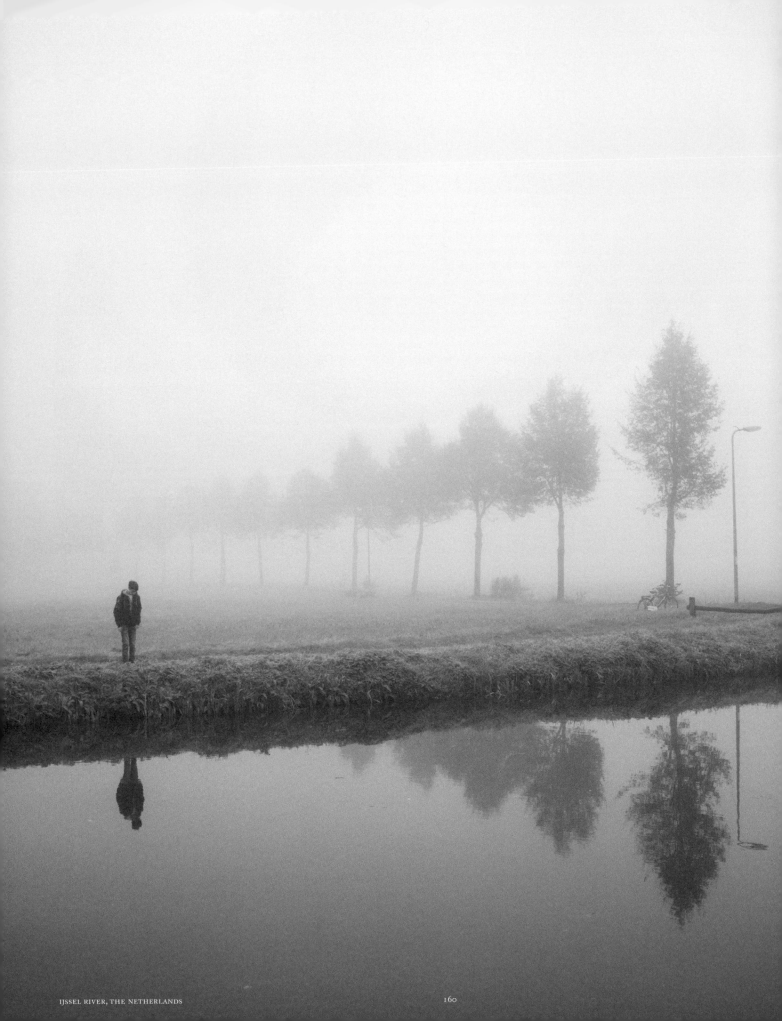

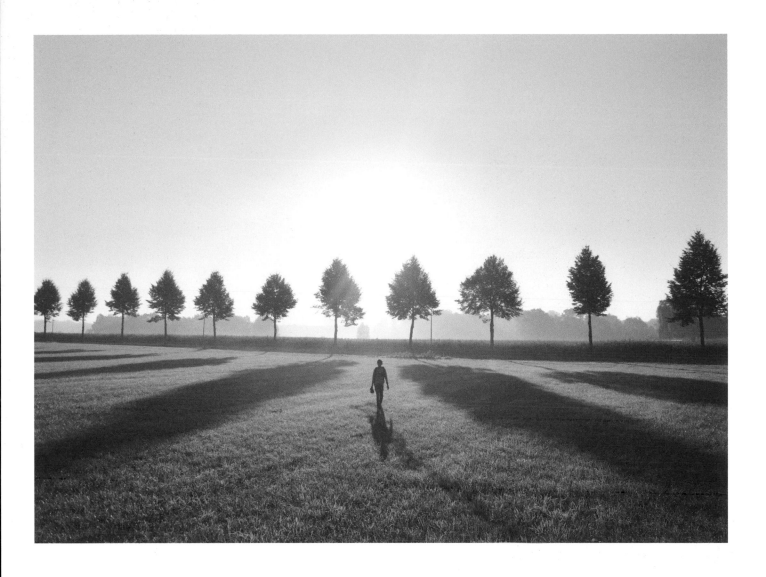

← **Warnsveld, The Netherlands** My brother Willem taking in the scenery of an early morning. I really like how the calm, reflective water and fog add so much mood to this photo.

↑ **Warnsveld, The Netherlands** The same spot as the photo on the left, but this time with no fog and sunshine instead. I love how the low sun creates long shadows.

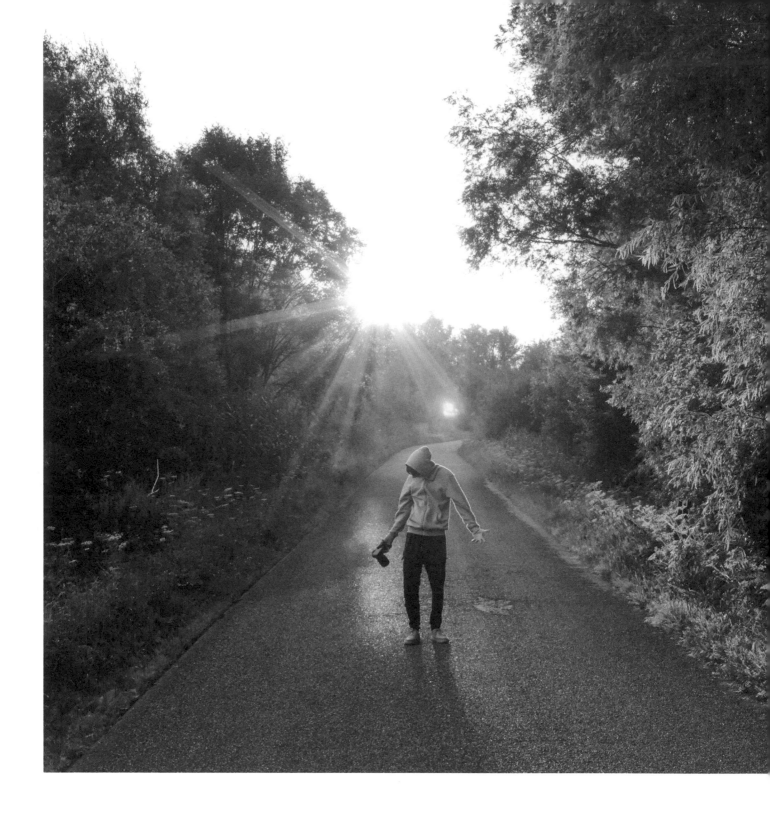

↑ **Almen, The Netherlands** First rays of sunlight touching a rural backroad.

↗ **Eefde, The Netherlands** This particular morning, the fog was so thick you couldn't even see the end of the road.

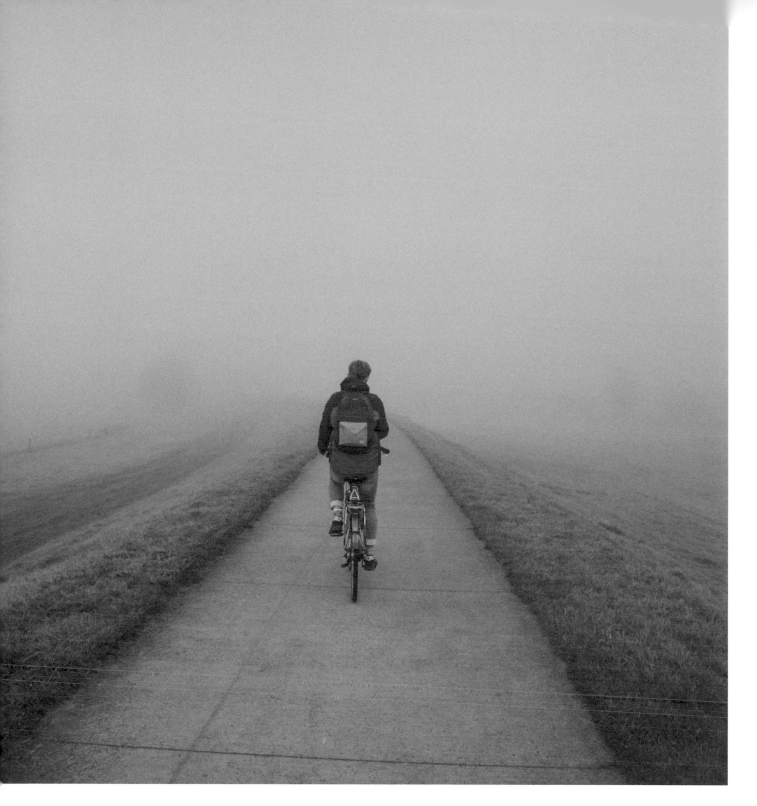

Together with his two brothers Bastiaan and Willem, Bob has lived in the Achterhoek region for over seven years. He's based in a small town called Zutphen, which is a perfect hub to get to the Dutch countryside. "The area is unique and very peaceful," Bob says. "It's well suited for cycling and photography, and not a lot of people come here, so it's an original place to take photos." That might also be a downside, though. "There's not a lot to do in the Achterhoek region, since there's not a single big city in the neighborhood." Bob finished high school, and he's now planning to move to the Amsterdam area to learn more about photography.

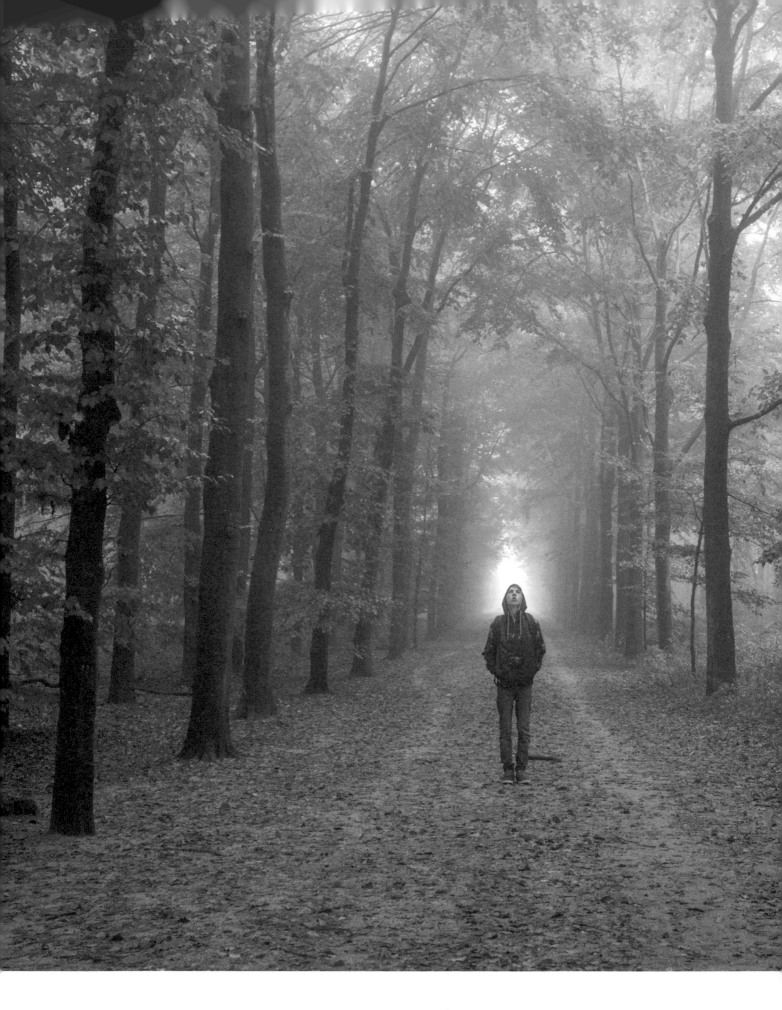

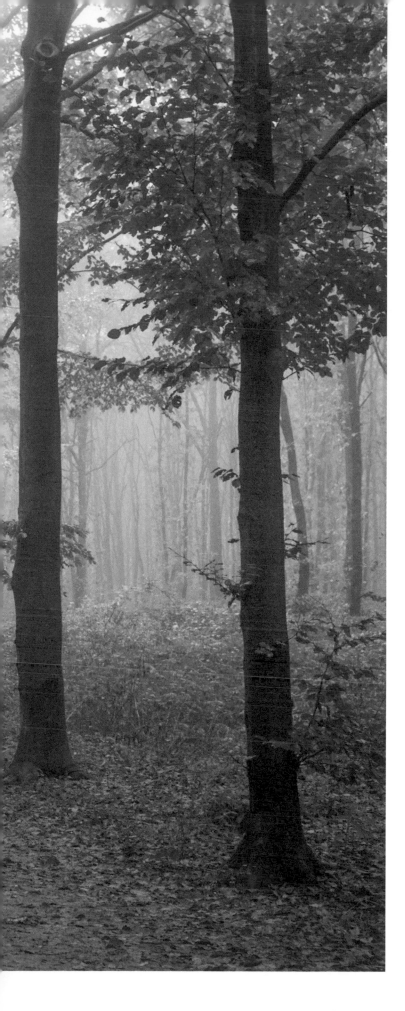

" I love the area because there is no such thing as pollution and there's a lot of green nature which is perfect for photography. "
– Bob Sizoo

Warnsveld, The Netherlands During my bike ride to school I came across this majestic looking tree alley and just had to take a shot.

EXPLORING

&

CAPTURING

LOCATION Quarten, Switzerland **COORDINATES** 47.113245, 9.249464
PHOTOGRAPHER Mohamed Abdulle, London, United Kingdom @mabdulle

"I'm passionate about photography," says London-based photographer Mohamed Abdulle, "taking pictures has brought me more than just photos. I have met some great people, and been able to witness some amazing sights. I've explored a great deal, and as a bonus I get to listen to some fine music while I'm endlessly editing my photos." Mohamed continues, "photography isn't just a hobby for me, it's actually become a part of my life. I love that I'm able to capture all the moments that are part of my daily life and travels. That's why I love to travel and explore the world. Switzerland has always been on my list of countries to visit and explore. The Alps, the remote towns, the countryside and lakeside towns. Who wouldn't want to go explore a place like that and capture it?"

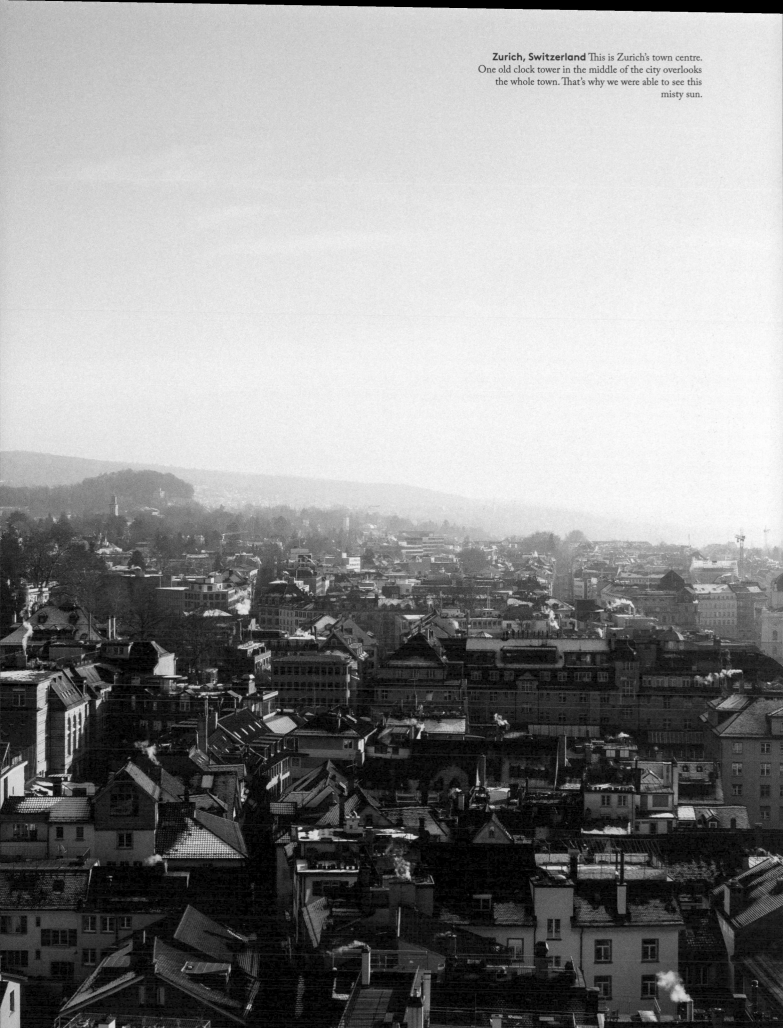

Zurich, Switzerland This is Zurich's town centre. One old clock tower in the middle of the city overlooks the whole town. That's why we were able to see this misty sun.

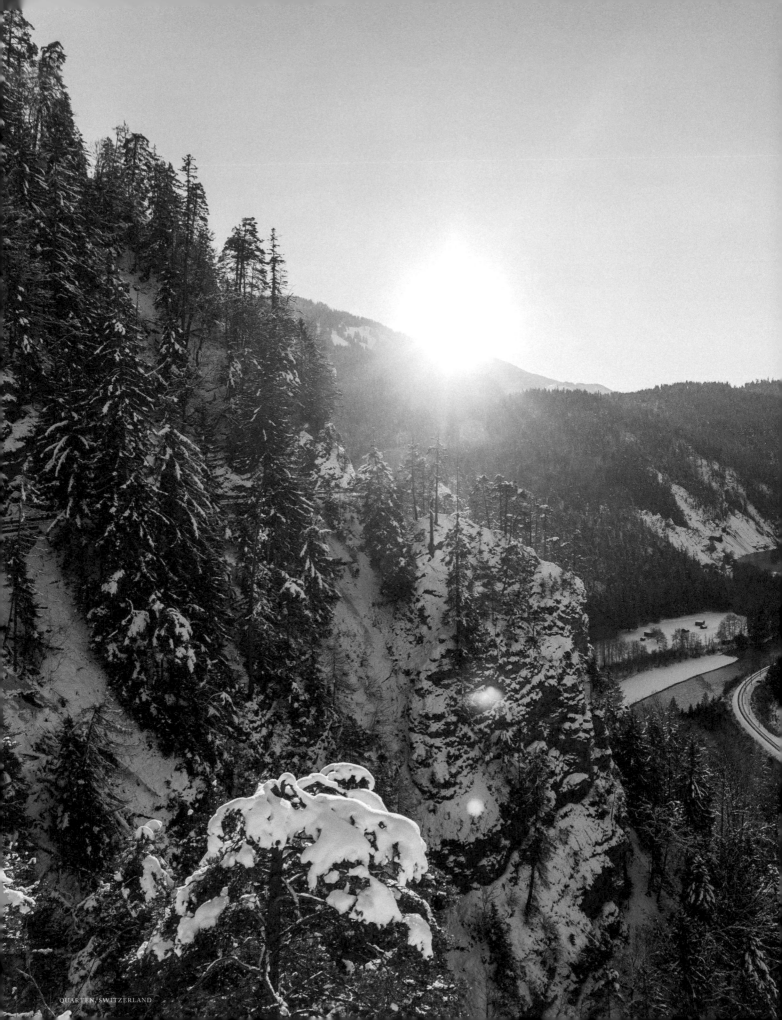

↑ **Films, Switzerland** Ollie Nordh is a good friend I met through Instagram. He was visiting London, so I showed him around and since then we've become good friends. We've been to London, Sweden, Switzerland and Hong Kong together. Victor was also with me during this Switzerland trip.

↗ **Films, Switzerland** I met Victor Bergstedt through Ollie. Same story really. Victor was also visiting London, so Ollie put him in touch with me and just like that, we became good friends, and have travelled to countless other countries since.

← **Altstetten, Switzerland** My favourite and most memorable photo from Switzerland. On the first day we hiked for about 13 hours in total, and this was the view towards the end of the hike.

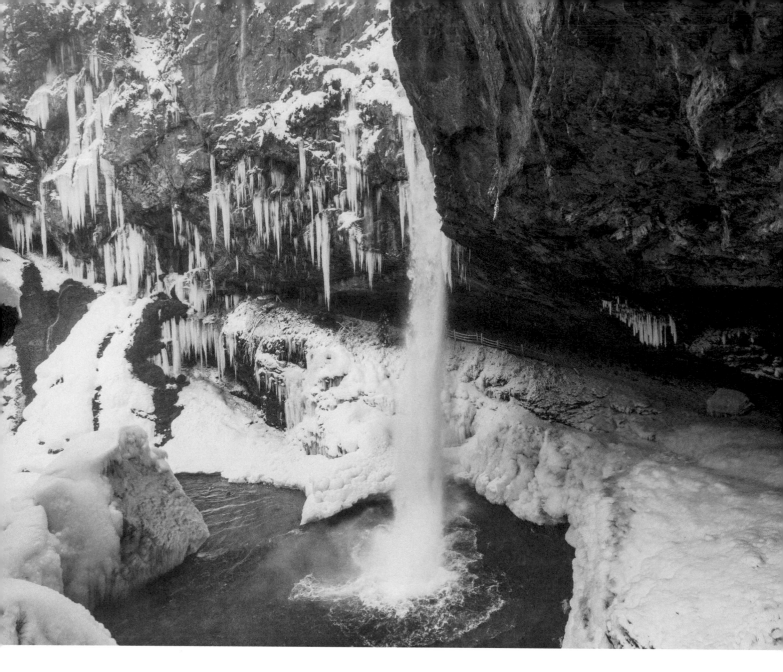

↑ **Linthal, Glarus** Seeing a half frozen waterfall was a sight I'll never forget. I climbed up the thin mountain path covered in snow, then crawled away from the glaciers and was finally able to take this photo and enjoy the view.

↗ **Altstetten, Switzerland** Our first day, at 4 am, it was freezing cold, and completely pitch black. We shared whisky and talk about life on this beautiful island.

" Taking pictures has brought me more than just photos.
I have met some great people. I've explored a great deal,
and as a bonus I get to listen to some fine music
while I'm endlessly editing my photos. "

– Mohamed Abdulle

Quarten, Switzerland It feels like a fairy tale cartoon, with the perfectly untouched snow and crystal clear blue skies.

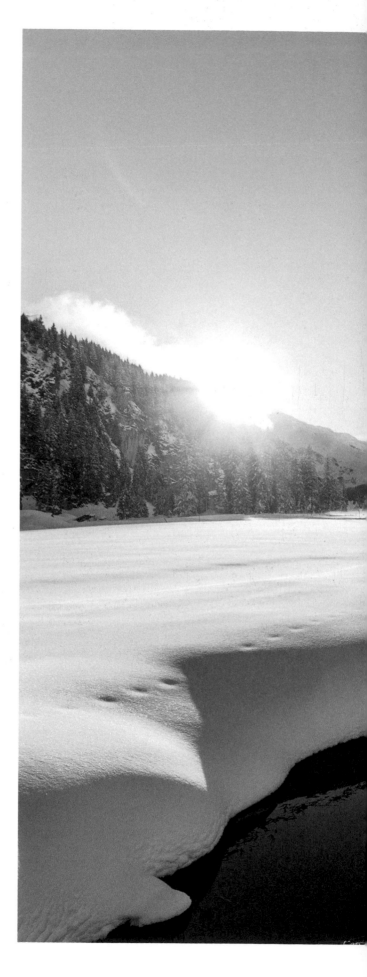

"This might sound random," says Mohamed, "but I went to Switzerland with two guys I never have met before. We became really close. It already sort of felt like family." Together with his two Swiss friends and some other Instagrammers, the British photographer and student started an international collective for young photographers. "It's called 'The World Grammers'," he explains. "It's a Facebook page and an Instagram account where we feature photos we like." Mohamed set himself a goal: "I want to visit a new country each month this year, or maybe even for the rest of my life."

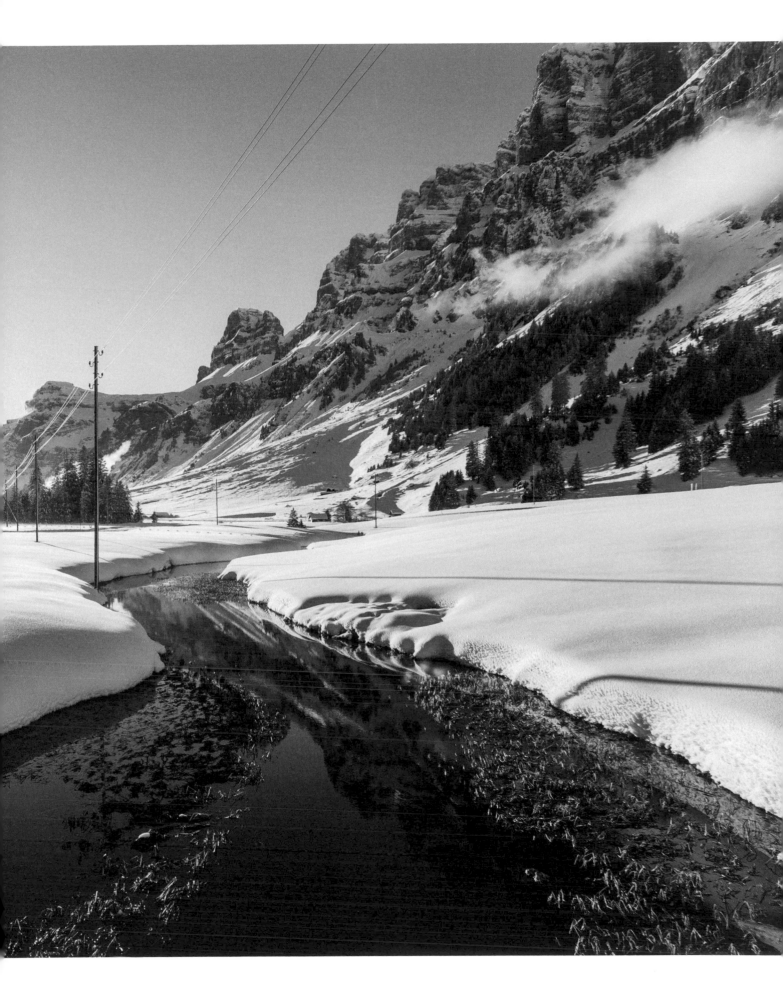

A TURNING

POINT

LOCATION Eikesdalsvatnet - Nesset, Norway **COORDINATES** 62.584912, 8.160299
PHOTOGRAPHER Najim Jansen, Nijmegen, The Netherlands @dailyroutine__

"To me, this was the start of something big," says Najim Jansen about his first ever photography trip outside The Netherlands. "After this trip, I knew that this is what I want to do more often, through photography or not. It truly was a turning point." Najim and his friends visited a friend of a friend in Trondheim, Norway. "He happened to live on a hilltop just outside of the city, next to a beautiful lake," he explains. "From there we drove southwest to the Eikesdalsvatnet Lake, in order to head into the mountains for a hike. "I love to travel. I think it's one of the most valuable things you can do in life. Bringing a camera and capturing your trip is even better — now I have a lasting memory of our journey. Norway's landscape is amazing, the people are lovely and the Norwegian fish dishes are great," Najim continues, "but if you're a student like me, make sure you save enough money for your trip! It's not a cheap country. Oh, rent a 4x4 car, so you can also get to places normal cars can't get to."

Elkesdalsvatnet, Norway That moment you reach the top of the mountain —
there is no better feeling. Take a deep breath and enjoy the view.

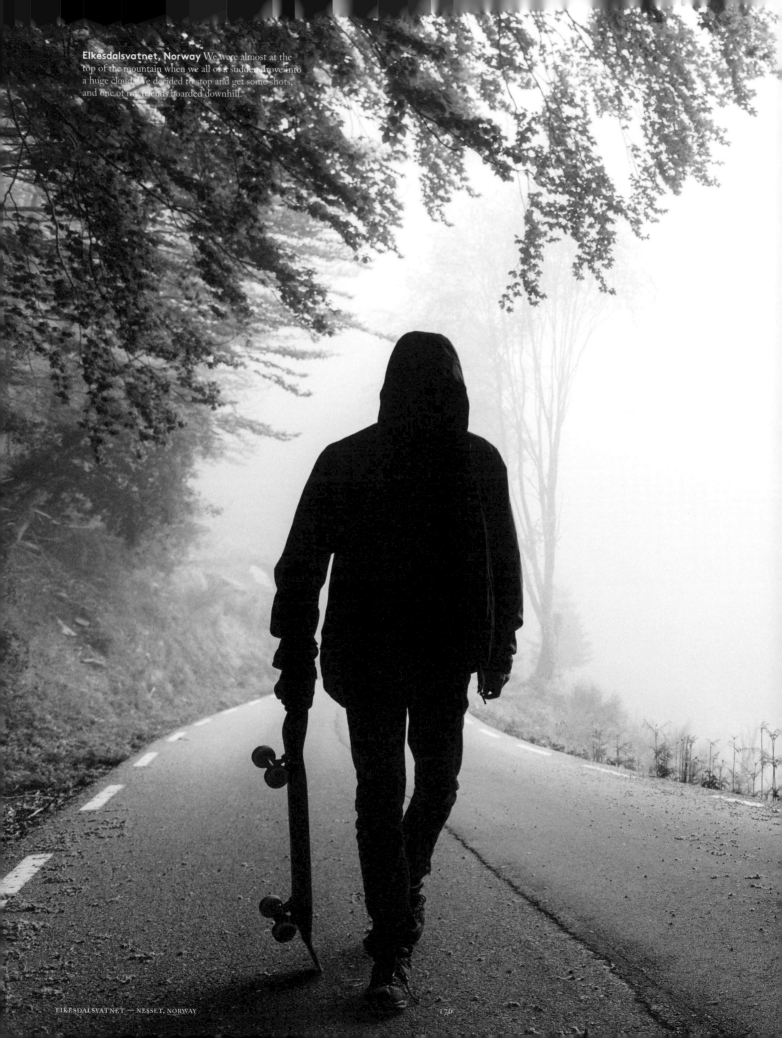

Elkesdalsvatnet, Norway We were almost at the top of the mountain when we all of a sudden drove into a huge cloud. We decided to stop and get some shots, and one of my friends boarded downhill.

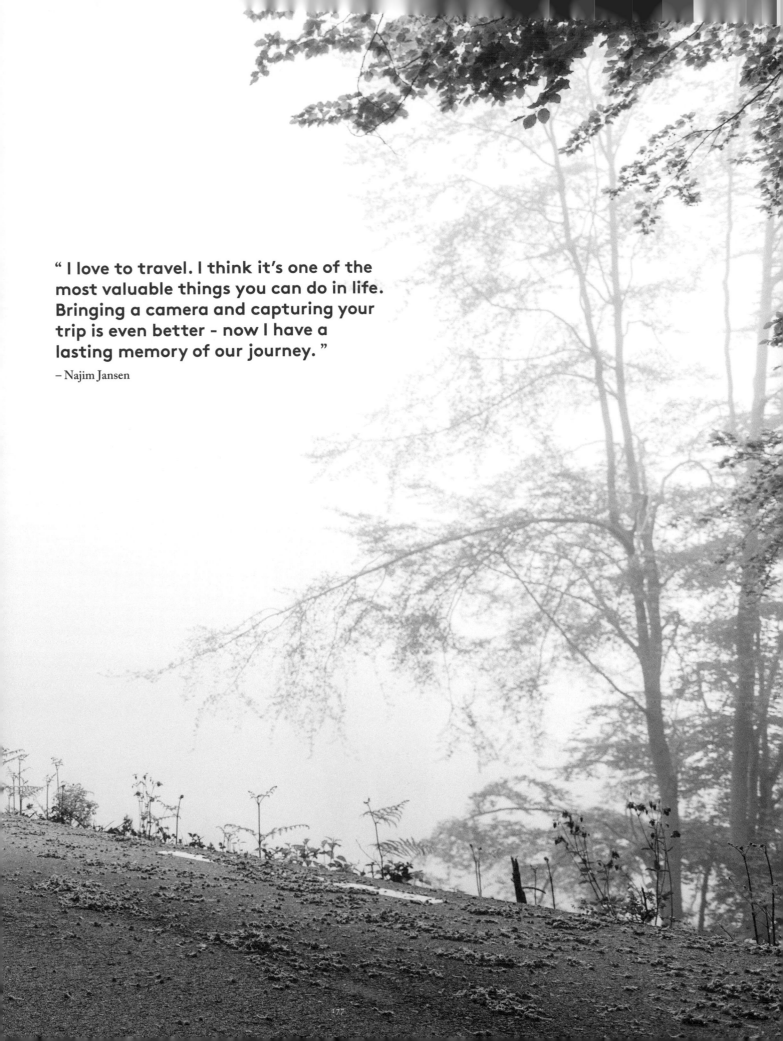

" I love to travel. I think it's one of the
most valuable things you can do in life.
Bringing a camera and capturing your
trip is even better - now I have a
lasting memory of our journey. "

– Najim Jansen

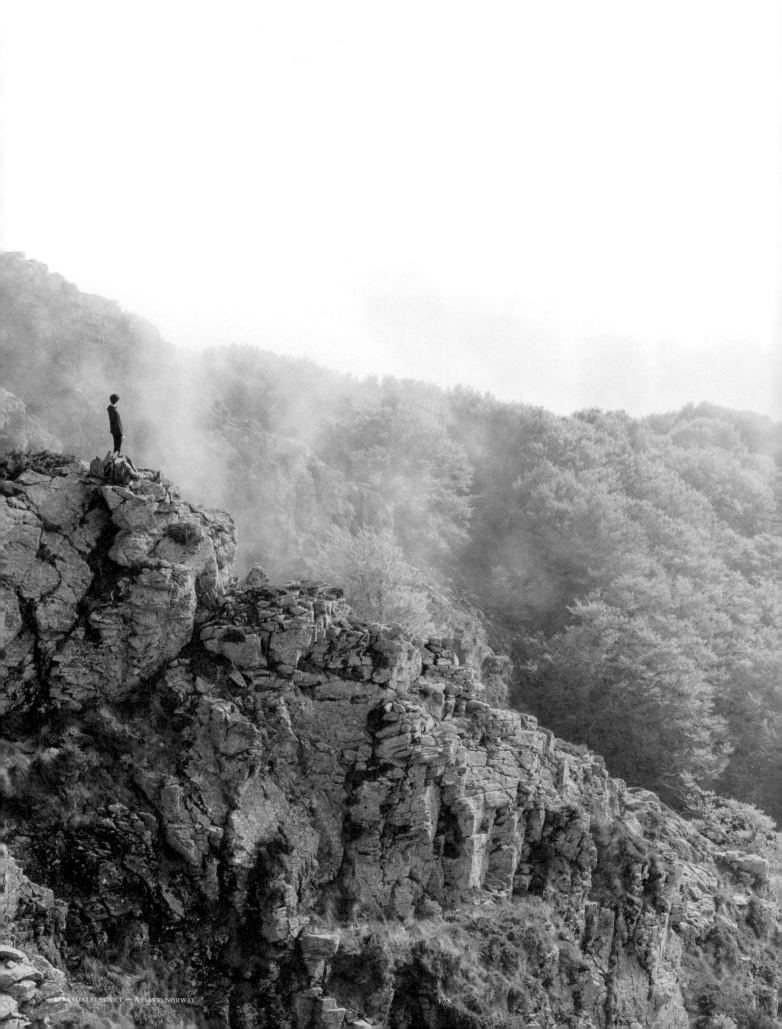

↑ **Eikesdalsvatnet** I took this picture right
before we reached the top of the mountain. It was
still very cloudy, so we couldn't really see or know
when we would reach the top. But we knew we
were almost there.

← **Eikesdalsvatnet, Norway** When we arrived
at the top of the mountain, clouds passed by
quickly and created some amazing textures.

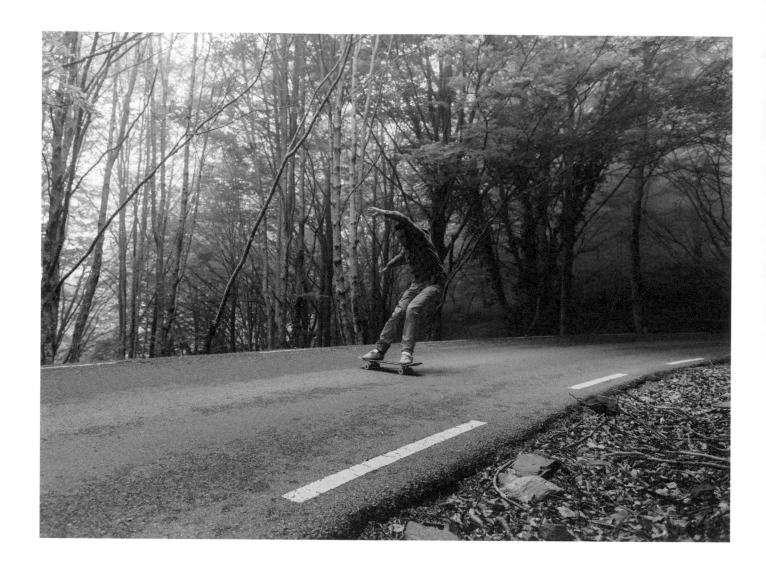

Najim Jansen is a 20-year old photography student from Nijmegen, The Netherlands. He plans to combine travel with taking pictures, "because it's really an eye-opener to experience all those different surroundings and to meet people you can't understand because they're speaking another language," Najim says. Apart from studying and taking photos, Najim is a professional dancer. "I'm specialized in b-boying," he says, "I've been performing in different theaters throughout The Netherlands, and I also do dance battles." He's a member of two "crews": "Concrete Jungle" and "Hidden Artifacts".

Elkesdalsvatnet, Norway During a break from driving around, we had some fun skating down the mountain.

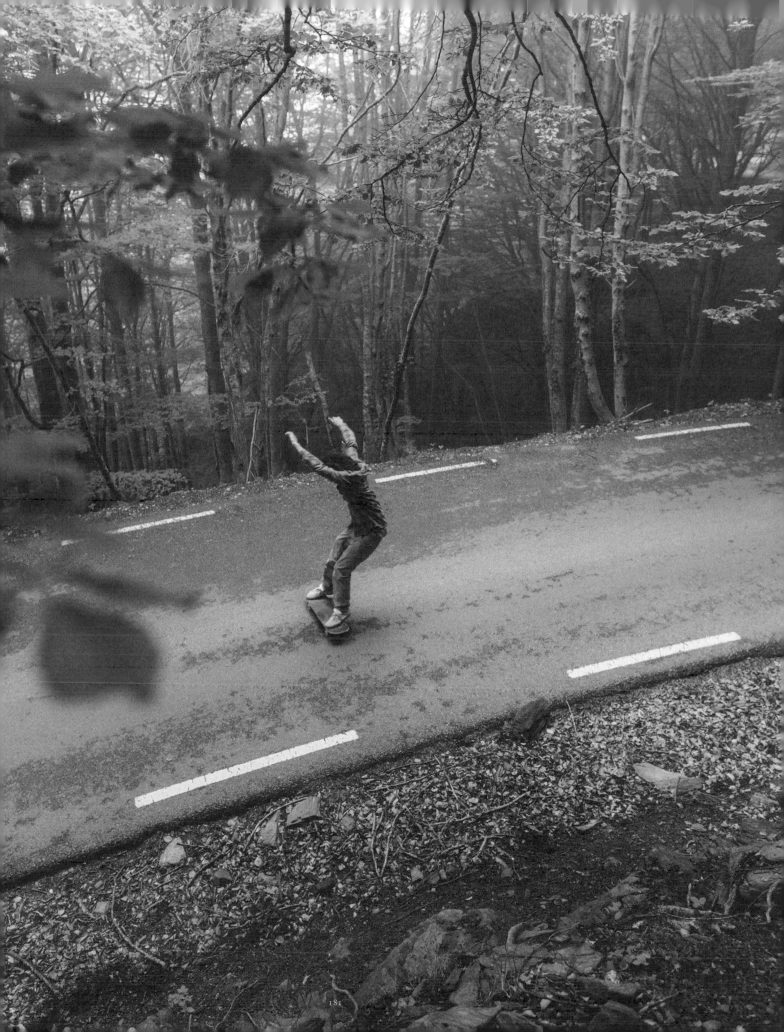

Eikesdalsvatnet On top of the hill.

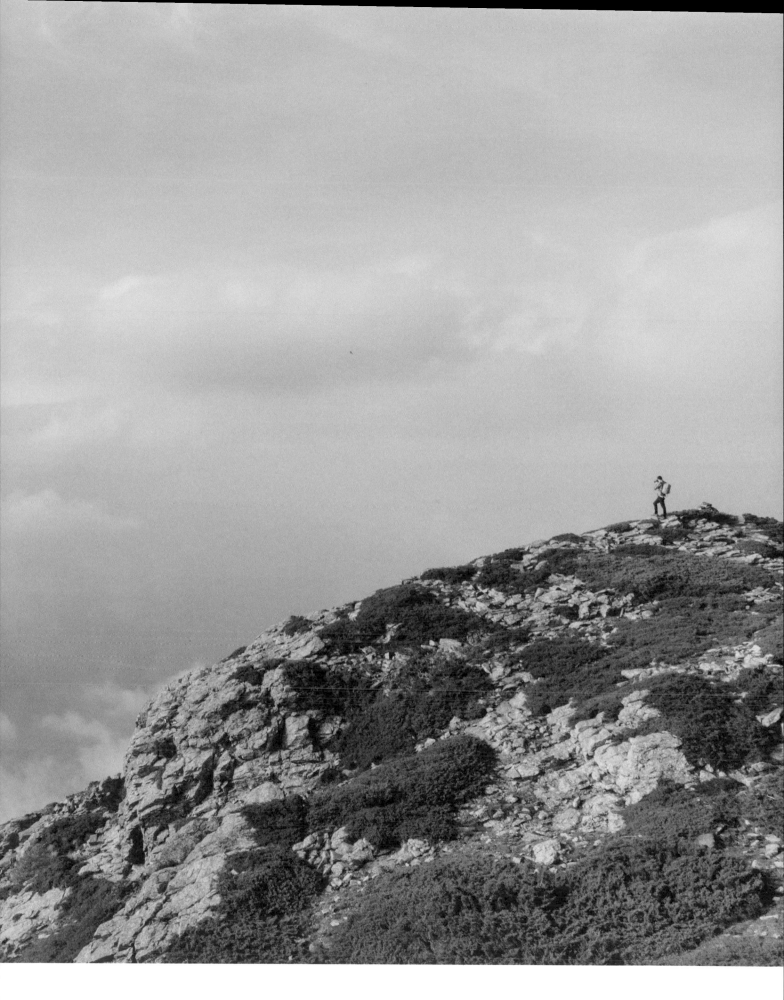

A sense
of
scale

When it's captured on your camera, that huge mountain or vast landscape might not look as majestic as it does in real life. One of the hardest parts of taking a good photo is creating depth, proportion and a sense of scale. There are a couple of tricks, though, that the new photographer often uses to show how insanely big and overwhelming or intimidating nature can be. Use a wide angle lens, and ask that bright-colored jacket-clad fellow traveler to get far away from you until you can just barely see him. Place him or her against the sky, or right before a lake, and voila: your picture-perfect shot is fit to post online. Don't forget the hashtags!

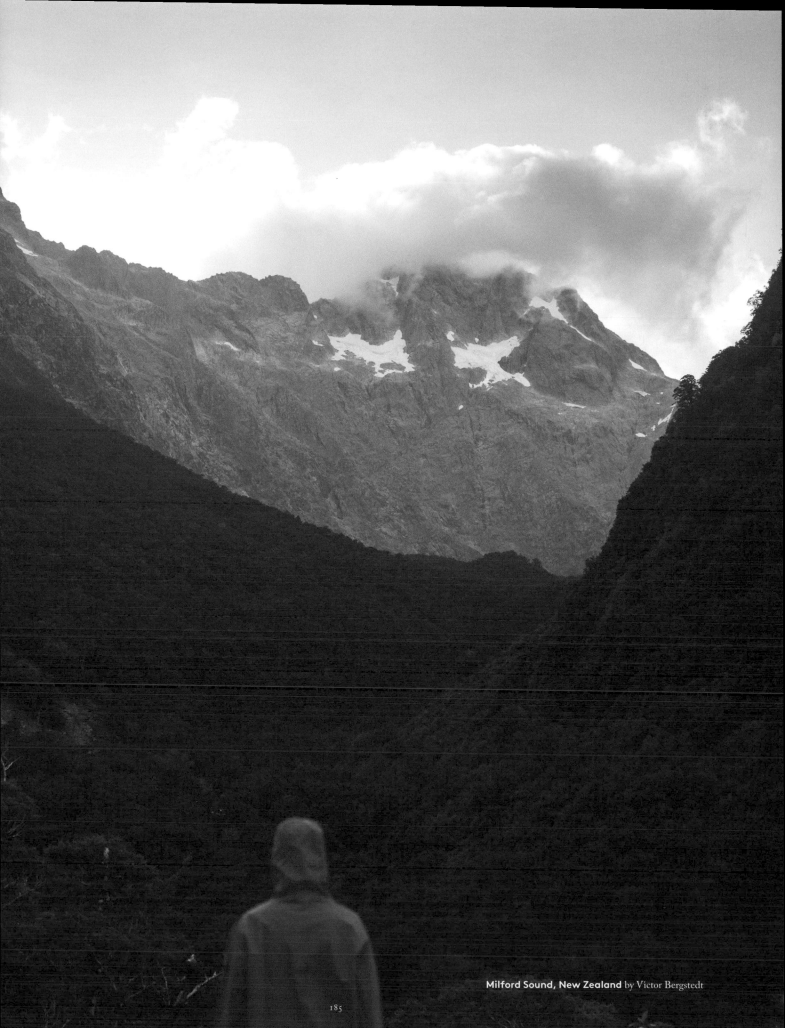

Milford Sound, New Zealand by Victor Bergstedt

SHIFTING COLORS

LOCATION Antelope Canyon, Arizona, USA **COORDINATES** 36.862307, -111.374330
PHOTOGRAPHER Julian Castaneda, Uppsala, Sweden @meetjulian

"It was a blessing, traveling along America's West Coast. Like therapy for the soul," says Swedish photographer Julian Castaneda. In the Summer of 2016, he was invited by an American company to teach a group of aspiring photographers some handy tips and tricks, while traveling through the States. "It felt great to help out a little when somebody needed a helping hand on how to shoot a specific picture. Plus, the places we all got to see were out of this world." When Julian visited the Antelope Canyon, he had already seen some photos and videos of its caves. "But I'm not lying when I say that it felt like a blessing to be there in real life," he says. "The pure sand with the soft but strong light shining through into the slot canyon was mind-blowing - truly magical." Julian didn't even edit his shots a lot: he captured the colors of the caves with his camera's RAW mode. "They were shifting from really strong orange to soft, faded purple. I've never seen anything like it in my whole life. I recommend that everyone visits this place, at least once in your life."

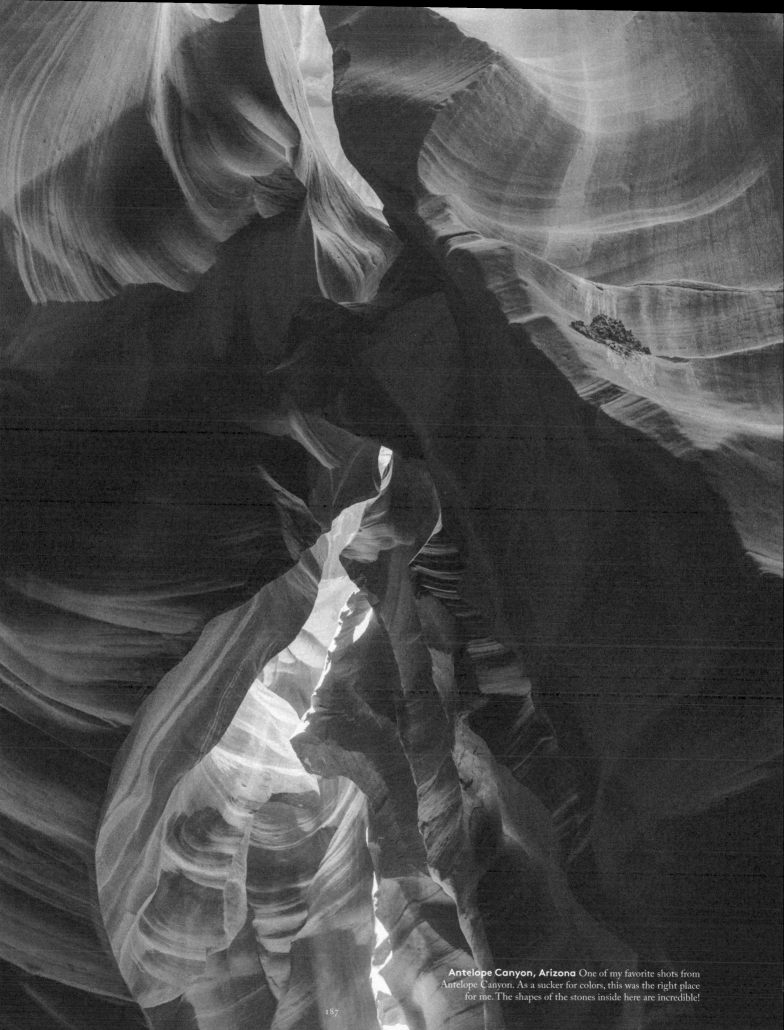

Antelope Canyon, Arizona One of my favorite shots from
Antelope Canyon. As a sucker for colors, this was the right place
for me. The shapes of the stones inside here are incredible!

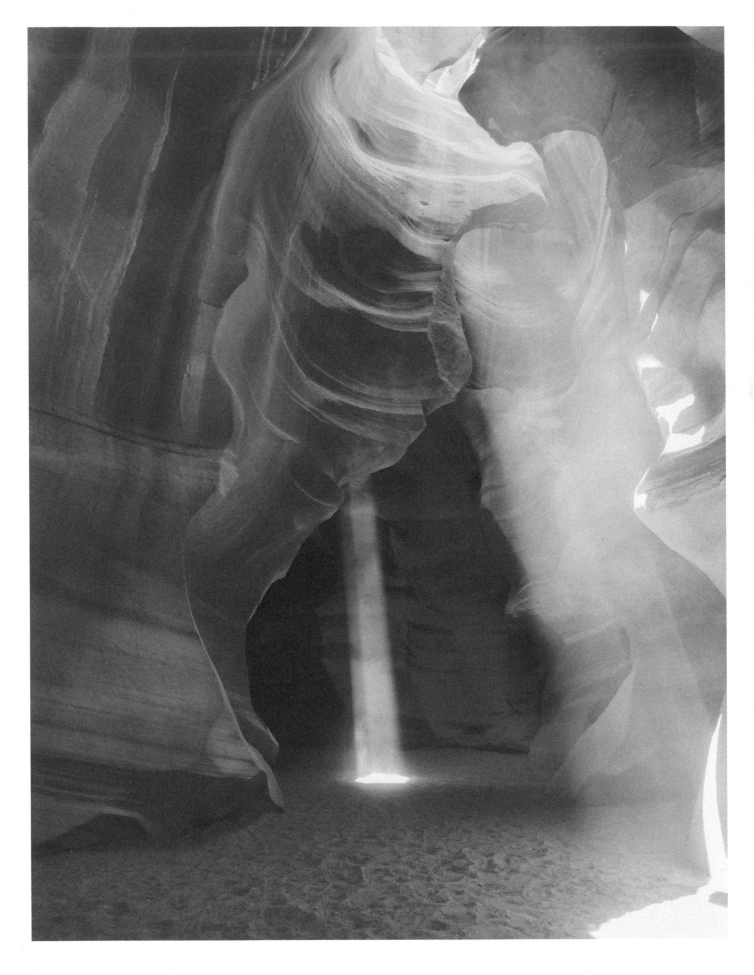

ANTELOPE CANYON, ARIZONA, USA

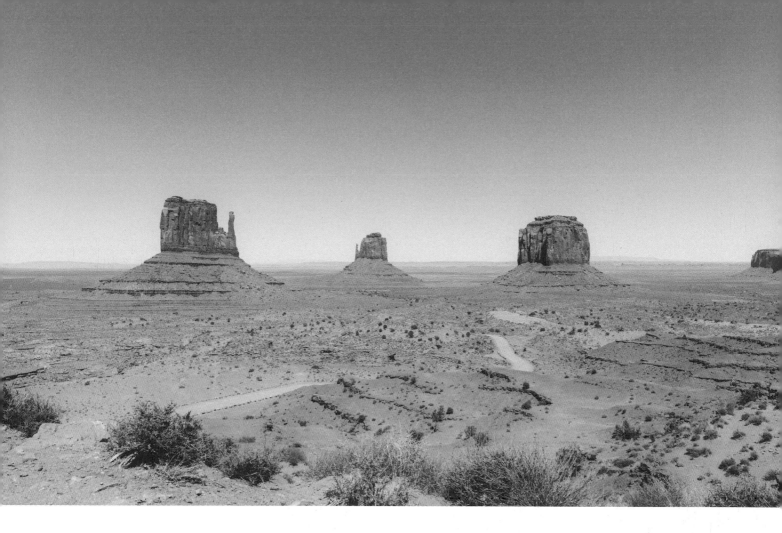

" It was a blessing, traveling along America's West Coast. Like therapy for the soul. "

– Julian Castaneda

↑ **Monument Valley, Arizona** Looking out over Monument Valley made me feel like I was in a movie. The scene felt like it was coming straight out of Lucky Luke. Something to remember.

← **Antelope Canyon, Arizona** Pure light shining through the caves of Antelope Canyon.

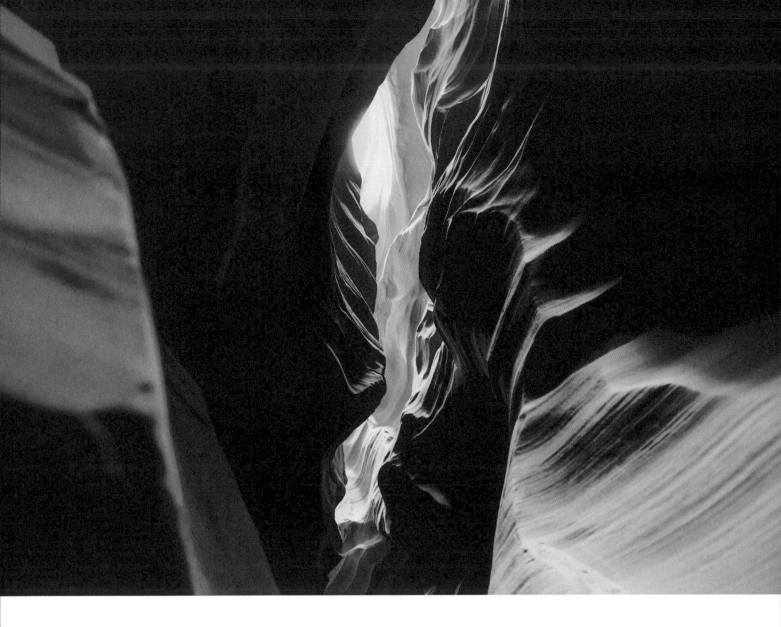

↑ **Antelope Canyon, Arizona** Natural eye candy inside the caves of Antelope Canyon.

↗ **Antelope Canyon, Arizona** We spent more than one hour in the caves, and even though it was very hot out in the desert, the trip to the canyon was totally worth it!

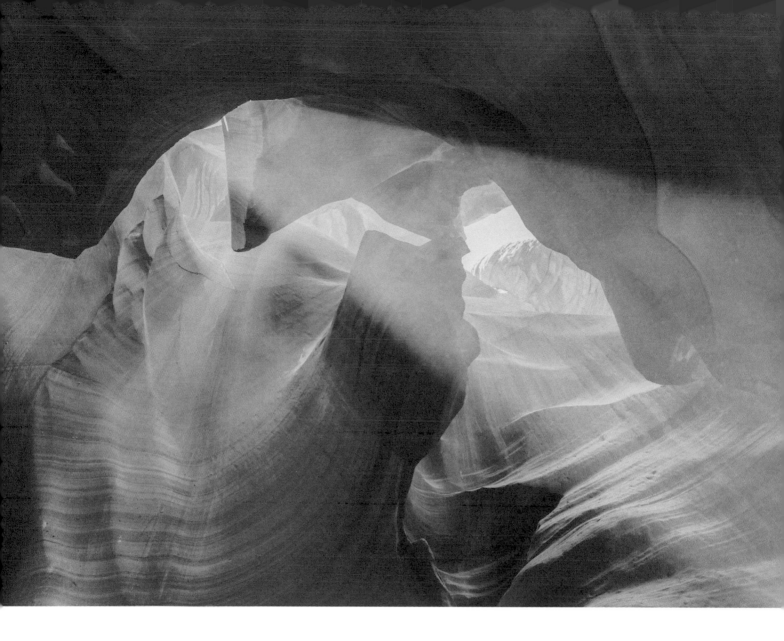

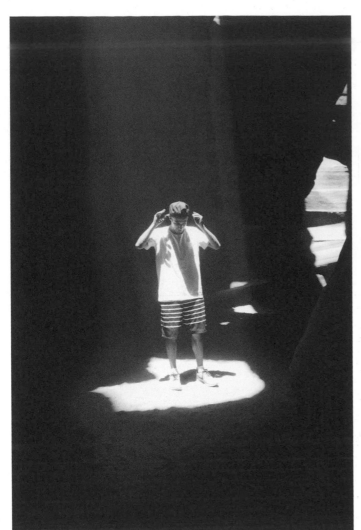

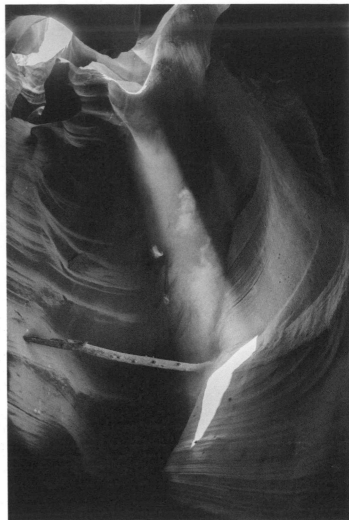

↑ **Antelope Canyon, Arizona** A self-portrait inside
Antelope Canyon. A must!

↗ **Antelope Canyon, Arizona** If someone told me
there is a place on earth that would make me feel like
I was in heaven I wouldn't have believed it. Until now.
Antelope Canyon is that place. I can't describe in words
the atmosphere inside these magical caves.

→ **Antelope Canyon, Arizona** A pure purple tone
from the stone showed up inside one of the caves.
Mind blowing!

Even though the 31-year old Julian Castaneda wasn't really into photo-
graphy, his life changed when he downloaded the Instagram app. "Back
in 2011, I saw what people could do with only an iPhone. I was amazed,
and started taking pictures myself. I used my creativity to push myself,
to take better pictures," he says. Five years later, Julian has gathered
nearly 300.000 followers from all over the world, and he works together
with big international brands.

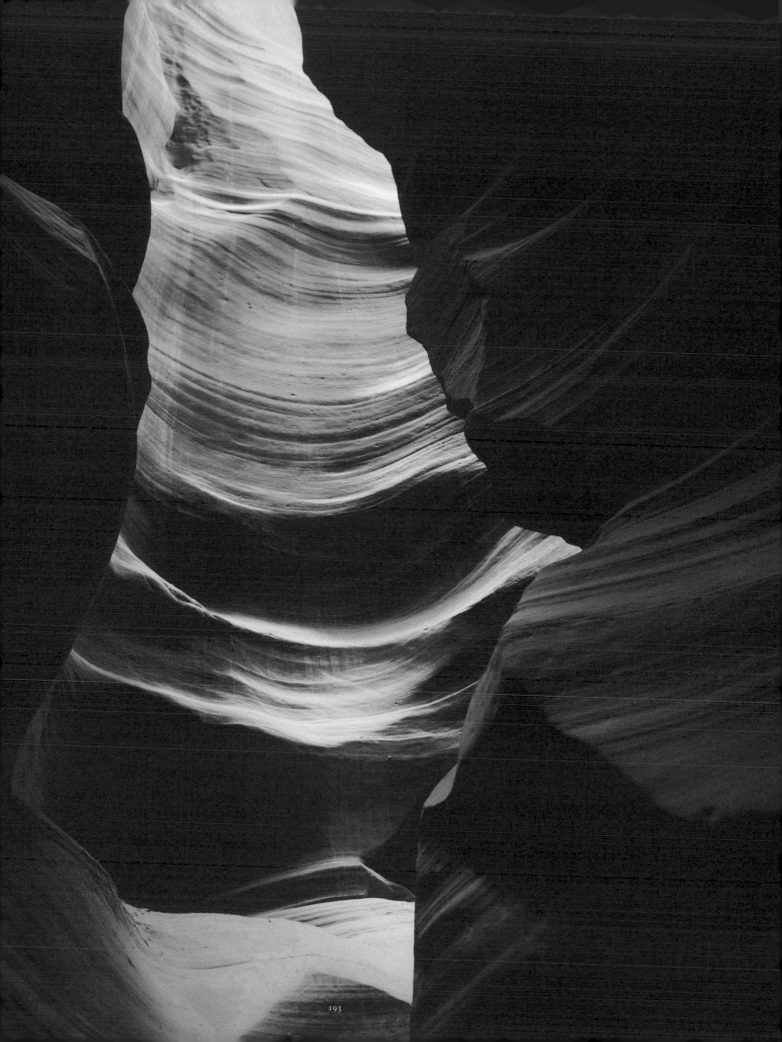

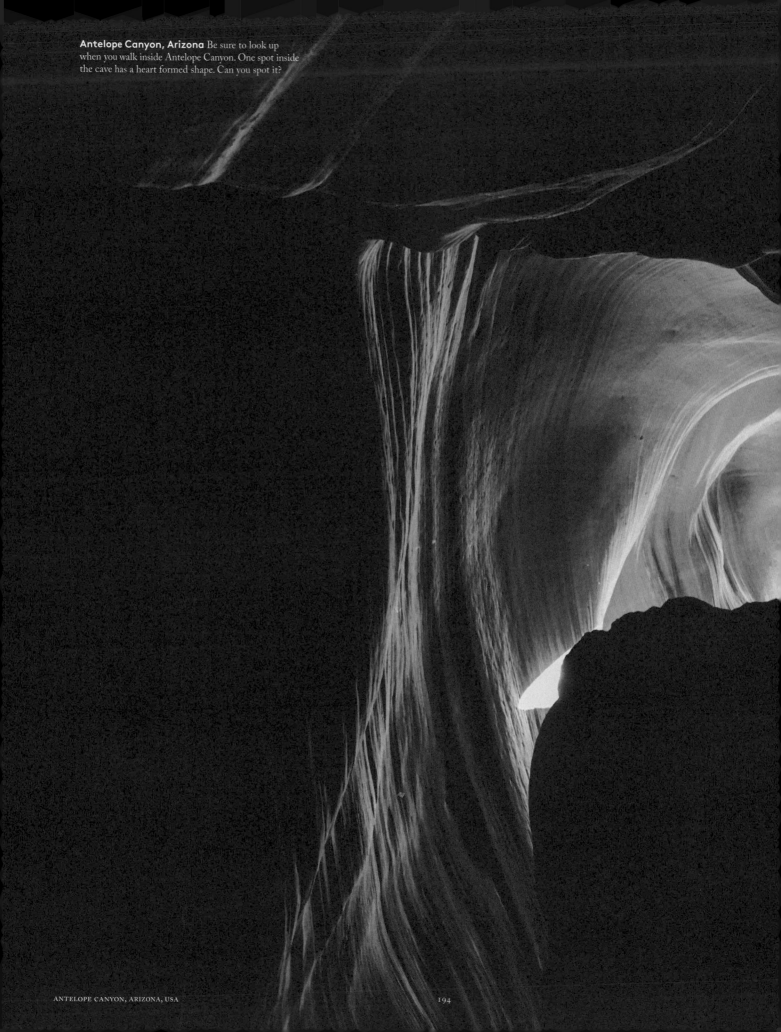

Antelope Canyon, Arizona Be sure to look up when you walk inside Antelope Canyon. One spot inside the cave has a heart formed shape. Can you spot it?

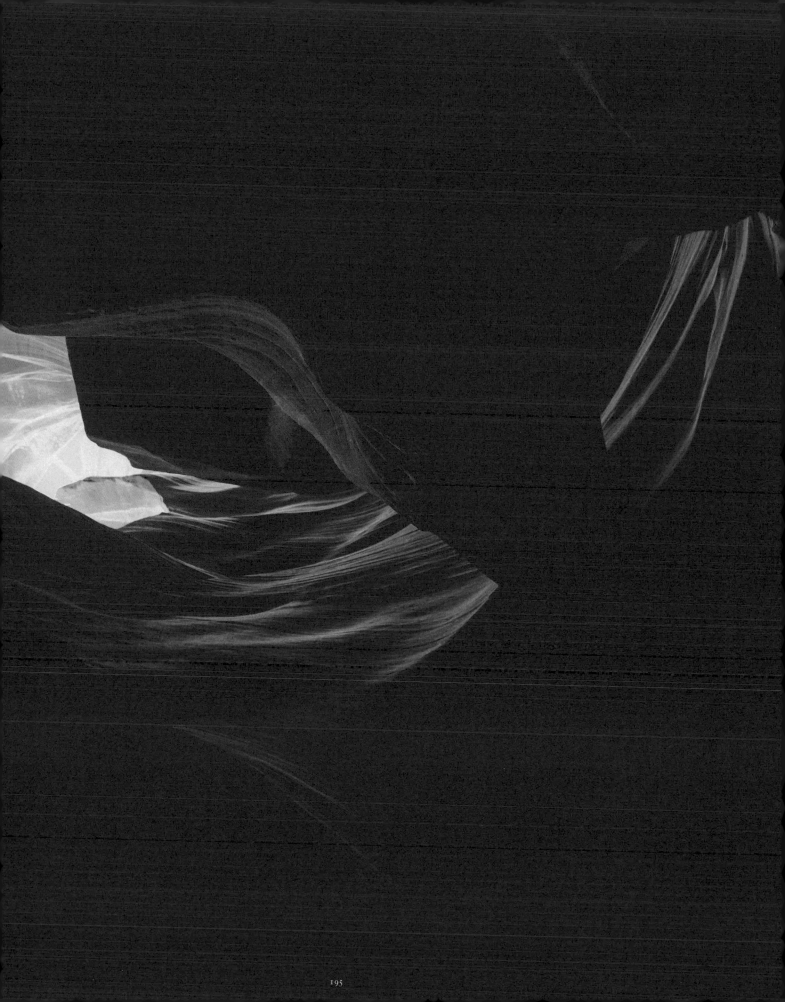

COUNTRY OF CONTRASTS

LOCATION Galápagos Islands & Equador, South America **COORDINATES** 0.325240, -89.958063

PHOTOGRAPHER Roel Ruijs, Amsterdam, The Netherlands @roelservice

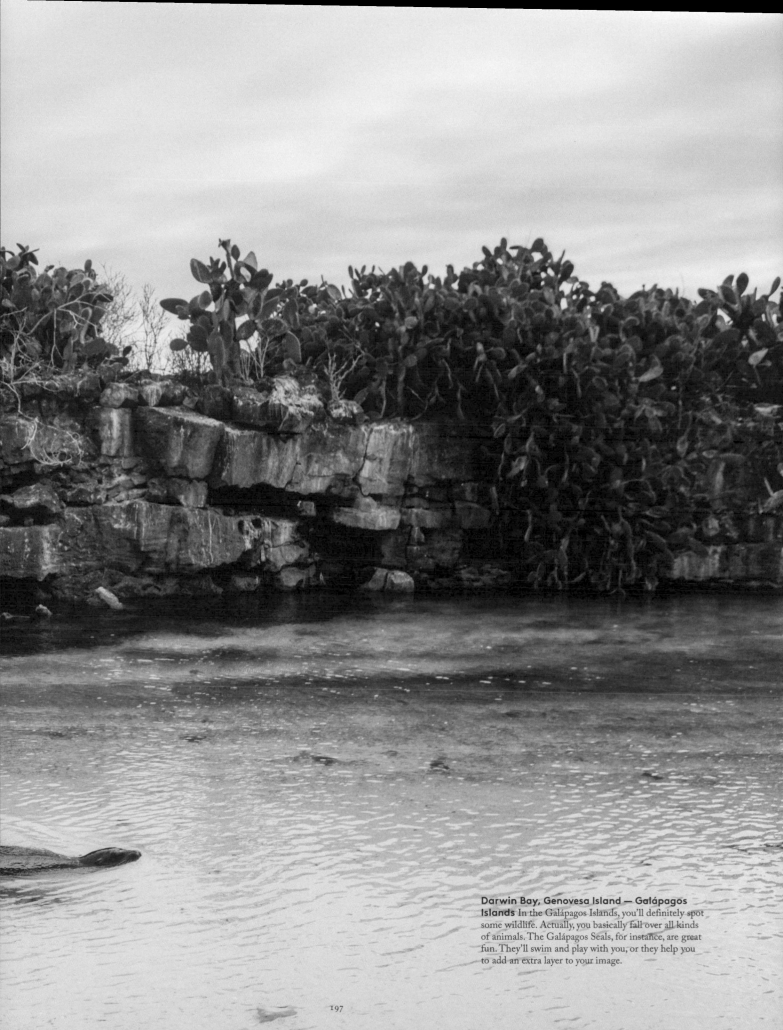

Darwin Bay, Genovesa Island — Galápagos Islands In the Galápagos Islands, you'll definitely spot some wildlife. Actually, you basically fall over all kinds of animals. The Galápagos Seals, for instance, are great fun. They'll swim and play with you, or they help you to add an extra layer to your image.

Both passionate about photography, Roel Ruijs and his friend Floor packed their backpacks and headed to the Ecuadorian Galápagos Islands, "in search of that perfect photo." Roel likes Ecuador, "though it is a country full of contradictions," he says. "Quito, for instance, Ecuador's capital, is a huge place where it isn't safe outside as soon as evening falls. Even if we needed to go two blocks down the street, we had to take a cab. Almost every building is half-built, and there is a lot of poverty. But Quito also offers stunning views on the Cotopaxi Volcano, and as soon as you leave the city you're surrounded by stunning nature. We drove two hours to Mindo, for instance, where we spotted a huge variety of the most beautiful exotic birds. These contradictions are a photographer's dream," Roel says, "they're what made our trip so great. You can shoot a variety of images, and you're faced with all kinds of challenges. The world we live in is formed by both nature and human hands, so it's great to document both. In the Galápagos, though, everything is regulated. You can't just go to an island and shoot a beautiful sunrise. There are visiting times and specific visiting areas, so nature is disturbed as little as possible. That sometimes means that you have to shoot that perfect image in some harsh Ecuadorian sunlight. But you always can, because yes, the Galápagos Islands are that beautiful."

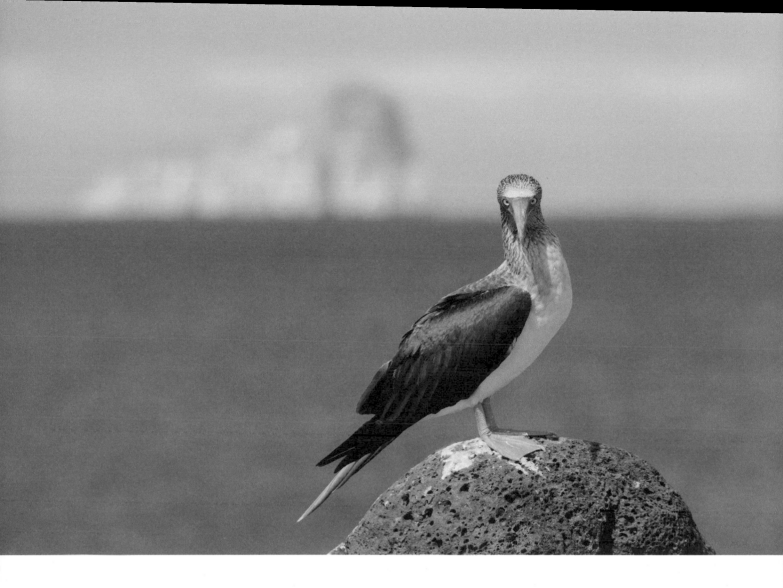

↖ **Bachas Beach — Santa Cruz Island, Galápagos Islands** I can only imagine how amazed Charles Darwin must have been when he visited the Galápagos Islands. Every island has a different landscape and its own specific plants; in this case cactuses. The first island where we disembarked, this was the first image I took. I knew immediately: this is going to be a special trip.

↑ **Lobos Island, Galápagos Islands** When I took this picture, I promised this blue-footed booby I'd make him famous, in return for the most seductive look he has. And well - here we are!

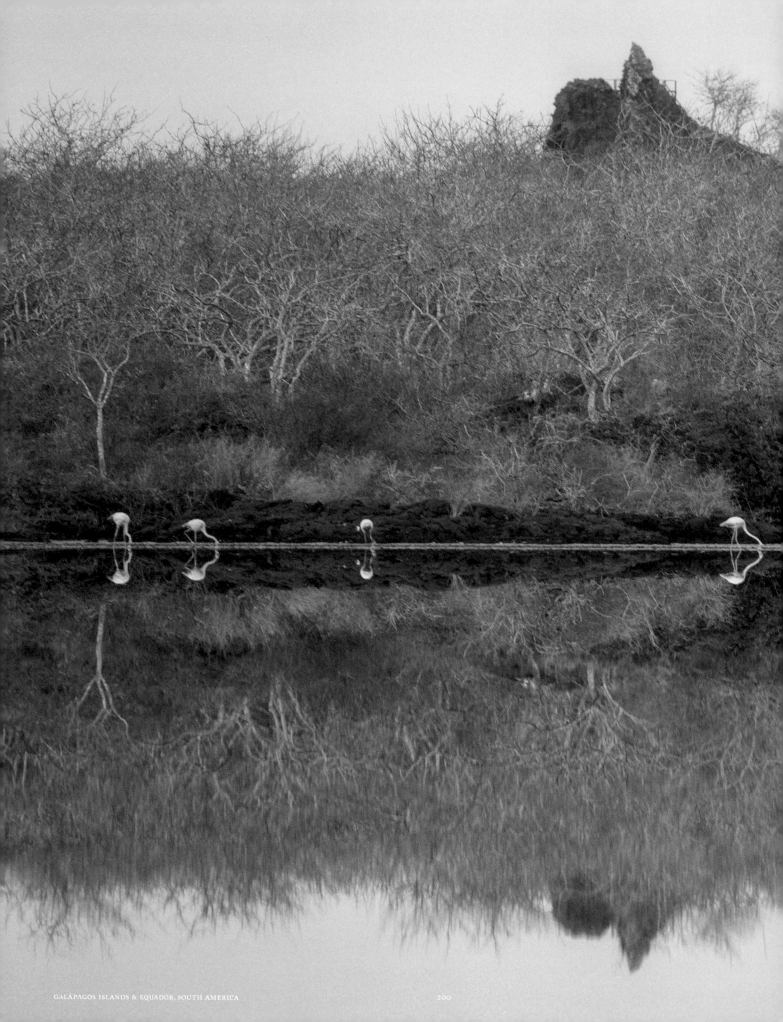

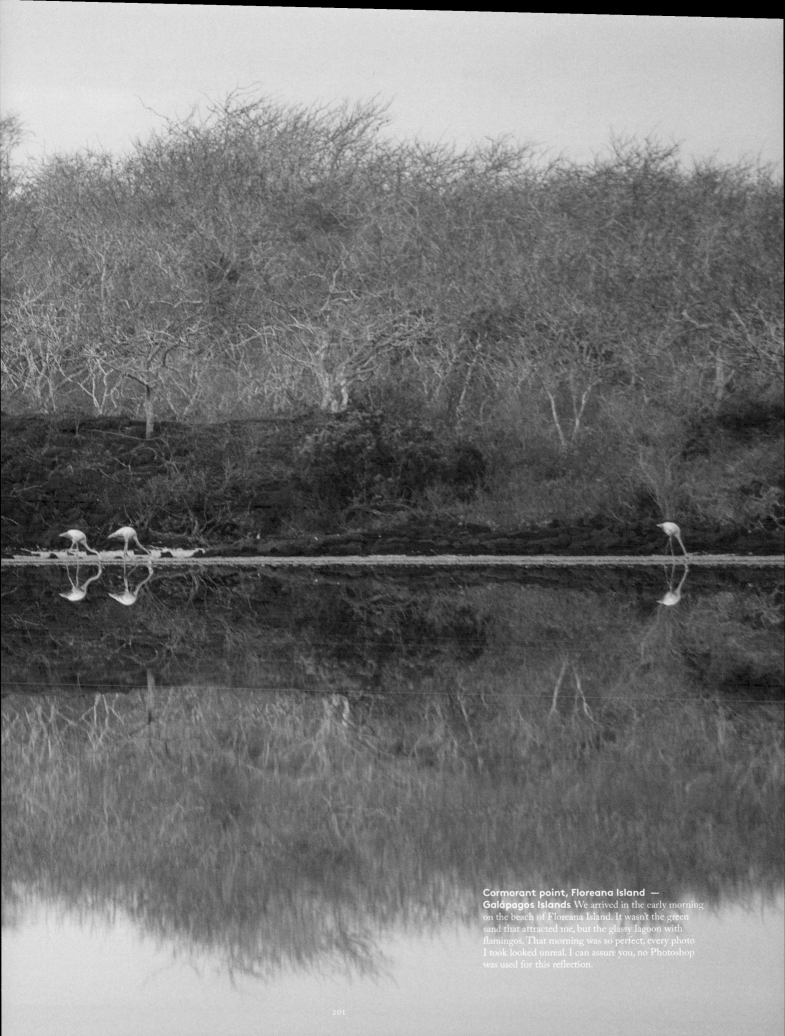

**Cormorant point, Floreana Island —
Galápagos Islands** We arrived in the early morning
on the beach of Floreana Island. It wasn't the green
sand that attracted me, but the glassy lagoon with
flamingos. That morning was so perfect, every photo
I took looked unreal. I can assure you, no Photoshop
was used for this reflection.

↑ **Baños, Ecuador** Back in the more crowded and
touristy surroundings, after all the hikes and adventures,
Floor treated herself to a pedicure, which gave me some
time to take it to the streets. The colours and beautiful
people really make it an ideal photography spot.

↗ **Isla Isabela, Galápagos Islands — Ecuador**
Isla Isabela is the biggest island of the Galápagos, and
one of the three inhabited islands. It features only
one sand road and one village, where you really need
to bring cash. You can't pay with plastic. Wandering
around during the "golden hour" makes this magical
place even more breathtaking. Make sure to finish at
Bar de Beto!

" The world we live in is formed
by nature and human hands,
so it's great to document both. "

– Roel Ruijs

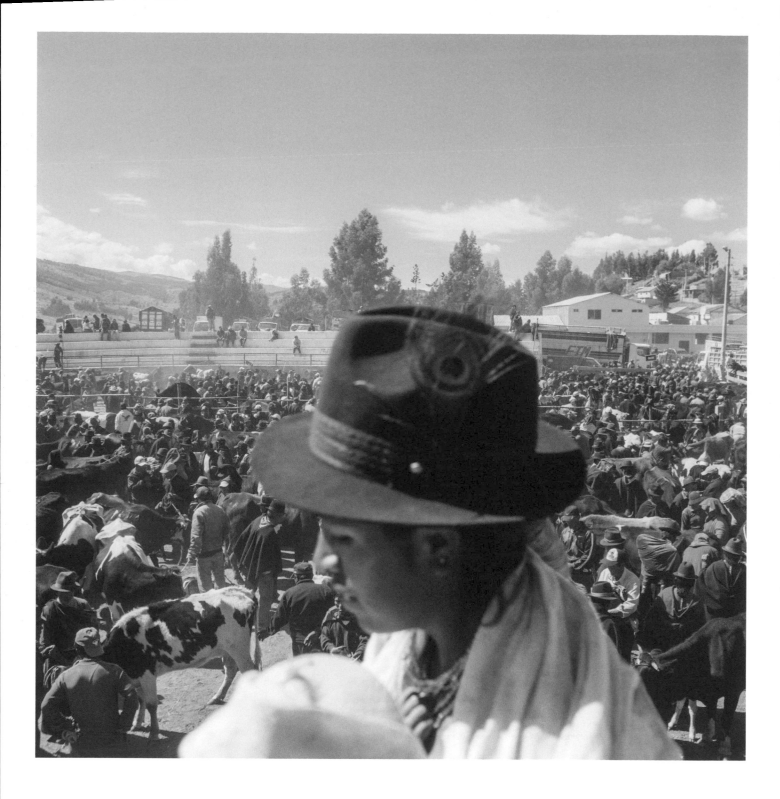

↑ **Guamote, Ecuador** The Thursday market in
Guamote is for sure one of the most impressive
markets in the world. There were thousands of locals
and only eight tourists around.

↗ **Guamote, Ecuador** Visiting Guamote is as if
you're going back in time, with its indigenous people
in their colourful traditional clothing. It's like portrait
heaven. But locals believe that when you take a photo-
graph of them, the camera steals a bit of their soul. So
respecting that wish was a bit of a challenge, when I
wanted to get that shot I was dreaming of.

Roel Ruijs always was impressed by cameras, but he really got into
photography when the digital era dawned. "Digital made it possible to
practice a lot," he explains. "I took a picture of everything I saw. As a
photographer I love to witness everything around me, to be somewhere
without anybody noticing me, while I'm capturing every detail. I really
like clean photography. Composition is key. I have no need to change
the world, but if I can entertain people with some of my images, I would
be happy to do so. I'm certainly entertaining myself."

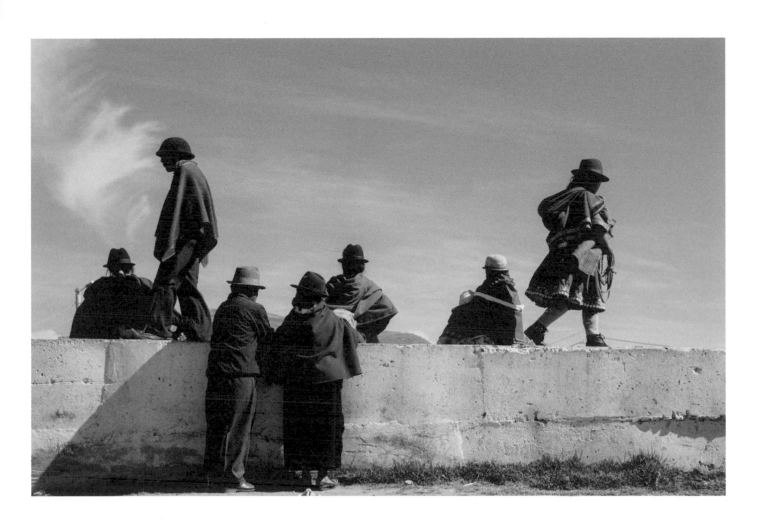

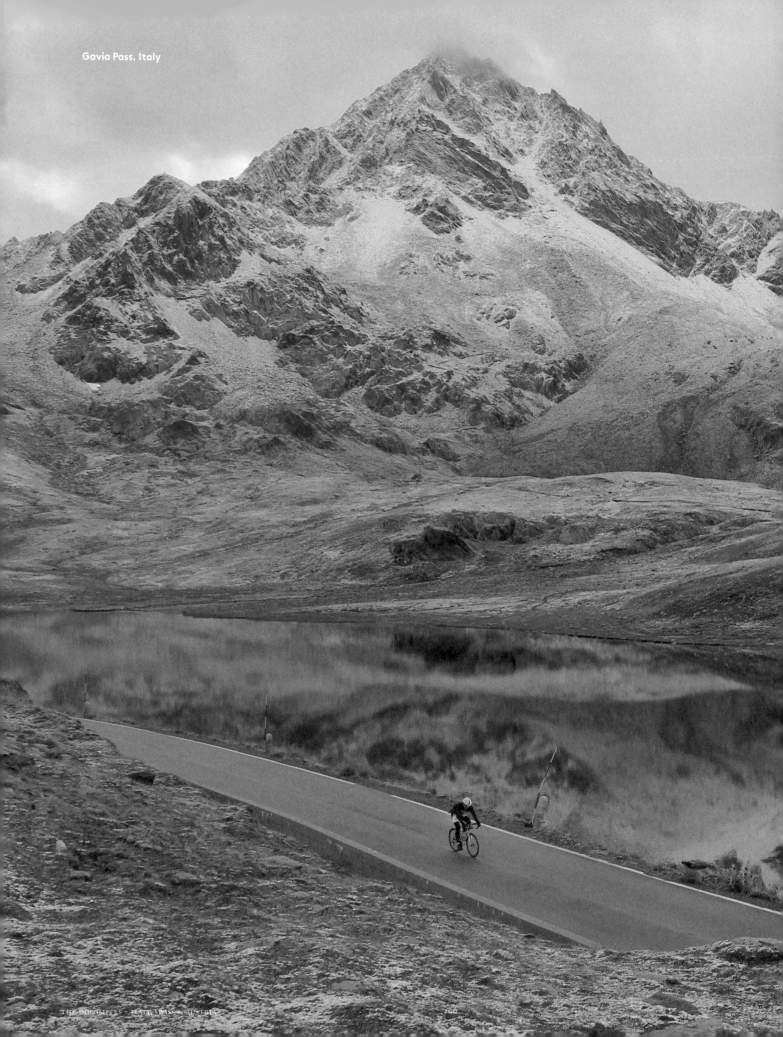

THE
DOLOMITES
DELIVER

LOCATION The Dolomites - Italy, Swiss & Austria **COORDINATES** 46.411984, 11.843777
PHOTOGRAPHER Tristan Bogaard, Bergen, The Netherlands @tristanbogaard

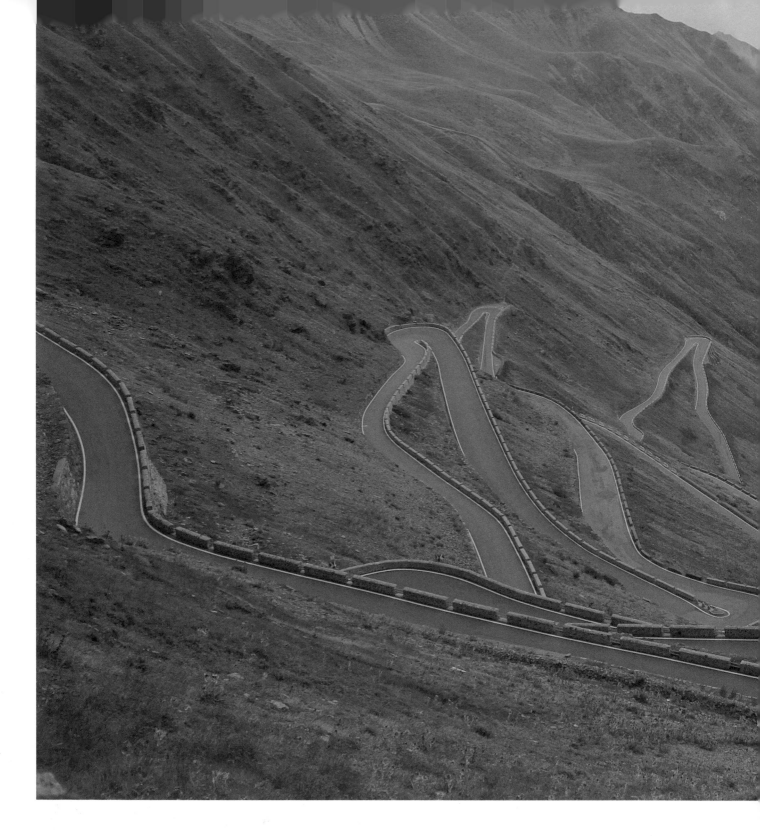

"In April 2015, I set out to cycle twelve thousand kilometers through Europe, in a search for inspiration, treasure and thrill - and I can certainly say, this place delivered it all." Dutch photographer Tristan Bogaard visited the higher Italian Alps and kept on cycling until he reached the top. "Treasure hid itself at the top and thrill came in the descent, after the hard and burning climb - not to mention the staggering views," he says. "I had cycled across countless places and met an even larger number of people throughout the eight months it took me to reach the Dolomites, but my days there were fundamentally different from the rest," Tristan continues. "I stayed with a lovely Italian family who adored my enthusiasm for the place. They left me the house for the weekend and got me in touch with a friend of theirs. Together we toured each corner of the park, capturing every striking place we could find. And so, discovering this haven of natural beauty has been one of the highlights of my ride, since behind every Dolomite bend, a new perspective awaits."

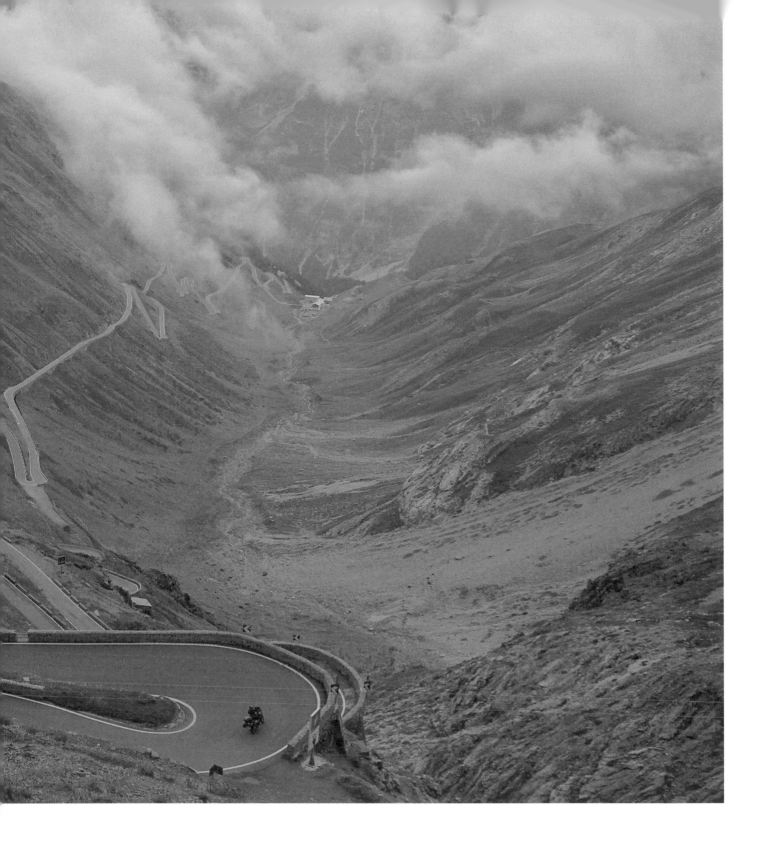

↑ **Stelvio Pass, Italy** Climbing the Stelvio pass by bicycle must be the experience of a lifetime, and seeing the view on top must be the best reward. I was staggered by the way the clouds in the distance wrapped themselves around the peaks, as well as the road wrapping itself around whatever land it grabs on to... this is an awe-inspiring place created by man and nature.

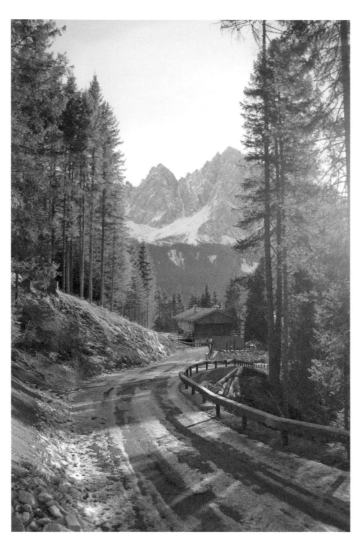

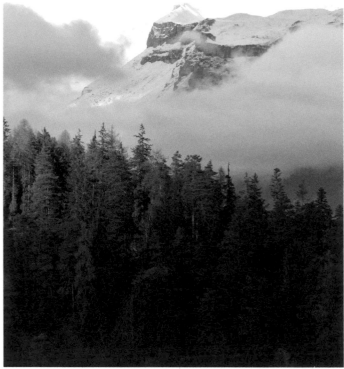

↑ **Costalta, Italy** This photo was captured by complete coincidence, while a friend of my host drove us up an icy path, in his desire to show me a mountain-top view. When he decided not to go further since it would be too dangerous to continue, I stepped out of the car and saw what was behind us. It's refreshing to know how looking back can make you appreciate a situation.

↗ **Swiss Alps** Cycling brings unexpected gifts behind every turn. When cycling a bend on a wet and narrow Swiss alpine road, this mountain presented itself in the distance. Lucky me for having a proper zoom lens.

→ **Misurina Lake, Italy** Lago di Misurina made me feel lucky to be a visitor of the Dolomites during winter, as scenes can change drastically. Seeing this man wandering over the ice, with a backdrop like that made me so happy to be there in that exact moment.

Bergen-based Dutch photographer Tristan Bogaard loves to combine photography with traveling on his bicycle. "Since I first set foot on the pedals of a bicycle, I've thoroughly enjoyed the freedom, playfulness and challenge that it brought with it," he says. He became passionate about photography through the online community of Instagram: "it's something that has changed my life in such a drastic way, that I can call it one of my biggest passions," Tristan says. "I left The Netherlands in order to break my routine. To do, see and experience something new every single day, until I'd be so tired that a fixed routine would comfort me again."

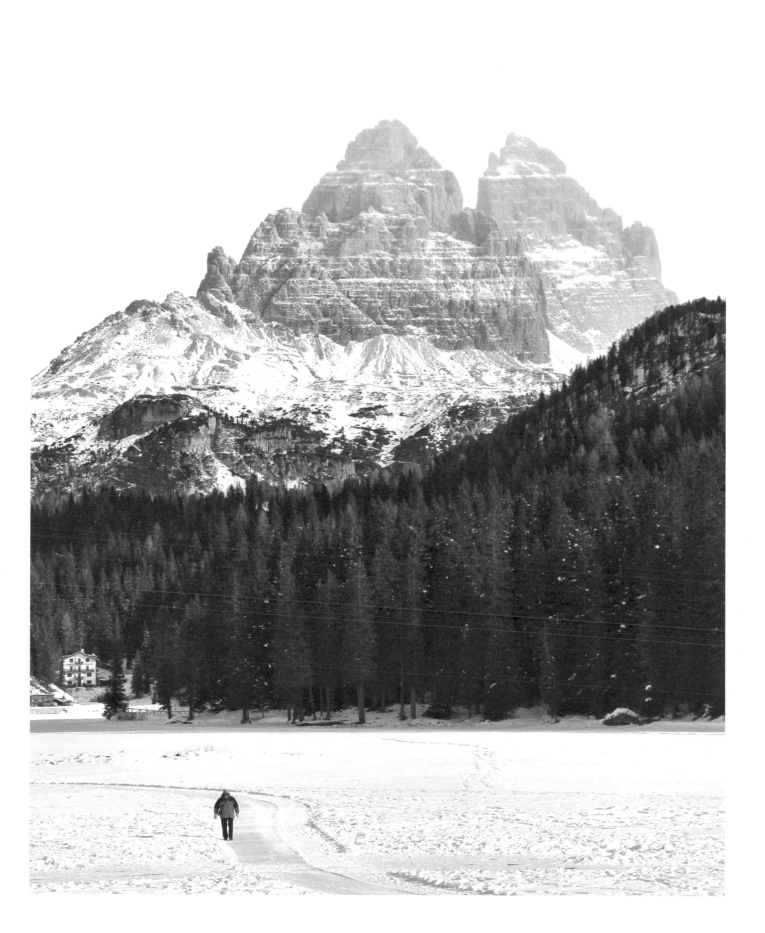

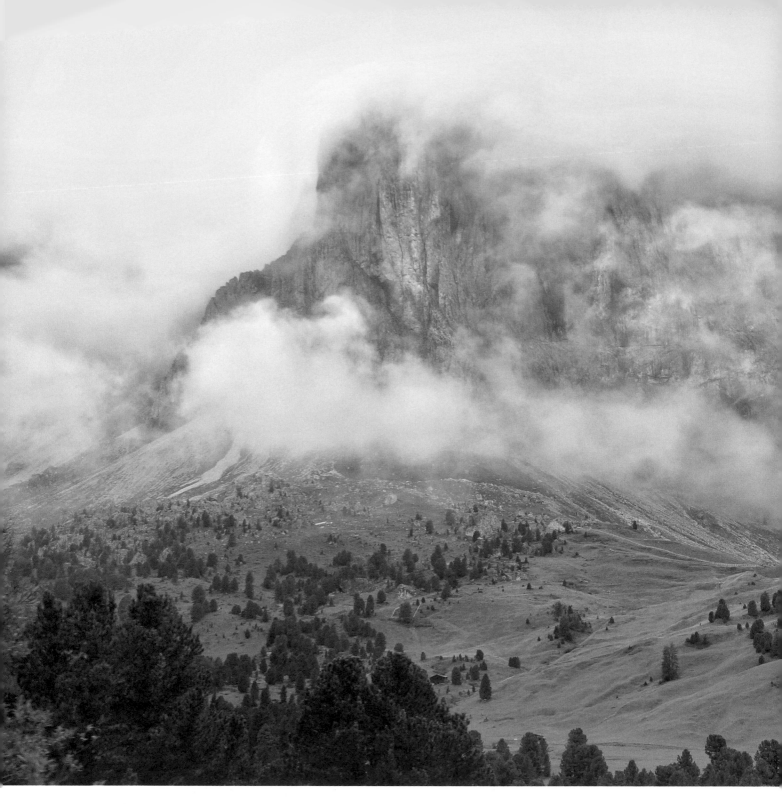

↑ **Dolomite Mountains, Italy** While sitting on the back of a motorcycle, this sight, also part of the Haute Route, came into view, out of nowhere. Shooting a picture at sixty kilometres an hour was certainly something I'd never done before, but as they say, there's a first time for everything…

↗ **Gavia Pass, Italy** One of the things that enchants any place, is something that is not supposed to be there. And, on a ridiculously high mountain pass, the last thing you'd expect someone to bring up is a little red boat. Shot at around 10am, the blues reflected nicely with the clouds, whereas the red made it all the more magical.

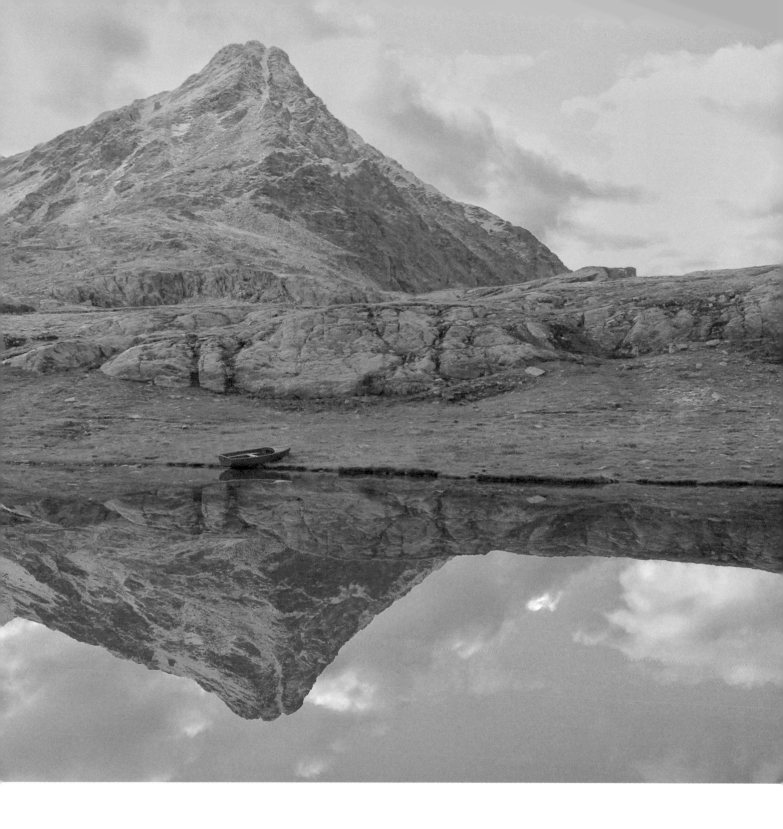

" Treasure hid itself on top and thrill came in
the descent, after the hard and burning climb
- not to mention the staggering views. "

– Tristan Bogaard

AN ENLIGHTENED CITY

LOCATION Sydney, Australia **COORDINATES** -33.856508, 151.215275
PHOTOGRAPHER Ramon Gilbert Klomp, Amsterdam, The Netherlands @ramongilbertklomp

So-called "light festivals" always attract a lot of photographers, but "Vivid Sydney" takes the denominator "light festival" to the next level, as Dutch photographer Ramon Gilbert Klomp saw with his own eyes. Ramon has lived and worked in Australia for a couple of months, and even though he also took pictures of a lot of other places in the country, "Vivid" left quite the impression. "When the festival's there, in Sydney's city center, you simply can't miss it. It's the world's largest festival of light," he says. "The 180 installations can be seen everywhere - spectacular! By night, the city becomes one big experimental playground for photographers, and Instagram blows up with a constant feed of the show. People get really creative." Through Instagram, Ramon met

and became friends with James Dvorak, a local photographer. "We just headed out and experimented with whatever we could find along the way," he says. They ended up going back to the festival seven times: "It's really something you can keep coming back to, experiencing different light set-ups in the smallest back streets throughout the city." Ramon has some practical tips for whoever's planning a visit to the festival: "return on multiple occasions, and during the evening, stay around the Central Business District and walk in the direction of the harbor. This will give you the full experience of spontaneous light setups along your way, but they also have maps in case you get lost. Oh, and make sure to get there early, because the lights are turned off at 10pm!"

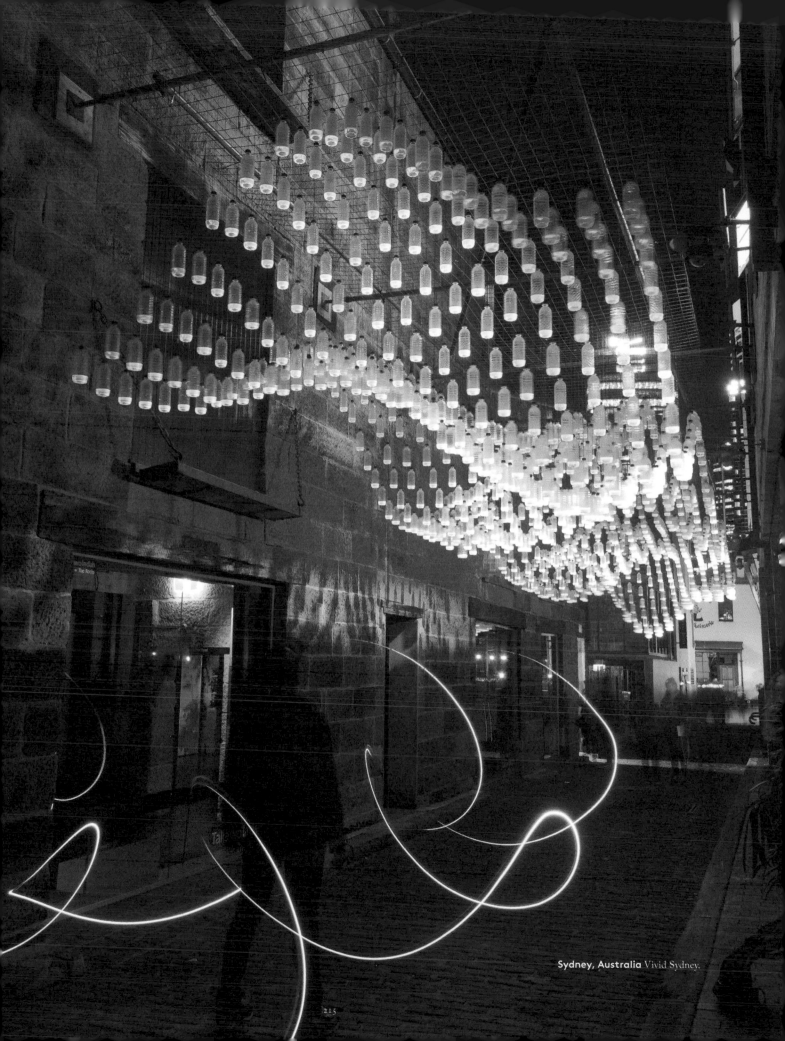

Sydney, Australia Vivid Sydney.

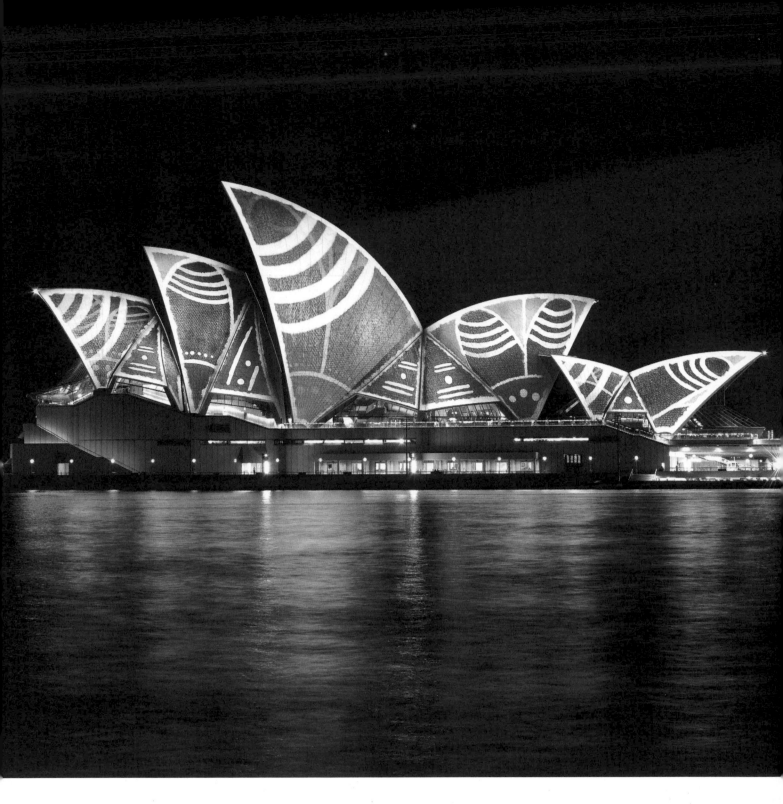

↑ **Sydney Opera House, Australia** During my first visit to Vivid Sydney, I didn't know it would all stop around 10pm, so we had to rush over to this side of the harbor to get a perfect side view angle of the Opera House light show. The patterns on the Opera House are Australian aboriginal art.

→ **Sydney Opera House, Australia** These are Sydney's biggest highlights in one shot. This was a lucky 30 second exposure shot. I took it at 9:59pm, and all of the lights were turned off mid-way my shot. But the camera had caught enough light before that moment, to produce this end result.

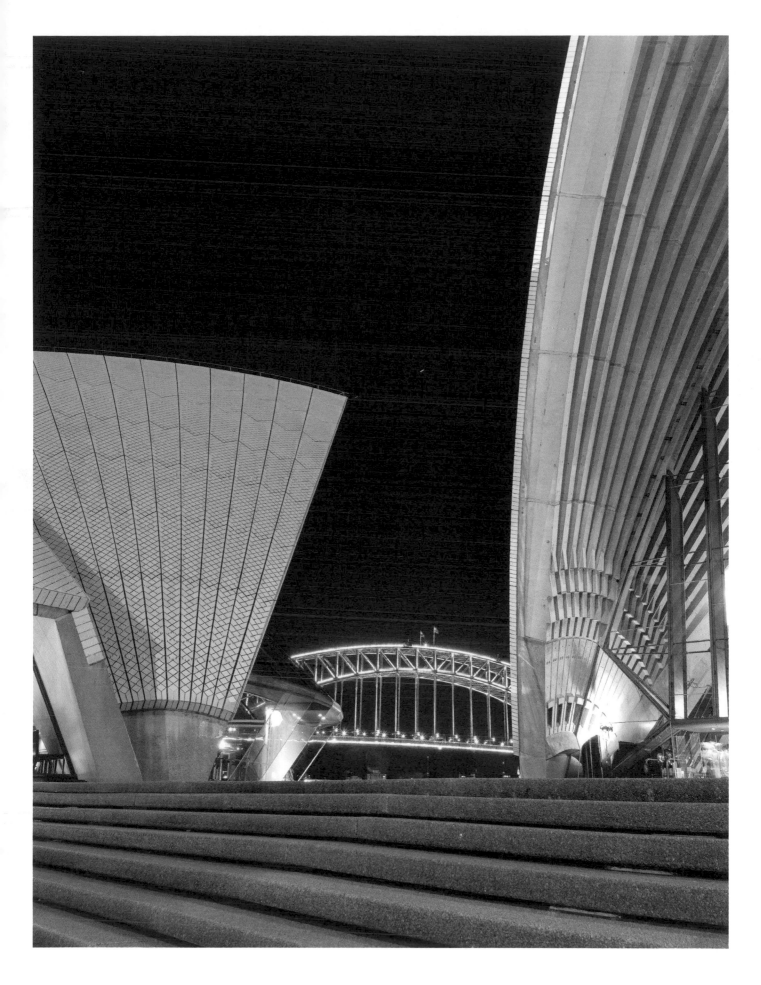

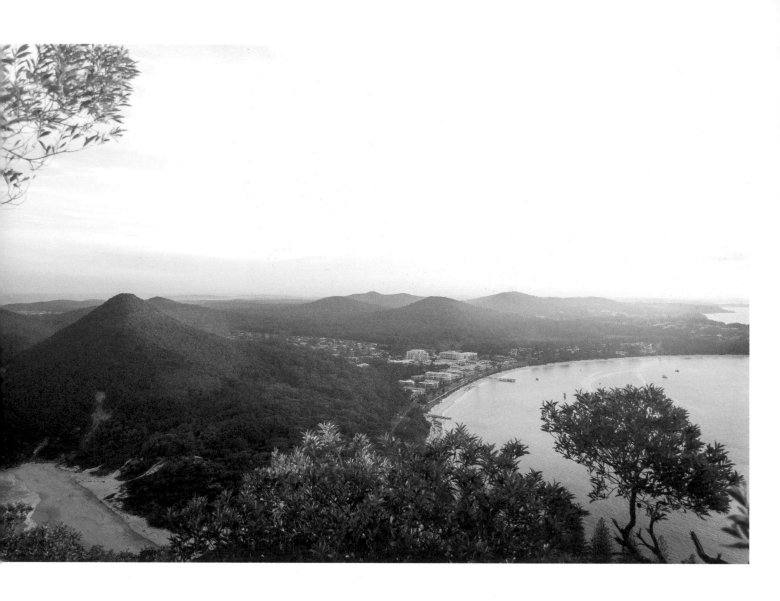

↑ Mt. Tomaree. Nelson Bay, Australia

Mt. Tomaree was a bit of a spontaneous visit during my road trip along the East coast. It really showed me the beauty of travel. It was day three of our road trip and we were planning to head over to Port Stephens. I hope the picture speaks for itself, but oh boy was it worth the effort getting up there. We were literally chasing that sunset light!

→ Sea Cliff Bridge, Coal Cliff, Australia

The Sea Cliff bridge is another popular local instragram spot, specifically from this viewpoint. You can find it along the famous East Coast highway. It's not all that easy to find the path and go up. Your best shot is to get in touch with someone who knows the way up. James, the friend I went with, even brought pink chalk with him, to mark our way up. I thought it was a silly at first, but only realized on our way down how it saved us from getting lost.

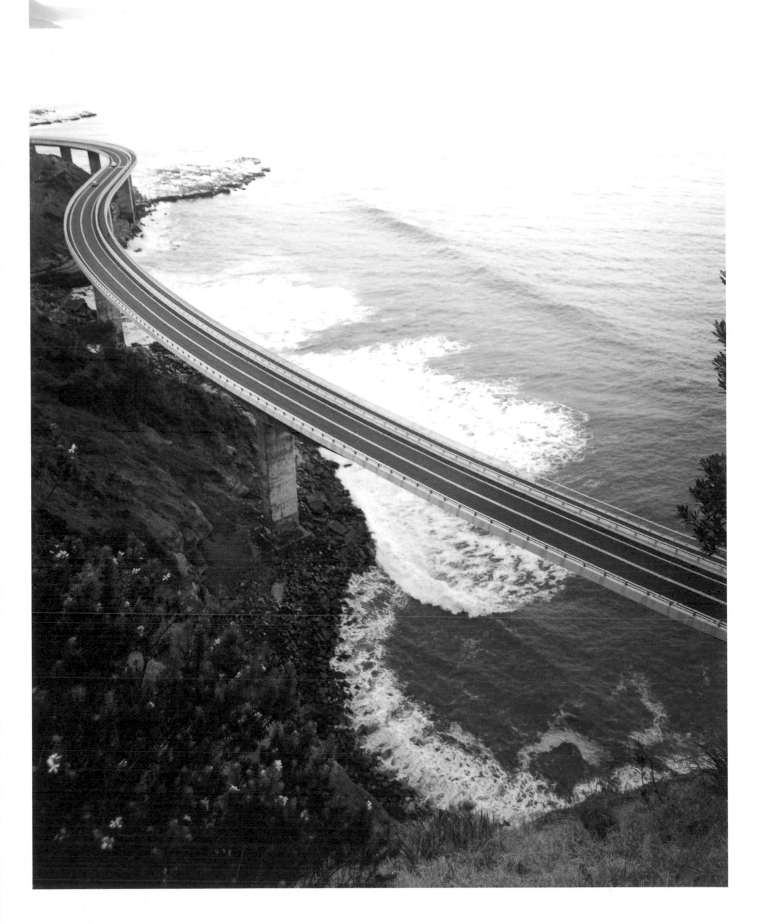

HELENSBURCH

Tunnels of Helensburgh, Australia

There are a lot of legendary tales surrounding the abandoned railway tunnels. According to one of them, a coal miner named Robert Hales was walking home through the relatively short 80m Helensburgh Tunnel, on June 13, 1895, after a hard day's work. A steam train appeared behind him. He ran, but wasn't fast enough. Some say his ghost still haunts the tunnel and can be seen running from the darkness as if he's trying to flee.

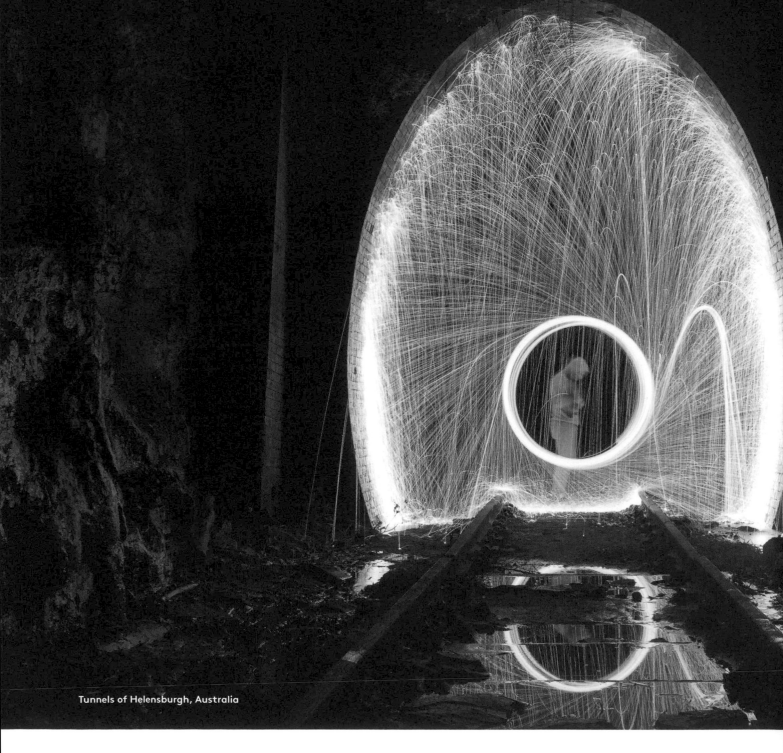

Tunnels of Helensburgh, Australia

" **By night, the city becomes one big experimental playground for photographers, and Instagram blows up with a constant feed of the show. People get really creative.** "

– Ramon Gilbert Klomp

The Dutch, 19-year old photographer Ramon Gilbert Klomp lives for "adventure, travel and challenging his fears". He'd like to call himself a "professional amateur photographer," and loves the golden hour moments at sunset and sunrise. "Photography has allowed me to get out and experience adventures on a new level," he continues. "Through Instagram, I can easily connect with people that I've never met before, but I know that they all have one common passion. That's all you need. I feel most in the moment and fulfilled when I'm taking pictures, with other people, while chasing that sunset."

Ista-
Iceland

So, you have a social medium full of wanderlust-wild photographers and a bag of money to promote one of the most beautiful islands of the northern hemisphere, what do you do? The Icelandic tourism board (and later on, also an Icelandic airliner) knew the answer to that question, and flew a bunch of famous Instagrammers to the island as a part of their social media campaign. It's one of the reasons that Iceland is now super Insta-famous: all year round there are a ton of photographers roaming the island. It's hard not to take a beautiful picture of the breathtaking glaciers, black beaches, the old crashed American cargo plane on Sólheimasandur beach, Reykjavik's Hallgrims church or simply the fascinating, mountain-filled landscape that changes along with the weather. One can already fill a timeline just with stunning shots of Iceland. However, if you'd like an occasional break in your timeline from all those stunning nature shots, be sure to follow the puppy-filled, awesomely down-to-earth Instagram account of Reykjavik's police force, @logreglan.

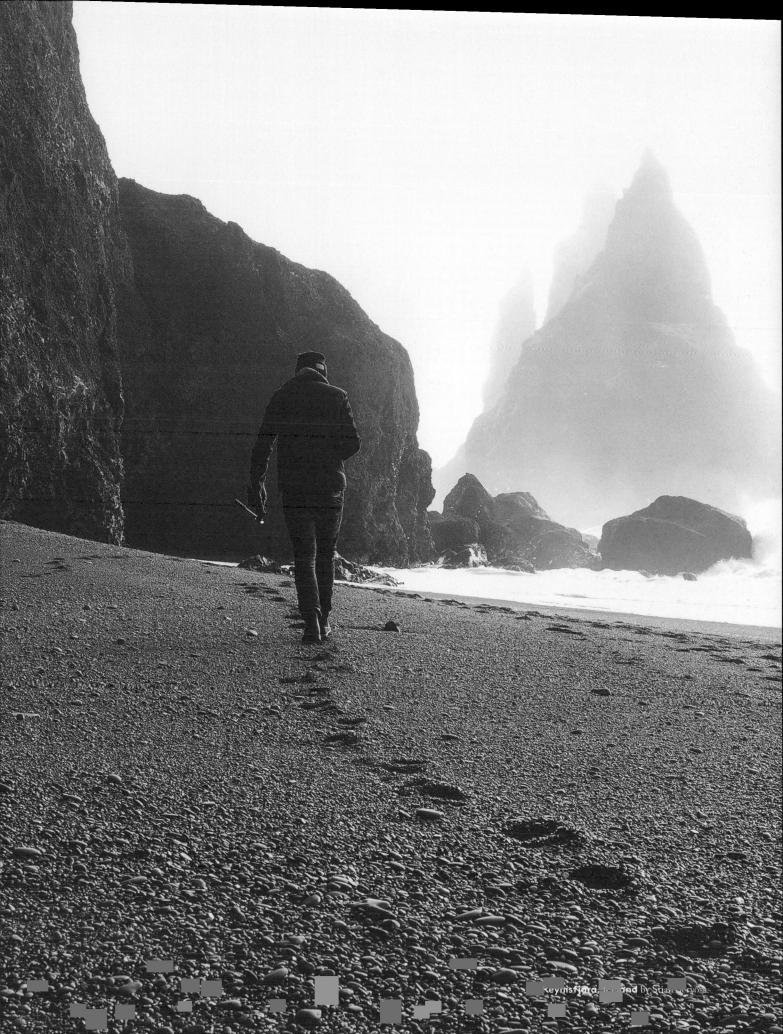

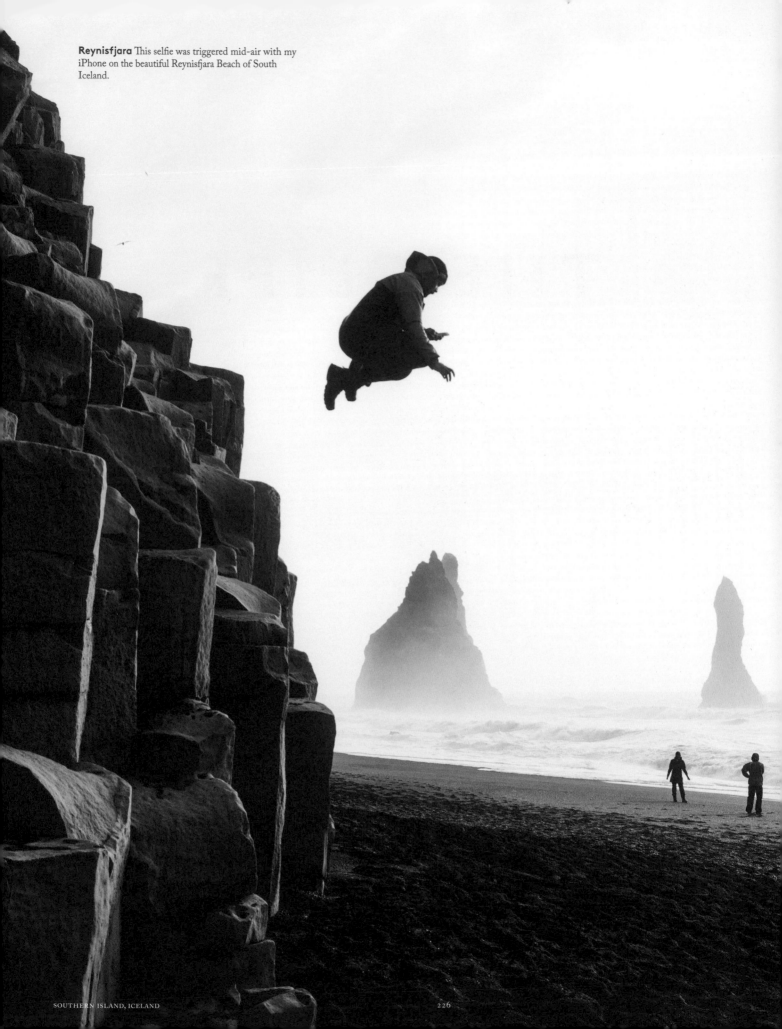

Reynisfjara This selfie was triggered mid-air with my iPhone on the beautiful Reynisfjara Beach of South Iceland.

THE CLIFF

LOCATION Southern Island, Iceland **COORDINATES** 63.406511, -19.069739
PHOTOGRAPHER Stian Servoss, Bergen, Norway @Servoss

"Iceland is by far the most beautiful place I've ever been," says Norwegian photographer Stian Servoss. Although he lives in a country with impressive natural areas, the beauty of Iceland blew Stian away. "It's due mostly to its variation in landscapes," he explains. "It really feels like another planet, and it continues to impress in new ways for every minute you travel." Together with a bunch of other photographers, Stian was invited to Iceland's south coast to try out a new digital camera. They rented a car and drove around for four days, although Stian thinks that might've been a bit too short: "I feel that I missed a lot of locations. The views we saw, however, are spectacular in so many different ways. As you're driving along the main roads of Iceland you will pass waterfalls, deserts of black sand, glacial lakes, geysers, and lots of cozy small towns. It just might be the most spectacular landscape you'll ever see in your life."

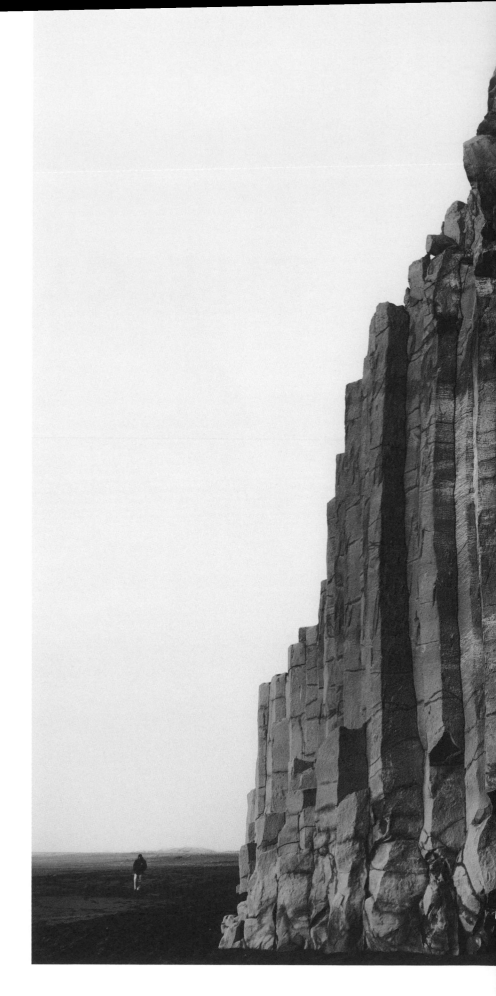

Reynisfjara The Reynisfjara beach features an amazing cliff of regular basalt columns resembling a rocky step pyramid.

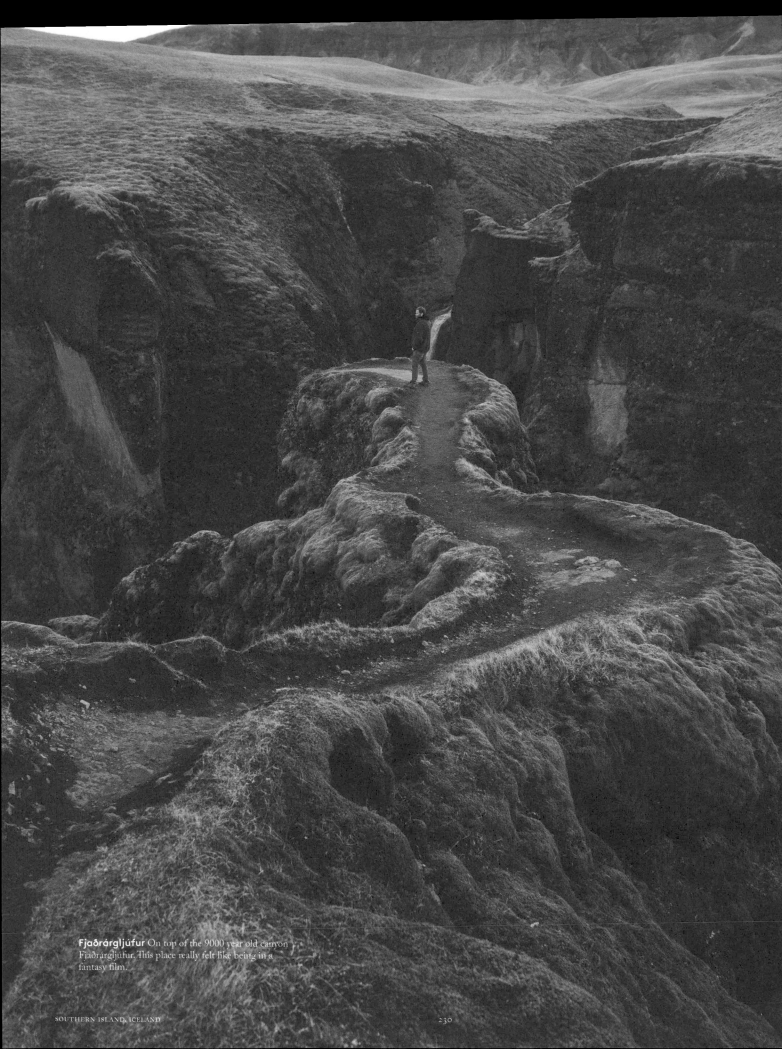

Fjaðrárgljúfur On top of the 9000 year old canyon Fjaðrárgljúfur. This place really felt like being in a fantasy film.

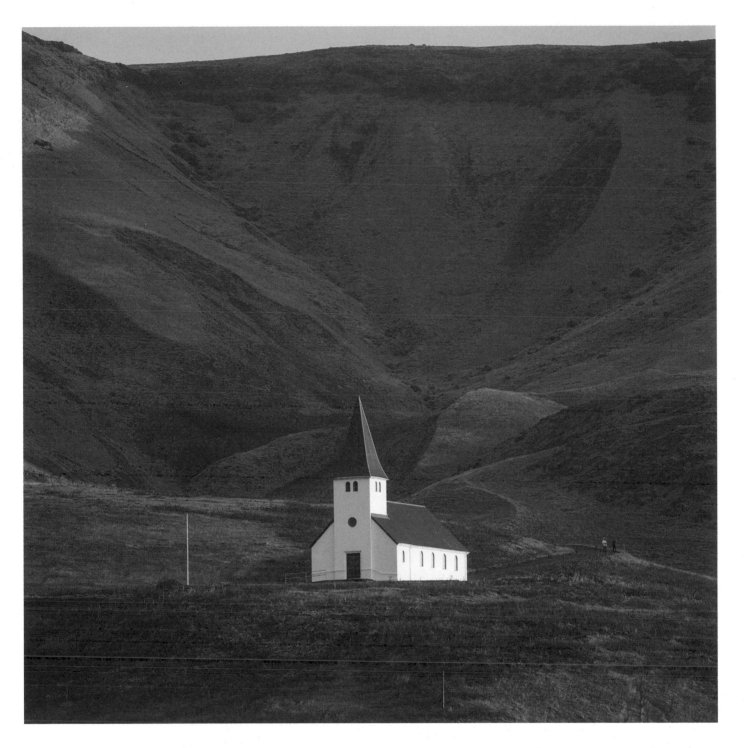

Vík The church of Vík, a small town in Southern Iceland.

" As you're driving along the main roads of Iceland you will pass waterfalls, deserts of black sand, glacial lakes, geysers, and lots of cozy small towns. It just might be the most spectacular landscape you'll ever see in your life. "

– Stian Servoss

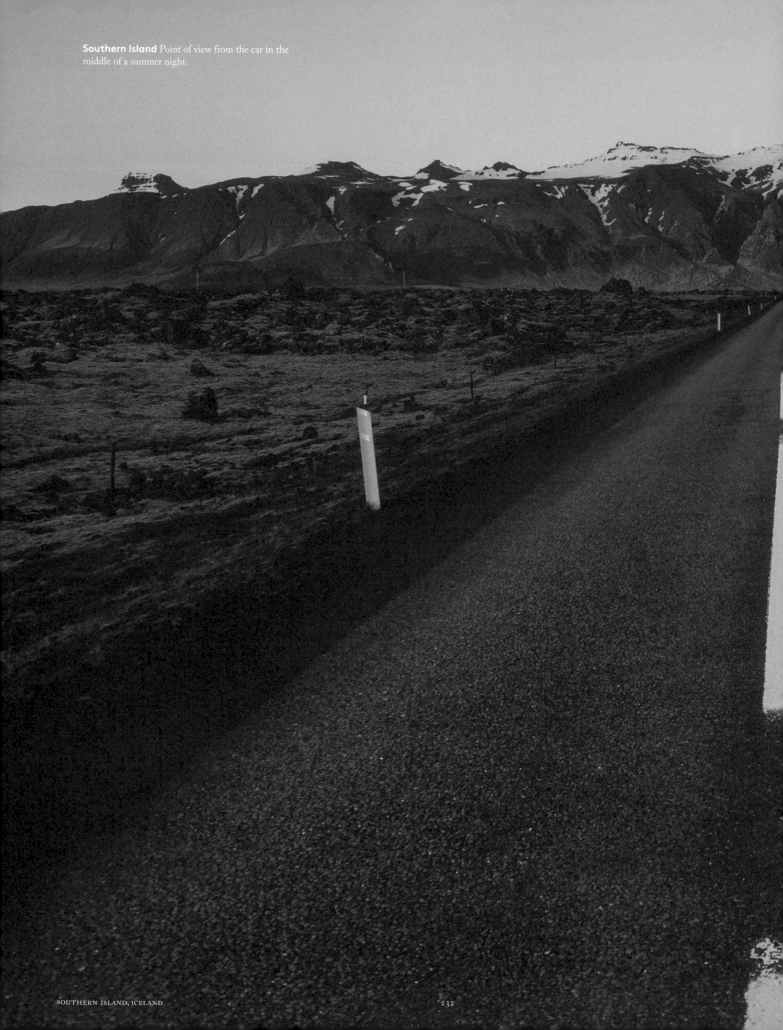

Southern Island Point of view from the car in the
middle of a summer night.

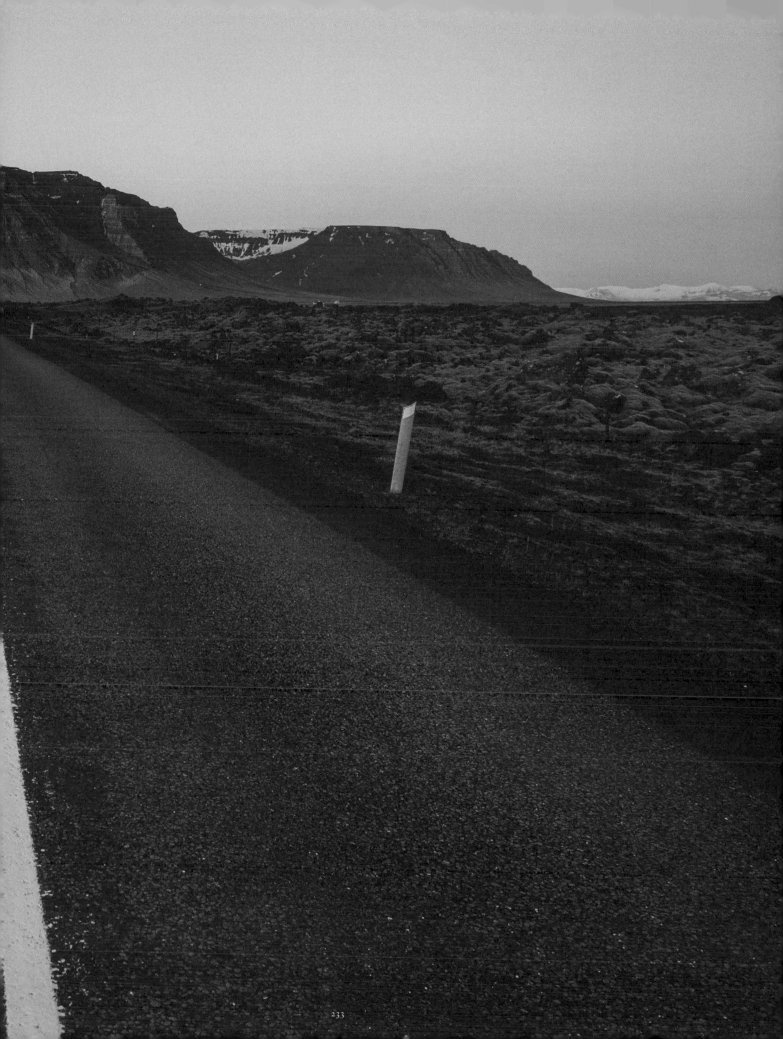

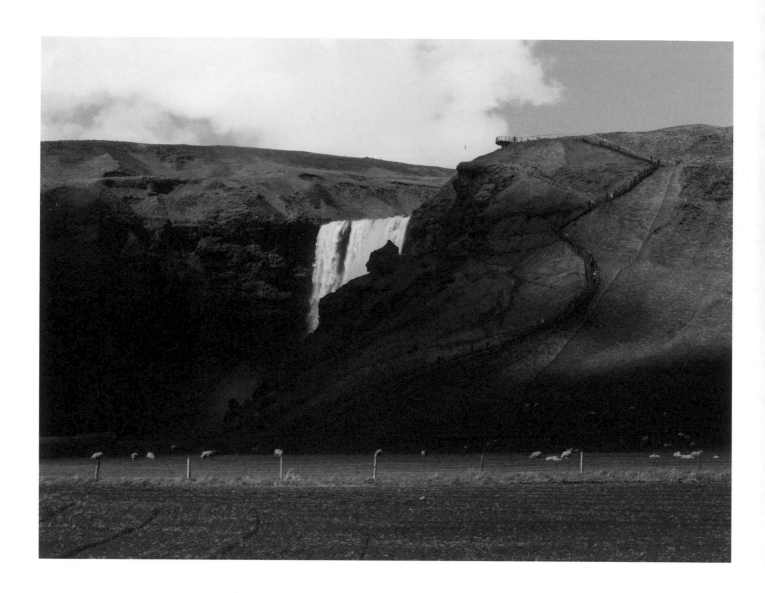

↑ **Skógafoss** This is probably the most visited waterfall on Iceland, but because it's one of the biggest, it's definitely worth checking out. There are also no restrictions on how close you can go.

→ **Skógafoss** If you're visiting on a sunny day it's likely that you'll see a single or double rainbow.

When Stian Servoss downloaded the Instagram app in March 2012, he was hooked from the start. "I'd been working as a director of photography in television and film, so naturally I was immediately interested in mobile photography," he says. "After a lot of experimenting with different apps, I developed my own style. I focus on shapes and lines and try to add a cinematic feel to my photos. When I put people in my shots, I usually don't let them take up to much space in the frame. They kind of look like 2D-video game characters. I guess it brings back good memories from my childhood."

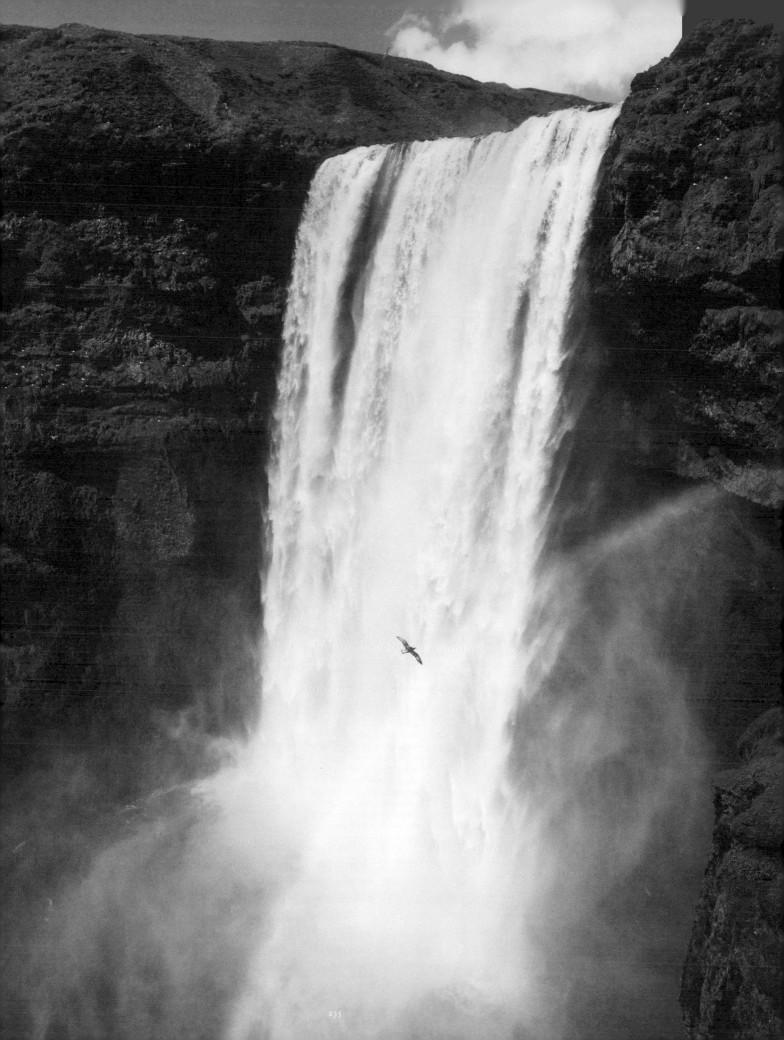

CHASING SUNRISE

LOCATION Achill Island, Ireland **COORDINATES** 53.975214, -10.085257
PHOTOGRAPHER Willem Sizoo, Zutphen, The Netherlands @willemsizoo

Though Dutch photographer Willem Sizoo didn't really expect that much from his trip to Ireland's Achill Island, he soon loved the place because of its natural beauty. "It's one of the most surprising and diverse countries I have ever been to," he explains. "You never know what view you should expect - there's a different beautiful view around each corner. The best place we stayed was a camping site called "Sandybanks," 750 meters from Keel village. It's located right next to the sea, so it's great to wake up with a view on the sea, the beach and the huge cliffs." Willem and his family went camping on the island, and he loved it. "Go there with your tent, wake up early to catch sunrise, do lots of outdoors activities such as hiking or canoeing, and go surfing! A lot of people don't know it, but Ireland is actually one of the best surf countries in the world." He was stunned by Achill Island's nature, but that's not the only reason he would recommend a visit: "also, the history of the area is interesting, and the people are great. They made us feel really welcome, and they always wanted us to try their local dishes."

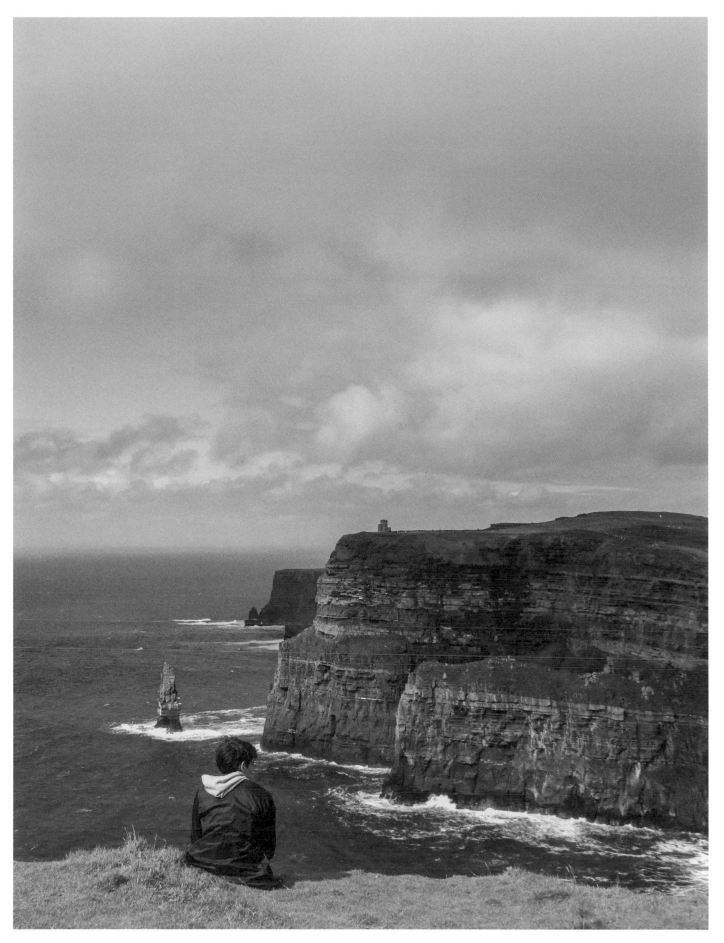

Achill Island, Ireland
Bob sitting by the cliffs of Moher.

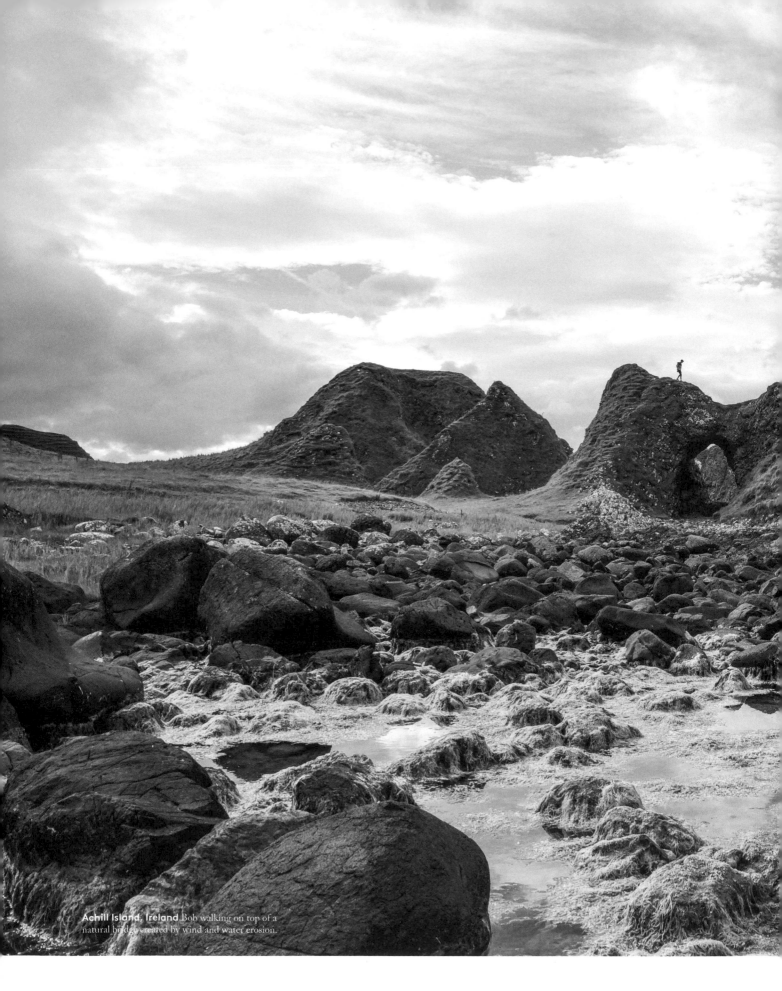

Achill Island, Ireland Bob walking on top of a natural bridge created by wind and water erosion.

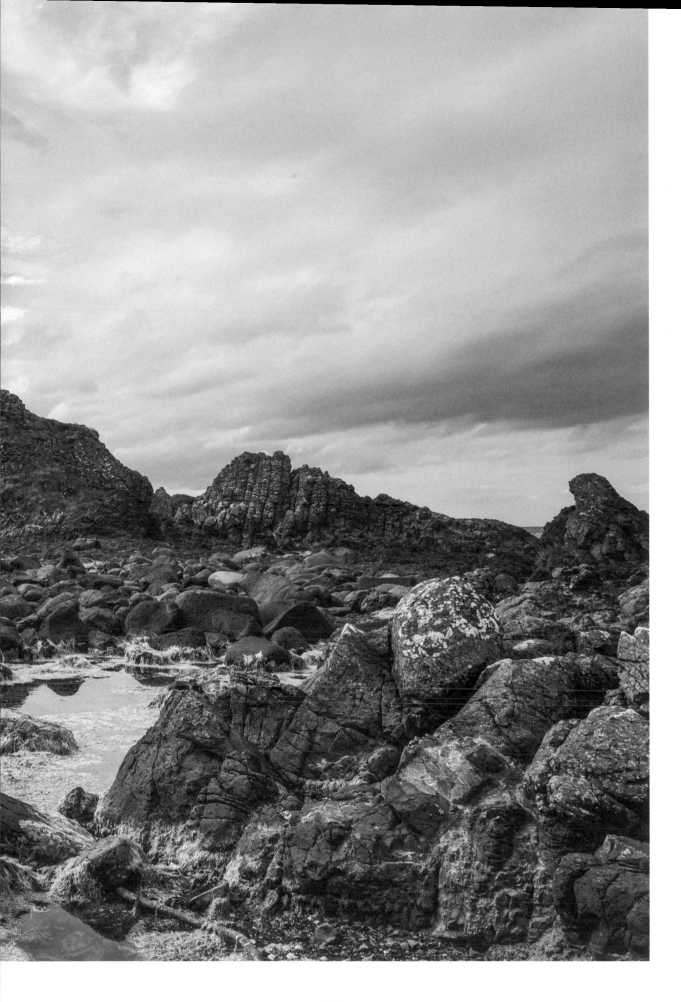

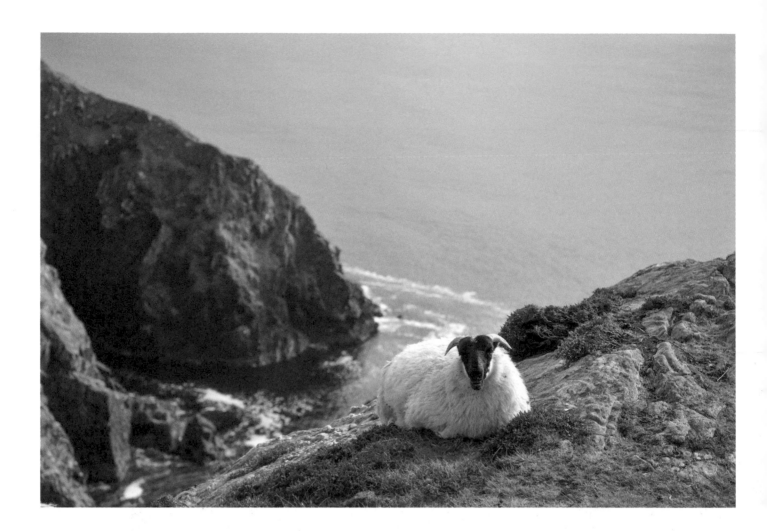

" Go there with your tent, wake up
early to catch sunrise, do lots of
outdoors activities such as hiking
or canoeing, and go surfing! "

– Willem Sizoo

↑ **Achill Island, Ireland** A sheep chilling at the edge
of a 150m cliff. The Irish sheep are real mountaineers.

→ **Achill Island, Ireland** Golden hour at one of the
abandoned houses of Achill Island.

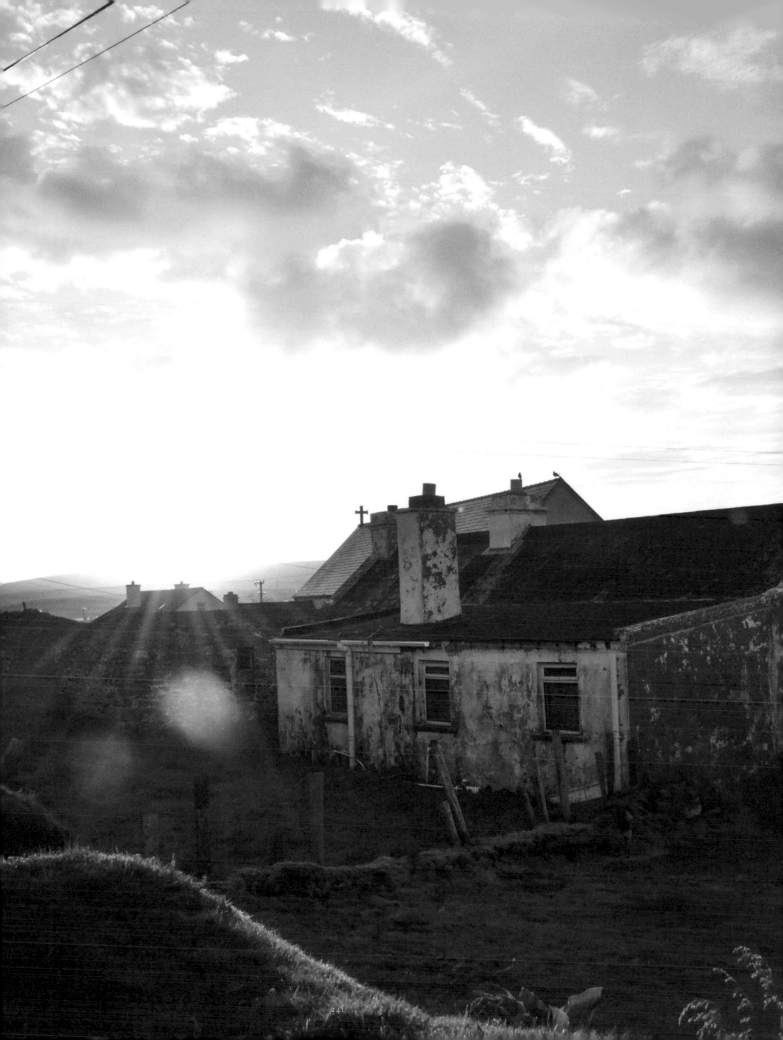

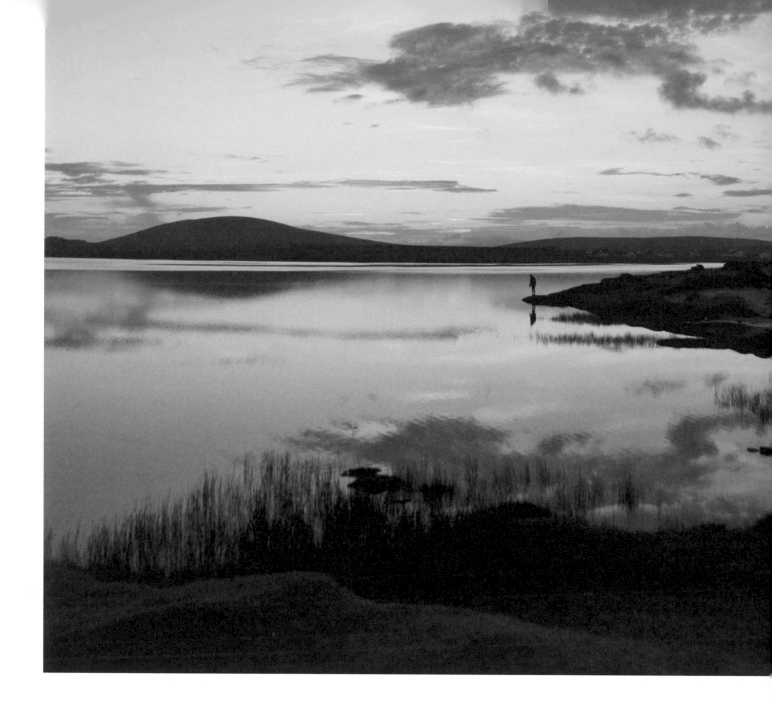

↑ **Achill Island, Ireland** Chasing sunrise at Achill
Island, 5:45 am.

↗ **Achill Island, Ireland** Bob taking in the view.
This is one of the lakes on Achill Island, just after
sunrise.

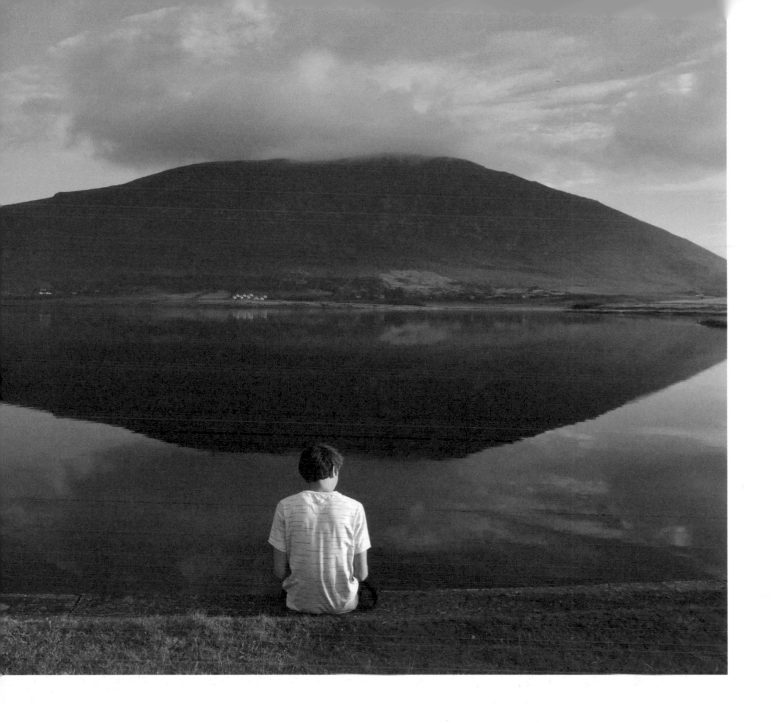

Willem Sizoo entered this world on the 2nd of August, 1999, in the Dutch city of Leiden. He spent his first few years in the African country Malawi, before he and his family moved back to The Netherlands. "My parents, my brothers and I have always traveled a lot," Willem says, "traveling and going somewhere new is one of the best things in the world. I have always taken photos on my travels, but I only started taking it seriously when I discovered instagram. I met lots of new people through the app and went to new places. My hobby has now turned into a job, and I love it."

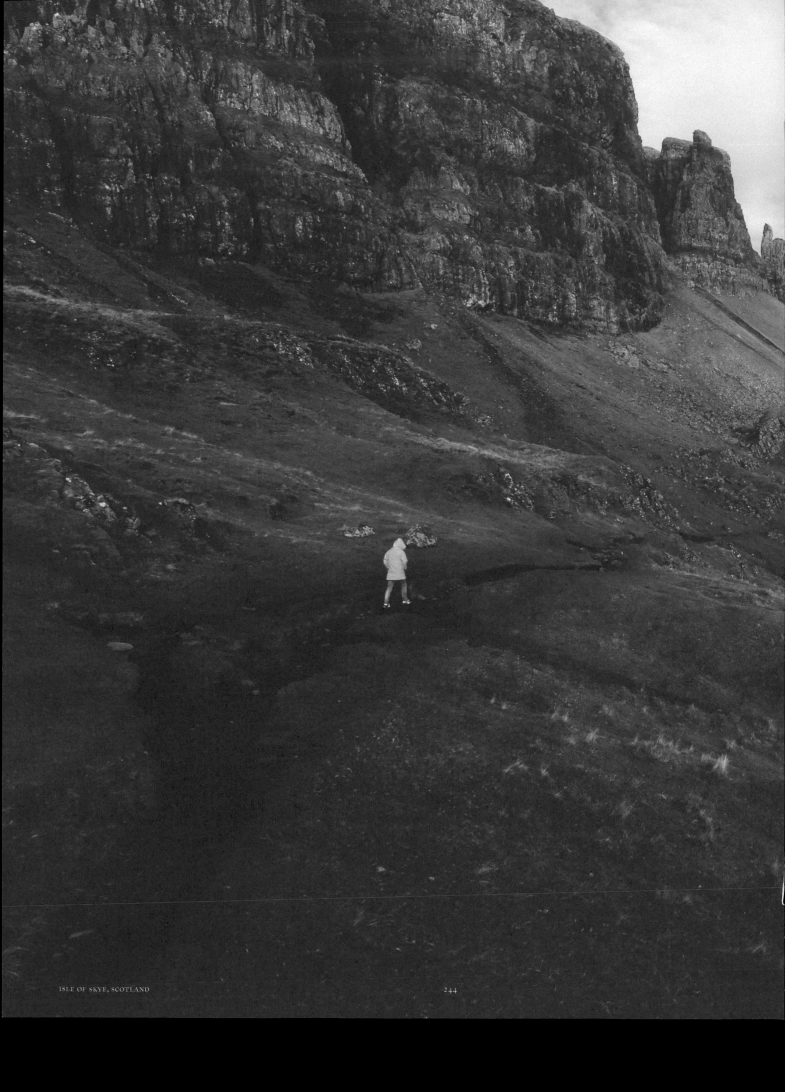

ISLE OF SKYE, SCOTLAND

A MAGICAL
SKYEFALL

LOCATION Isle of Skye, Scotland **COORDINATES** 57.615630, -6.187915

PHOTOGRAPHER Pie Aerts, Amsterdam, The Netherlands @pie_aerts

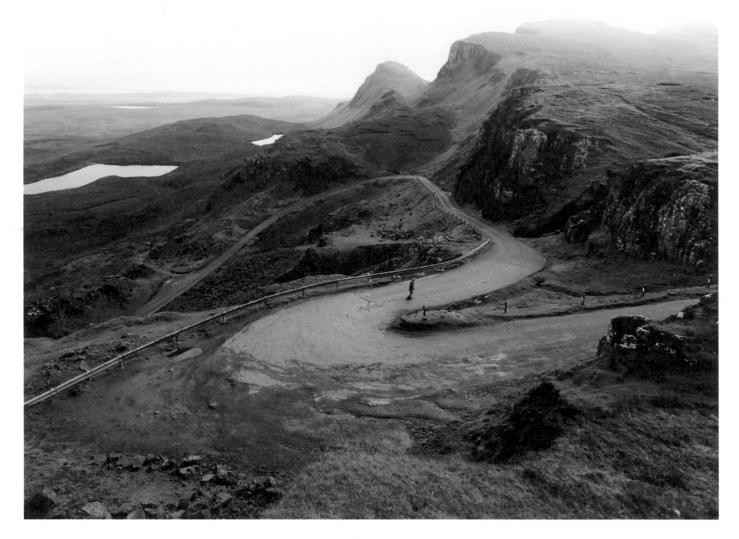

↑ **Isle of Skye, Scotland** Life's more fun when you don't act your age. You should try it.

→ **Isle of Skye, Scotland** Once you've visited this island, you'll start planning when you can come back.

Photographer Pie Aerts and his friend Hans Roozekrans visited Skye in the first two weeks of November, when the people of the small and remote island on Scotland's West Coast were preparing for winter lockdown. "I'd been hearing many things about Scottish weather, especially in fall season, but shiny, calm and sunny hadn't been any of them," says Pie. "Tourists had fled with the summer sun and sea mist covered the land in shadows. What's left are deserted roads, curling through rough landscapes dotted with thousands of sheep." "On Skye, each morning was a gift," Pie continues. "Every time we opened the door of our campervan, we would find ourselves deserted under a perfect blue Scottish sky, looking out at spectacular cliffs or lush green valleys. The landscapes are so diverse, and the autumn colors breathtaking. With names like The Fairy Pools, The Quiraing, The Fairy Bridge, Dunvegan Castle and The Old Man of Storr written on Skye's map, you can imagine that on this little island, fairytales do come true."

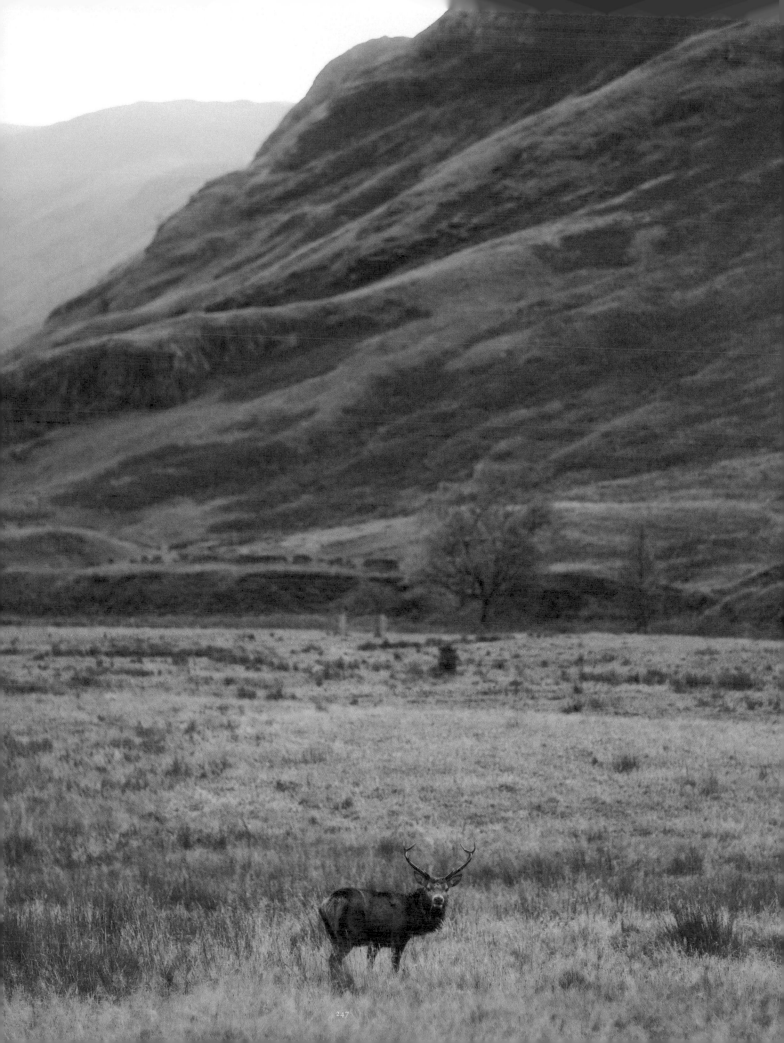

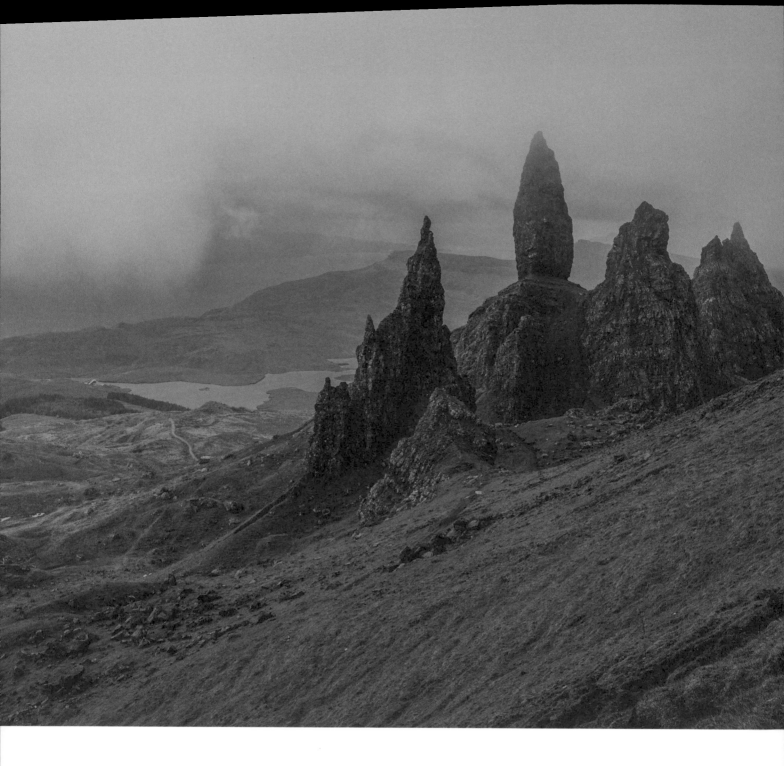

↑ Isle of Skye, Scotland On this day, it felt as if we had somehow hiked ourselves into the latest episode of *Game of Thrones*.

↗ Isle of Skye, Scotland During this trip, I found my new favorite word, "petrichor." It's the word for the earthy smell that's produced when raindrops fall on soil. Sometimes, rain isn't a bad thing.

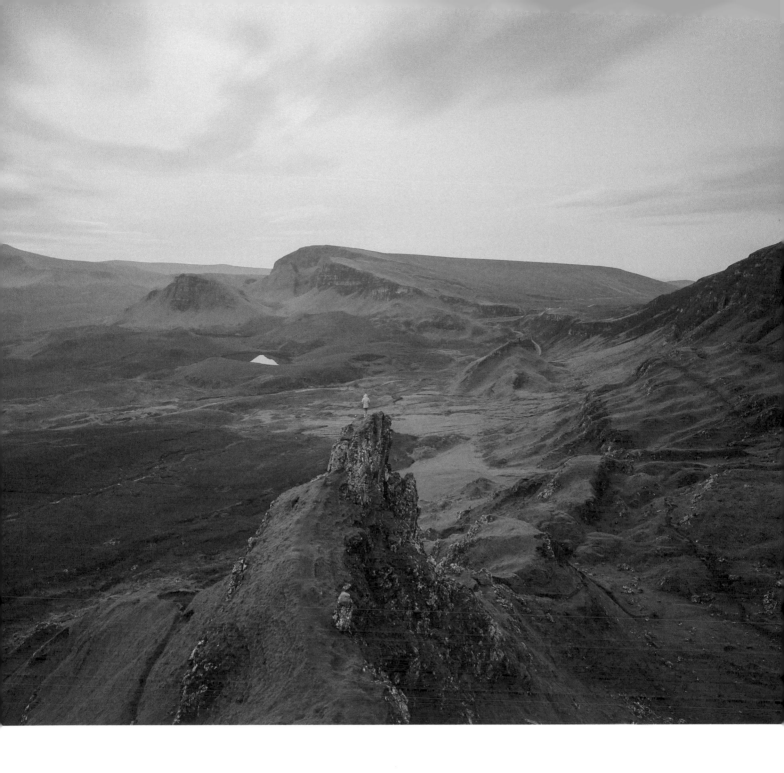

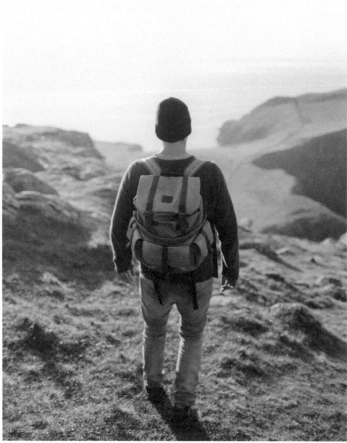

" With names like The Fairy Bridge, Dunvegan Castle
and The Old Man of Storr written on Skye's map,
you can imagine that on this little island, fairytales
do come true. "

– Pie Aerts

Outdoor & lifestyle photographer Pie Aerts is always on the hunt for the most rugged and remote landscapes to travel to and photograph. One of the things he truly loves about photography, is that it gets him outdoors. "So many long hikes to amazing views, sleeping under the stars and walking for days without a soul being around," Pie says. "I love the independence of it. Walk outside your door and do whatever you want to do — it's your own creative outlet, there's no wrong or right way to do it. It's about wandering and observing. Whether it's your own backyard or a 24-hour journey away from home, always make sure you enjoy every minute of it, in your own unique way."

↑ **Isle of Skye, Scotland** Above all else, light is the most inspiring thing to me in photography. Especially those first rays of sunshine that announce a new day.

↗ **Isle of Skye, Scotland** To me, the ability to see and experience places like this is more valuable than anything I own.

→ **Isle of Skye, Scotland** Some mornings are meant to be walked, and this was definitely one of those mornings.

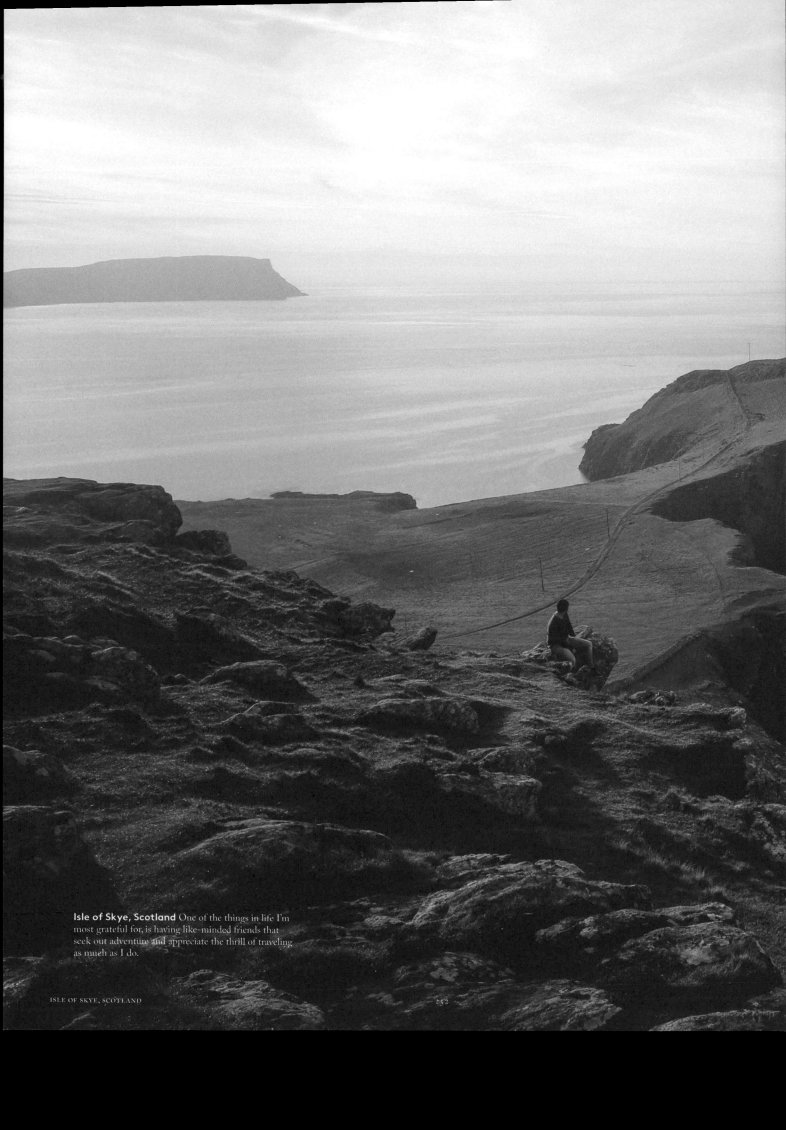

Isle of Skye, Scotland One of the things in life I'm most grateful for, is having like-minded friends that seek out adventure and appreciate the thrill of traveling as much as I do.

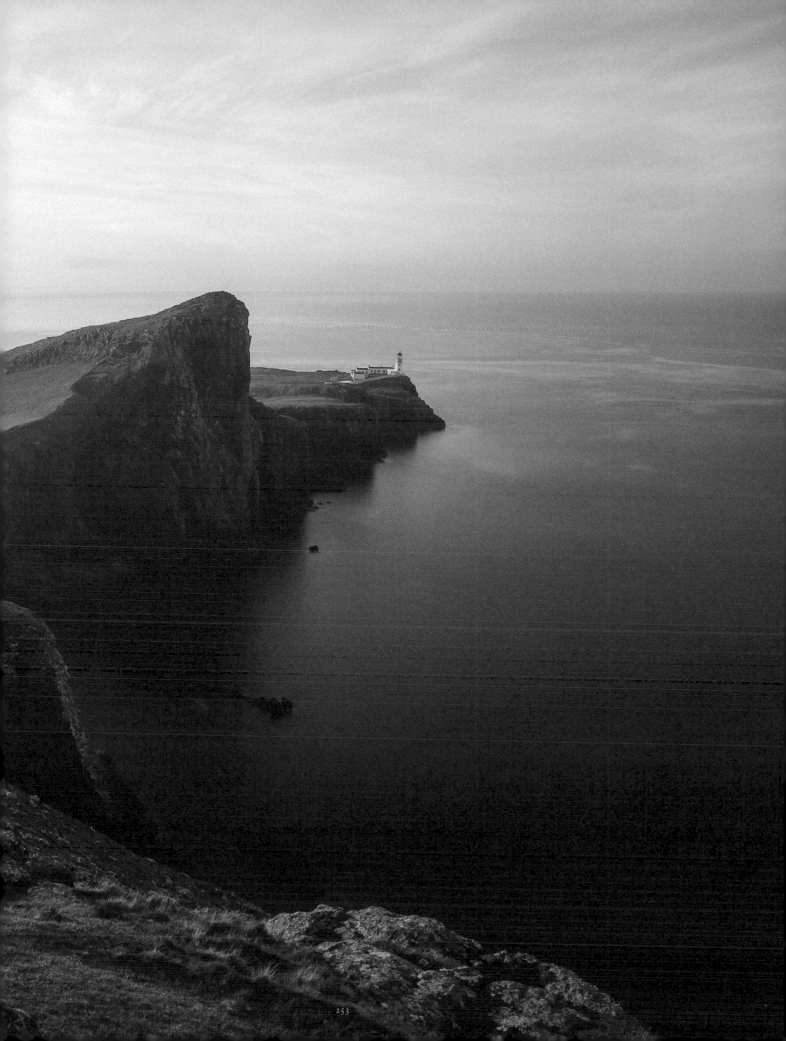

Credits

First printed in October 2016

ISBN 978 90 8989 704 6
NUR 653

Publisher
Uitgeverij TERRA
TERRA is part of TerraLannoo bv
P.O. Box 97
3990 DB Houten
The Netherlands
info@terralannoo.nl
terralannoo.nl

Initiative & design
MENDO, Amsterdam
mendo.nl
@mendobooks on Facebook,
Twitter, Instagram and Pinterest

Curated by
The Sizoo Brothers
@thesizoobrothers on Instagram

Text
Joost Bastmeijer
joostbastmeijer.com
@joostbastmeijer on Facebook,
Twitter and Instagram

Special thanks to
Timothy Van Laar & Lucas Ribeiro
Hashtag The World, Amsterdam
hashtagtheworld.com
@hashtagtheworld on Facebook and
Instagram and *@hashtaggedworld*
on Twitter